# HPBooks®
## How to Select & Use
# Electronic Flash
### James Bailey

**Publisher:** Rick Bailey
**Editorial Director:** Theodore DiSante
**Editor:** Vernon Gorter
**Art Director:** Don Burton
**Book Design:** Paul Fitzgerald
**Typography:** Cindy Coatsworth, Michelle Claridge
**Book Manufacture:** Anthony B. Narducci
**Photography:** James Bailey, unless otherwise credited

**Published by HPBooks, Inc., P.O. Box 5367, Tucson AZ 85703    (602) 888-2150**
ISBN: 0-89586-144-5.   Library of Congress Catalog No. 82-84042
© 1983 HPBooks, Inc. Printed in U.S.A.
2nd Printing

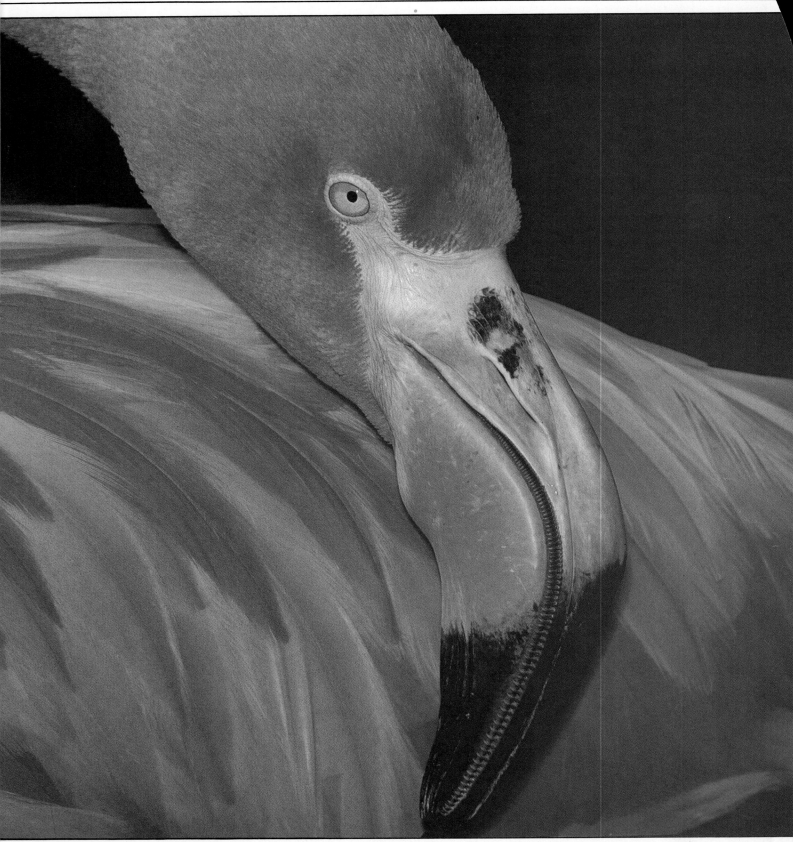

Photo by George Lepp, Bio-Tec Images.

# CONTENTS

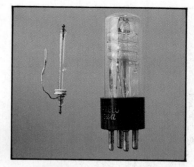
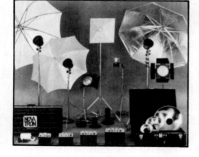

# Introduction

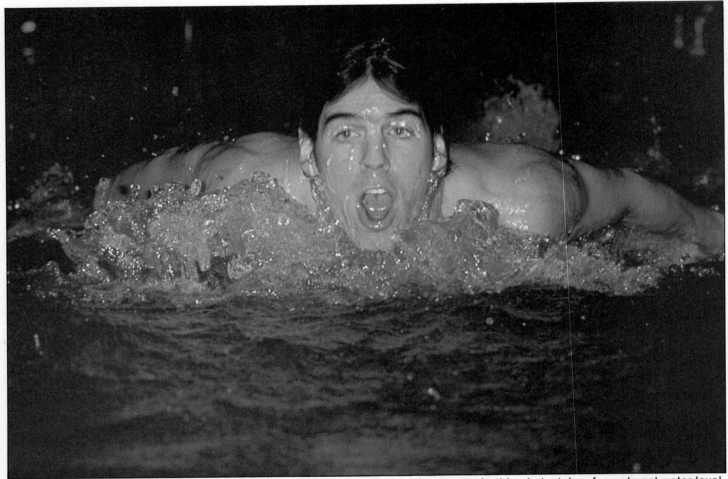

Short duration of electronic flash makes it ideal light source for fast-moving sports. In this photo, taken from almost water level, flash has dramatically highlighted the turbulent water in front of the swimmer. Photo from Focus on Sports, Inc.

From the moment electronic flash first appeared on the scene, its motion-arresting speed endeared it to the general public. People loved the eye-catching and dynamic new photographs it made possible. The contorted features of athletes in action, flattened golf balls, "frozen" splashes of water and riffled playing cards suspended in mid-air soon became familiar sights in magazines and newspapers everywhere.

As the technology of electronic flash matured, people were able to do more than simply *enjoy* the pictures made with it. They were able to *make* photos with electronic flash.

In addition to its motion-stopping ability, electronic flash offered other attractive features. Its light output had almost the same color characteristics as midday daylight. This meant that daylight-balanced color film could be used without color filtration. Flash photography became more economical because you could make exposure after exposure without expending flashbulbs. You didn't need to carry a supply of bulbs or worry about how to dispose of the hot, spent ones.

Today, electronic flash has uses beyond photography. It is used in phototypesetting machines, lasers, warning lights, chemical apparatus and for stage-lighting effects. New applications are developed each year.

This book deals only with the use of electronic flash in photography. The information that follows should stimulate you to use this wonderful tool to make spectacular pictures that could be made no other way. The book will also help you select and use the electronic flash equipment most suitable for you.

# The Evolution of Electronic Flash

Early photographers weren't faced with a choice of what light to use. When Joseph Nicéphore Niépce was experimenting with recording images using silver salts in the 1820s, direct sunlight was the only source available.

The first daguerreotypes needed 10 to 15 minutes of exposure in direct sunlight. By the 1840s, the plates had been improved to the point where daylight exposures of 10 to 15 seconds were standard practice.

Daylight is still our prime source of lighting. Whether in the form of direct sunlight, open shade or an overcast sky, daylight is the most common illumination for most photographers.

You have some control over natural light through the use of reflectors, diffusers and dark screens. But there are two important factors you can't control—its availability and its consistency in brightness and color temperature. Indoors, nighttime and fast action all frequently require some form of "artificial" light.

## ARTIFICIAL LIGHT

Artificial photographic lighting was first produced in the 1860s by burning magnesium ribbon.

Typical flash-powder gun from early this century. Flash powder was set off with a shotgun primer. Gun is still in good working condition and I use it frequently for teaching.

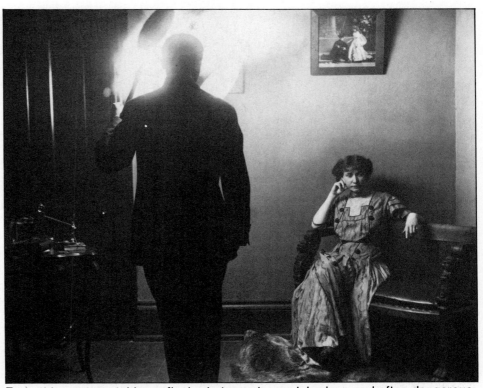

Early this century, taking a flash photograph was laborious and often dangerous. The subject needed courage to look relaxed and calm, knowing that a blinding flash and clouds of smoke were imminent. Photo courtesy of Eastman Kodak Co.

There were many clever devices made to handle the ribbons. They usually included a clockwork to feed the ribbon to the flame at the proper rate, and a reflector to concentrate the light and direct it in the desired direction. Due to the long exposure times needed and the difficulty of working with the ribbon, the use of burning ribbon ceased after 1925.

When electricity became commercially available to homes and businesses, photographers turned to carbon-arc lamps. In these, two carbon rods are connected to a powerful source of electricity. The rods are momentarily touched together. This produces a brilliant spark, or arc, that continues as the carbon rods are consumed by the electric current. Either a mechanical device like a clockwork or frequent personal attention is needed to keep an arc adjusted for proper operation.

Because of the large amount of power required to operate them, arc lamps were limited virtually to studio use. At the Paris Exposition of 1875, a photo studio featuring a huge paper umbrella reflector lit by an arc lamp was demonstrated. Movie studios that were able to finance expensive portable generators found arc lamps useful for location filming.

Later, arc lamps were superseded by tungsten lamps for general photographic use. Xenon arcs are still actively used by graphic-arts photographers today.

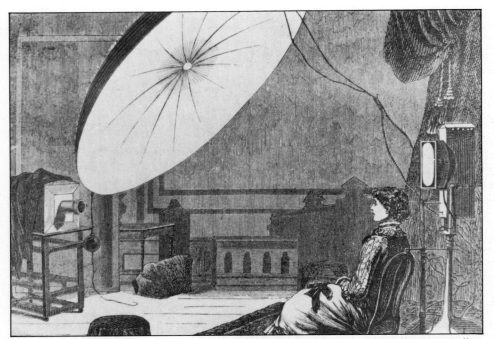

Umbrella reflectors, discussed later in this book, are not new. A large one, similar to the one shown in this drawing, was demonstrated at the 1875 Paris Exposition.

Safe, low-cost flashbulbs brought flash photography to every home. This photo was taken in 1944. Since then, electronic flash has taken over almost everywhere.

## FLASH POWDER

By the late 1880s, the gradual increase in film sensitivity made *portable* artificial lighting a practical reality. Flash powder was first introduced in Germany. It soon found its way into the hands of American photographers. It was made of powdered magnesium, potassium chlorate and other chemicals. Flash powder burned so quickly when ignited that a brilliant burst of light resulted. It also generated large amounts of smoke.

Although highly dangerous—even for experienced operators—magnesium flash powder helped bring unique pictures to the public. Previously impossible photographs became an everyday reality.

For example, in the 1880s New York reporter Jacob A. Riis made significant social statements with his flash-powder photographs of slum dwellers and child laborers. His poignant images rank as classic examples of concerned reporting.

Although flash powder is still commercially available, it is rarely used, except for special effects on stage and in films. I demonstrate it once a semester to the delight of my students. It helps to give them an appreciation of some of the difficulties that faced early photographers.

In spite of its hazards, flash powder was a valuable tool. It was capable of producing tremendous amounts of light on demand. This was a necessity when you consider that even by 1930 a fast b&w film had a speed of about ISO 12/12°.

## FLASHBULBS

In 1893, a Frenchman named Louis Boutan took underwater photographs using custom-made flashbulbs. The bulbs were made from heavy glass bottles by a French engineer named Chauffour. They burned magnesium ribbons in oxygen and were ignited by a battery.

It wasn't until 1927 that a practical disposable flashbulb was

# "BIG SHOT" PHOTOS

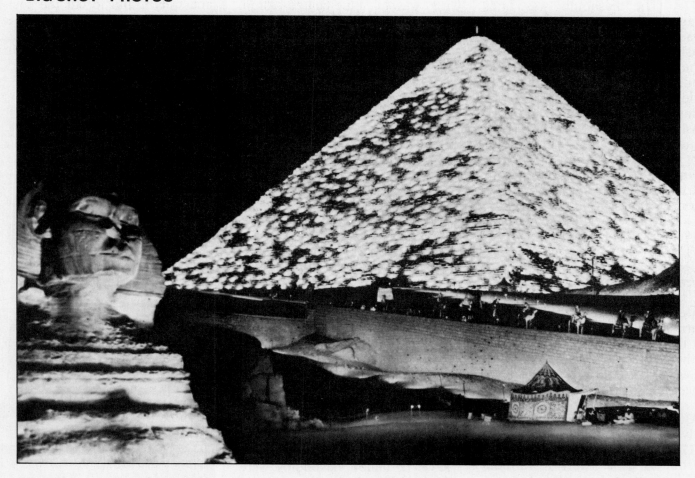

One of the most dramatic and best-remembered advertising campaigns for photographic products was started by Sylvania in 1951. Over the following 17 years Sylvania staged many "Big Shot" photographs to publicize their flashbulbs. It was a high point in flashbulb history.

Huge subjects or scenes were photographed by flash light. They included the aircraft carrier U.S.S. Antietam, the Horseshoe Curve of the Pennsylvania Railroad, and the Pyramid of the Moon, northeast of Mexico City. Thousands of flashbulbs and many workers were involved in each project.

This photograph of the Great Pyramid of Cheops was made in 1959. To illuminate the scene, 6500 Press-25 flashbulbs and 14 miles of interconnecting wire were used. Photo courtesy of Sylvania.

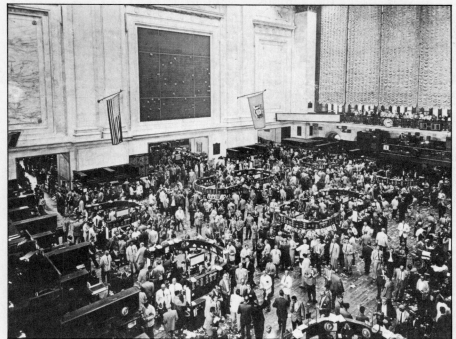

Another, slightly less ambitious, Sylvania "Big Shot" was of the New York Stock Exchange. This photograph was made with 76 of the large #3 flash bulbs. Photo courtesy of Sylvania.

patented. It was manufactured in 1929. The flashbulb was later marketed by Osram under the brand name Vacublitz. These first flashbulbs looked rather strange. They were seven inches long and had a tiny flashlight screw base. The small base permitted the lamps to be fired by an ordinary flashlight. This was necessary because commercial flash guns were not yet made.

In 1930, General Electric began to make its first flashbulbs. For economy, GE packaged the lamps in standard 150-watt lightbulb envelopes.

These early flashbulbs were filled with extremely thin aluminum foil. When first ignited, some of the light was blocked by the outer layers of foil until they, too, burned. This problem was solved by the use of a tangle of fine wire rather than foil. Wire-filled bulbs, designed in Europe, were introduced to American photographers by Wabash Lamp Company in 1936. Wabash was acquired by Sylvania in 1946.

GE added a plastic coating to flashbulbs as a safety feature in 1938. A year later, the famous bayonet-based No. 5 lamp was developed by GE.

Flash photography had now become affordable to amateur photographers. The growing appeal of flash was obvious. In 1940, more than 14 million bulbs were sold. By 1943, the annual quantity sold had risen to nearly 43 million bulbs.

Several new bulbs were developed between 1939 and 1942. Among them was the SM bulb, which used a chemical coating rather than a bundle of fine wire as fuel. It ignited more quickly than wire-filled bulbs. This created some synchronization problems.

At about this time another important new bulb was introduced. It featured a longer uniform peak light output than other bulbs, making it ideal for use with focal-plane shutters. It was called the *FP* flashbulb. Two lamps with colored

coatings also became available. One was a blue-coated lamp, giving light balanced for use with Kodachrome film. The other was a nearly opaque, infrared transmitting lamp, for use with infrared-sensitive film.

GE's all-glass AG flashbulbs came on the scene in 1958. Sylvania's flashcubes appeared in 1965. Zirconium wire—followed by hafnium wire—was featured in some flashbulbs to generate even more light in a small package.

The mechanically triggered Magicube, which operates without electricity, was introduced in 1970. Its spring-loaded firing mechanism made non-electric, batteryless flash cameras possible.

In 1972, the flashbar was developed especially for the Polaroid SX-70 camera. The flashbar featured built-in sensors that directed the trigger voltage from the camera to the first available unfired flashbulb. The Flipflash for Kodak Instamatic cameras appeared in 1975. It was followed in 1978 by Flipflash II with improved light output.

Over 2 billion flashbulbs were sold in 1973. Their simplicity of operation and convenience ensured them a continuing share of the amateur market for years to come. This was in spite of the fact that electronic flash had by now become very popular.

At the beginning of the 1980s, the Sylvania catalog still listed no less than 19 types of flashbulbs. They ranged in size from the tiny AG-1, used in simple cameras, to the large screw-base type 3, favored by industrial photographers for lighting large interior areas.

## ELECTRONIC FLASH

The initial developments of electronic flash took place at about the same time major advances were made in flashbulb development. However, it took a relatively long time for electronic flash to reach the amateur user. Methods had to be found to reduce the

equipment to a manageable size and weight and to cut the cost to an acceptable level.

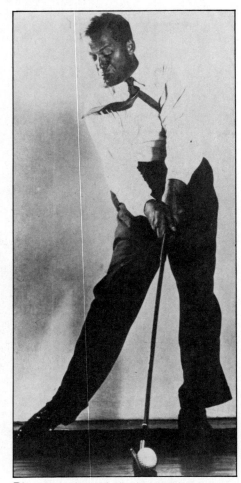

Big attraction of electronic flash from the beginning was its ability to stop motion on film. Using equipment he developed himself, Dr. Harold Edgerton of the Massachusetts Institute of Technology recorded famous golfer Bob Jones in mid-stroke. Notice that ball is slightly deformed to oval shape by impact of golf club.

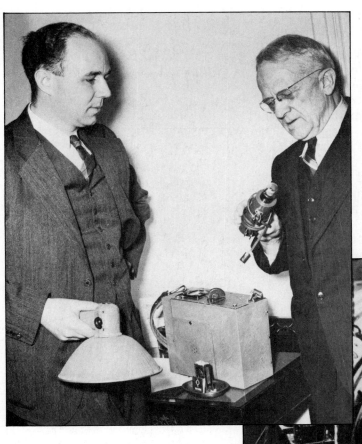

Left: Dr. Harold Edgerton, on the left, demonstrates his pilot model of the Kodak Kodatron portable electronic flash in 1941. Photo courtesy of Dr. Edgerton and *Photomethods* magazine.

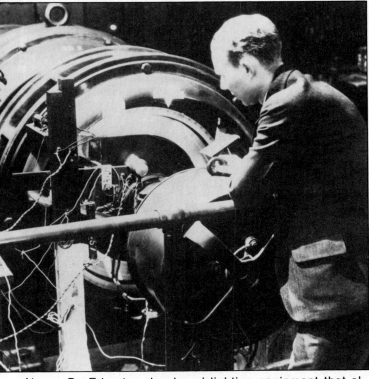

Above: Dr. Edgerton developed lighting equipment that allowed him to study the action of rapidly moving machinery. This stroboscopic lighting was a forerunner of modern electronic flash. Dr. Edgerton is here seen at work in his laboratory in 1931. Photo courtesy of Massachusetts Institute of Technology.

Left: Edward Farber, using the electronic flash unit he developed in 1941. It weighed 13 pounds and was one of the first battery-powered portable units. Photo courtesy of *Photomethods* magazine.

**Beginnings**—William Henry Fox-Talbot is given credit for much of photography's beginnings. He can also be regarded as a pioneer of sorts in the field of electronic flash. Fox-Talbot noticed that a lightning flash would seemingly stop the movement of rain water pouring from the eaves of his house. With this in mind, he developed a way of producing a very brief electric spark as a photographic light source.

In 1851 Fox-Talbot obtained a patent for his system. He successfully used electricity stored in a *leyden jar*—an early form of capacitor. It created a spark that was bright and brief enough to enable him to produce a sharp photograph of a rapidly rotating page from a newspaper.

Nearly 40 years later, Ernst Mach and, in separate work, Sir Charles Vernon Boys, used similar but more sophisticated techniques to photograph bullets in flight.

In 1926 and 1927, the Seguin brothers filed U.S. and French patents disclosing the basic principles used in present-day flash equipment. However, there seems to be no record of any photographs having been taken with their invention.

**The Era Of Edgerton**—Electronic flash, as we know it today, got its big start at Massachusetts Institute of Technology (MIT) with the research of Dr. Harold E. Edgerton. While a graduate student, Dr. Edgerton was studying the dynamics of large motors and generators. He wanted to study in detail the actions of machines while they were running at high speeds. He needed a way of making fast-moving parts appear stationary.

While working in the glow of nearby mercury-vapor tubes, Dr. Edgerton noticed that the poles of a rapidly moving motor appeared to be static. Experiments eventually led to the publication of his report in 1931 on the first electronic *stroboscope*. A stroboscope is a repeating flash that visually stops certain forms of rapid motion.

Dr. Edgerton and two MIT students, Kenneth Germeshausen and Herbert Grier, continued advancing the capabilities of stroboscopic lamps and circuits. In 1947, the three men formed a partnership to manufacture the equipment they designed. The company is now known as EG & G, Inc.

**Early Published Pictures**—In 1937, a Westinghouse engineer named Gjon Mili appeared as co-speaker with Dr. Edgerton at a professional society meeting in Boston. He was impressed with Dr. Edgerton's lights and obtained a set. Mili set up a studio in an old gymnasium in New York and began to produce remarkable studies of dancers and other subjects. His photographs appeared in many issues of *Life* magazine.

About the same time, *Milwaukee Journal* photographer Ed Farber, who had some knowledge of electronics, was shown a copy of the schematics for Dr. Edgerton's flash. Farber was asked to design similar equipment for the newspaper for use with press cameras.

Farber was already operating a neon-sign business part-time with some friends. This group began experimenting with making their own flash tubes. Their objective was to design a unit that would synchronize with existing flashbulb synchronizers. This way, their cameras would not have to be modified.

They settled on a design that used a *high-voltage relay*—an electro-mechanical switch—as the crucial element. The relay was adjustable so it could be set to close the flash circuit just as the camera's shutter blades opened. The relay required periodic adjustment, but it worked. Several of the units were delivered to the newspaper in 1939.

**Portable Flash**—Continuing their efforts, Farber and his associates developed the first battery-powered portable electronic flash in late 1940. It weighed 25 pounds but freed press photographers from the constraints of AC cords. A year later, Farber and his team completed an improved model

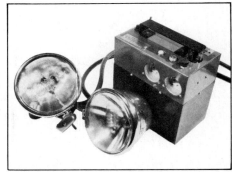
Strobo Research Model A, an AC-powered flash unit released in 1947. It featured two sealed flash heads with built-in reflectors. Photo courtesy of the Edward Farber Estate.

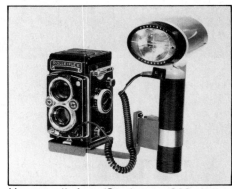
Honeywell Auto/Strobonar 660, introduced in 1965. It was the first commercially available automatic-exposure electronic flash.

Vivitar Zoom Thyristor Flash, Model 365. It attracted a lot of attention when it first appeared in 1977. Featured vertically-tilting head and remote sensor with adjustable field of view. An optional quick-release camera bracket—not shown—was also available.

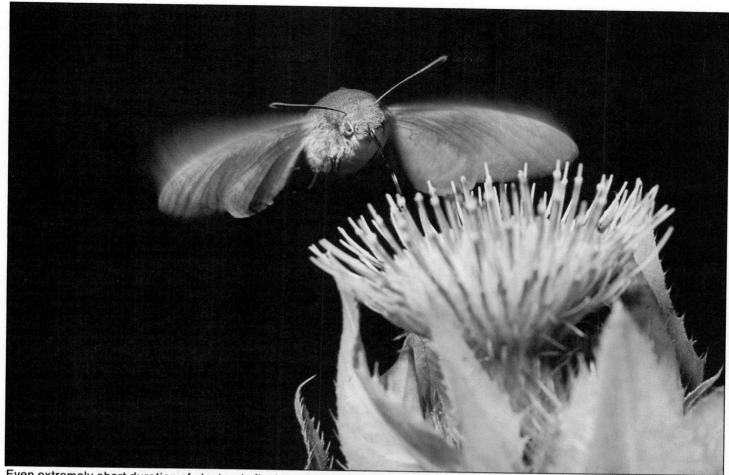

Even extremely short duration of electronic flash couldn't "freeze" the rapid motion of this hummingbird moth's wings. However, a small amount of blur adds to the impact of the picture. Photo by Hans Pfletschinger, Peter Arnold, Inc.

weighing only 13 pounds. Although large and heavy by today's standards, it was not considered so in those days. Camera equipment of the day—4x5 press cameras and a set of large sheet-film holders—was relatively unwieldy, too.

Twelve of the portable flash units were made for the *Milwaukee Journal* and were used throughout the ensuing war years.

During the same period, Dr. Edgerton and his associates made studio-flash units. They were marketed by the Eastman Kodak Company under the trade name Kodatron. Edgerton also designed a battery-powered portable unit in 1941, but production was halted by the war. Both Edgerton and Farber joined the war effort and were involved with the military use of flash. Nighttime aerial photography of bombing targets con-tributed to the ultimate Allied victory.

**The Stroboscope**—A stroboscope is a short-duration electronic flash that fires repeatedly at frequent intervals. You might call it the machine gun of electronic flash.

After the war, Ed Farber incorporated his company, called *Strobo Research,* and produced the first of his AC-powered SR Strobes. In the same year, 1945, Ed Wilcox came out with the Wilcox Strobo Speed Lamp. Later, this was known as the Heiland Wilcox Strobolite.

**Flash For The Mass Market**—By 1948, electronic flash units were being manufactured by 36 companies. Popular and professional magazines printed articles and plans for building your own flash.

In June 1951, Strobo Research began production of the first high-voltage, dry-battery portable flash.

In early 1952, Heiland began marketing a similar unit. Two years later, Honeywell bought out Heiland and began exploring the amateur market. A completely self-contained handle-mount flash was produced by Powell in 1946. But the style wasn't popularized and generally accepted by amateurs until Honeywell began selling Strobonars in 1957.

In 1954 Graflex bought Strobo Research and began manufacturing electronic flash units under the Graflex label. When Graflex left the photographic business in the mid-70s, the flash rights were bought by Graflite, a Florida group. The company continues to manufacture flash equipment under the name Graflex/Subsea.

## AUTOMATIC-EXPOSURE FLASH

The groundwork for automatic-

exposure electronic flash began in 1955 with the filing of a patent in Japan for automatic X-ray exposure control. The patent called for a *quench tube* that bypassed excess energy away from the X-ray tube. Two years later, Dr. Edgerton received a U.S. patent for a quench-tube-controlled electronic flash enlarger.

In 1964, R. D. Erikson of Honeywell filed a patent for a quench-tube controlled automatic electronic flash. A year later, Honeywell's Auto Strobonar appeared. Soon many other companies made automatic-flash equipment.

## THYRISTOR FLASH

The next major step in the evolution of electronic flash was the use of the *thyristor* for automatic-exposure control (see page 19). German and Japanese manufacturers introduced thyristor units simultaneously. Then Braun of Germany brought its Vario-computer to U.S. photographers in 1972. Sunpak followed a year later with a thyristor flash featuring a variable-power selector dial.

## OTHER DEVELOPMENTS

The 1970s saw a proliferation of accessories and operating features. Vivitar and Metz offered variable-angle, remote sensors. Vivitar also produced several variable-beam-angle "zoom" flash units.

Before the decade was over, we saw through-the-lens (TTL) metering for flash control. Olympus offered TTL metering first, followed by Nikon and others.

This was also the era of "dedicated" flash-camera systems, which will be described later, and multiple flash-tube units. When the 80s arrived, several "universal" flash units were available that would work with more than one dedicated camera system.

In 1984, Osram introduced the first flash with built-in flash meter. It simplified multiple-flash exposure.

You needn't limit yourself to one flash. This book will show you how to use several flash units, and how to get an attractive low-contrast picture such as this portrait. Photo by Ed Judice.

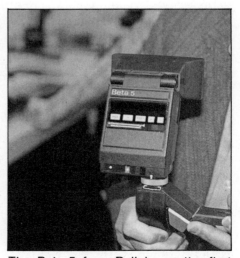

The Beta-5 from Rollei was the first flash unit to display exposure information in digital readouts.

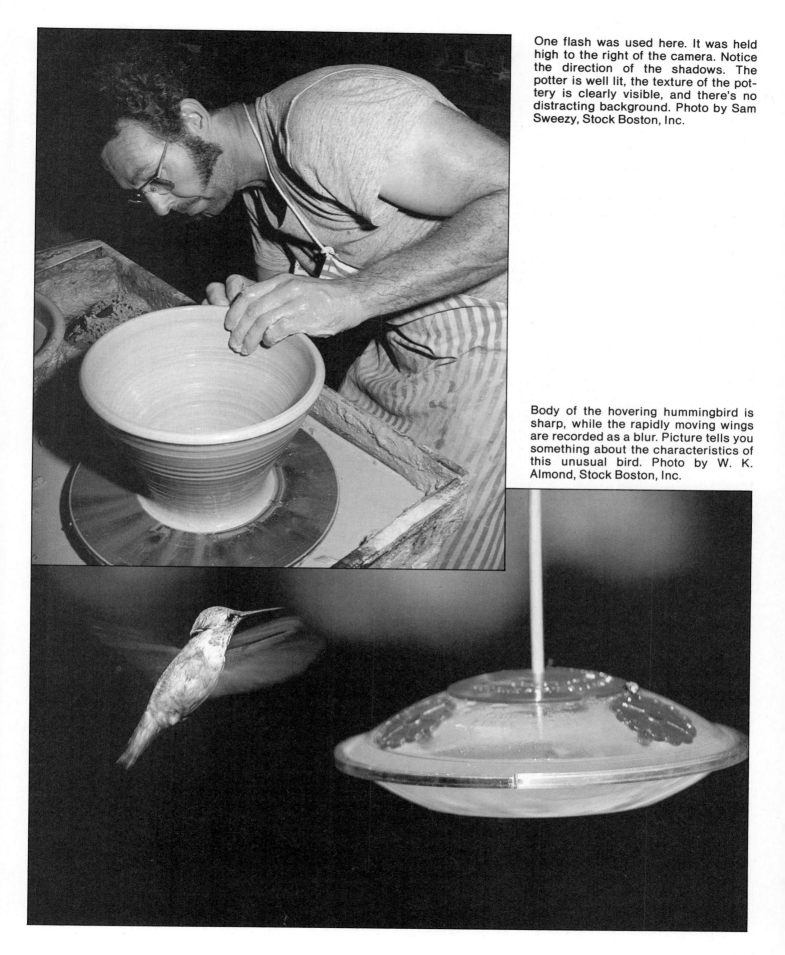

One flash was used here. It was held high to the right of the camera. Notice the direction of the shadows. The potter is well lit, the texture of the pottery is clearly visible, and there's no distracting background. Photo by Sam Sweezy, Stock Boston, Inc.

Body of the hovering hummingbird is sharp, while the rapidly moving wings are recorded as a blur. Picture tells you something about the characteristics of this unusual bird. Photo by W. K. Almond, Stock Boston, Inc.

Like most electronic devices, electronic flash units are a combination of several relatively simple circuits and parts. By studying the individual parts, it's not difficult to figure out how the complete unit works.

All electronic flash units work on the same basic principles. They usually differ only in minor circuit

At left is a modern non-automatic shoe-mount Osram electronic flash. It works on the same basic principles as earlier units, like the Strobo Research unit, right.

Flash tubes come in many shapes and sizes. Two contrasting and popular designs are shown here. Small, straight flash tube is frequently used in shoe-mount flash units and other units with rectangular flash heads. Larger tube is generally used with round reflectors. Choice of tube is largely dependent on what works most efficiently with a specific reflector design.

and component details. These differences are mostly prompted by patent or licensing considerations, or are incorporated to add competitive operating features. Even the automatic or so-called *thyristor* flash units are still the same basic device, except for some additional circuitry.

By looking at the features that all flash units have in common, you will understand the basics of how they work. It won't necessarily make you a flash repairman but will help you to be an informed user. That's important in today's technological world. It will help you get the best from your equipment and give you some insight into what may be wrong if your flash unit doesn't function.

## THE FLASH TUBE

Because it is the part that produces the light, the flash tube is probably the most important component of the electronic flash

unit. It is under a clear or textured protective cover that allows the light to pass through. The cover also prevents you from coming into contact with the high voltages in the system.

In several ways the flash tube can be regarded as a distant cousin of the common neon tube. But neon tubes produce a steady, low-intensity light. The flash tube must be able to give brief and intense bursts of illumination.

The neon tube is fashioned from a length of glass tubing with a metal electrode sealed at each end. Air is removed from the tube and the space is filled with neon gas. To produce different colors, other gases are also used.

These gases are normally insulators. This means no electric current will pass through them because the electrical resistance of the gas is high.

You can think of current as the flow of water through a hose. If you increase the resistance of the

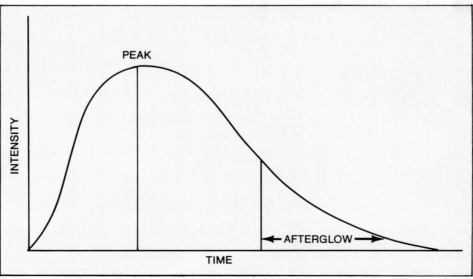

Although the burst of light from an electronic flash is apparently instantaneous, it takes some time to reach peak intensity and more time to extinguish. The time to reach peak intensity depends on flash unit design. It can be considerably less than one millisecond (1/1000 second), or as long as several milliseconds. As the diagram shows, the afterglow remains considerably longer.

hose by pinching it off, little or no water will flow.

Resistance is the characteristic of any material that makes electricity work harder to pass through it.

If a high enough *voltage*—or electrical pressure—is placed across the neon tube's electrodes, the gas inside *ionizes* or becomes conductive. When this happens, the gas glows.

Ionized gas has low resistance. Neon tubes have to be protected by a *high-resistance* power supply to prevent the current from getting excessively high.

The photographic flash tube is also a tube with electrodes at opposite ends. High-strength glass or quartz tubing is used because of the much greater demands that are made on flash tubes. There is

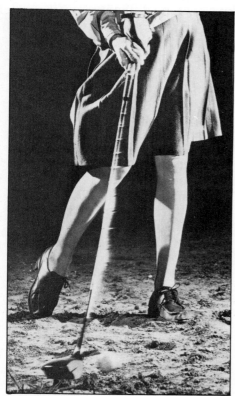

Swinging golf club shows high-speed motion. Photo was made with high-speed flash. Although the flash has effectively stopped the action, there is a blur along the leading edge of the club shaft. This was caused by afterglow of flash tube. Shaft appears to blur more than the head because the shiny metal reflects more light. Photo courtesy of the Edward Farber Estate.

little or no resistance built into most flash-tube circuits, so the pressure and current in the flash tube builds up quickly. It is not uncommon for flash-tube currents to reach several hundred amperes, even in small lamps.

Flash tubes are evacuated and then filled with *xenon* gas. It is stable, long lasting and gives off light of nearly standard daylight color temperature—about 6000K.

There is a chance of overheating some flash units when they are used with a camera having a motorized film winder. This happens if too many flashes are made in quick succession. I'll explain this in more detail in a later chapter. There is no danger of flash tubes exploding in well-designed equipment because the current flows only for an instant during each flash. Actually, the total time is usually less than 1/500 second.

## GETTING THE FLASH STARTED

It is unreasonable to expect the delicate flash-sync contact in your camera to carry a current of hundreds of amperes. A much more practical way of firing the flash tube is required. For this purpose, a third electrode is provided.

A typical flash tube has three

electrodes instead of two. The third is the *trigger* electrode. It is usually a strip of clear or metallized electrically conductive coating applied to the *outside* of the tube. Sometimes a short length of fine wire is used instead. To keep the flash tube from firing before it should, the two end electrodes are connected to a voltage that is too low to actually ionize the xenon gas.

A low-energy, high-voltage trigger circuit—which I'll describe in more detail later—is connected to the trigger electrode. This circuit is activated by your camera's sync contacts when you trip the shutter. After activation, the circuit sends a high-voltage pulse to the trigger electrode on the flash tube. It then ionizes a portion of the gas inside the flash tube. This causes most of the remaining xenon to ionize and the flash results. Ionization stops when there is insufficient voltage left across the two end electrodes to keep the action going.

## THE MAIN CAPACITOR

The power necessary to push several hundred amperes through your flash tube can't be supplied directly from ordinary batteries, or even from household AC current. The trick is to slowly collect

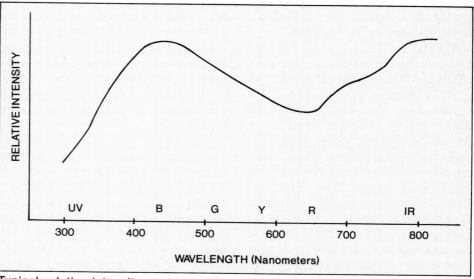

Typical relative-intensity spectrum of an electronic flash tube. Exact amount of each color emitted can vary a little from one brand of flash tube to another. UV = ultraviolet, B = blue, G = green, Y = yellow, R = red and IR = infrared.

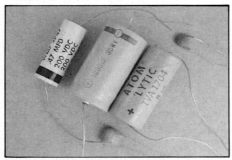

Different types of capacitors, such as those shown here, are used in flash units for energy storage and control.

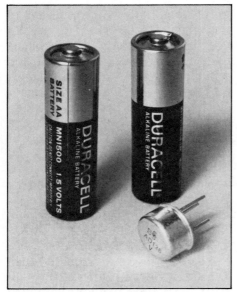

These low-voltage batteries cannot operate electronic flash without the help of the small transistor depicted in the foreground.

electrical energy in a device called a *capacitor* and to store it there until it is needed for the flash.

When the capacitor is full, or *charged,* the energy can be discharged through the flash tube in 1/500 second or less.

There are several capacitors in every flash unit. To keep their functions and identities clear, I'll call the biggest one the *main capacitor.* The main capacitor in a small shoe-mount flash unit can have 330 volts across its terminals. A side-pack flash can hold up to 500 volts. Even the smallest flashes pack enough power to give you quite a jolt. That's why the flash tubes are always behind a protective cover.

One way to charge the main capacitor is with a high-voltage battery connected to the flash and carried in a separate pack. Such battery-powered flash units are commonly used by press and wedding photographers. In these units, a 450- to 525-volt battery is connected to the main capacitor through a *resistor.* This limits the charging current to the correct value. Some high-voltage battery packs contain a circuit that drops the battery voltage to about 300 volts to match the rating of the main capacitor.

The main capacitor can also be charged from your household AC power supply. First, the *alternating current (AC)* from the receptacle has to pass through a device called a *transformer.* The AC voltage isn't high enough to charge the main capacitor adequately, so the transformer boosts it to the right level.

Alternating current is unsuitable for charging capacitors. Before the boosted voltage gets to the main capacitor, it goes through a *rectifier.* This is a small device that converts it to *direct current (DC).*

Some flash units eliminate the transformer and use a *voltage multiplying rectifier.* But it is generally safer to use a transformer because it isolates you from the AC line.

## LOW-VOLTAGE BATTERY FLASH

Most portable electronic flash units are powered by low-voltage throw-away or rechargeable batteries. The batteries supply 1-1/2 to 12 volts, which need boosting to adequately charge the main capacitor.

Just as AC power is useless for charging capacitors, DC power cannot be put through a transformer. What is needed is what we might call an "un-rectifier." There isn't such a thing, but it can be simulated with a transistor or two and a couple of extra connections on the transformer. This is called an *oscillator.* It converts DC battery voltage to AC so it can be boosted by the transformer.

These oscillators consume valuable battery power, even when the main capacitor is fully charged. To conserve power, many flash units feature a *battery-saver* circuit that either shuts off or turns down the oscillator when the main capacitor voltage is within reasonable limits. This is obviously a very desirable feature.

## TRIGGER CIRCUIT

We now have the flash tube and the power to operate it. All we need to create a flash, when we want to take a photograph, is something to trigger the xenon gas. A complete trigger circuit is shown on page 18. For this circuit, electric energy is stored in a *trigger capacitor.* This needs less than 1/1000 of the power of a main capacitor to do its job. Your camera's sync contacts can handle this level with no difficulty.

A *voltage divider,* which is a string of resistors, takes a portion of the main capacitor's charge and stores it in the trigger capacitor. Usually this amounts to about 200 volts—sometimes a little less. Because the trigger capacitor is much smaller than the main capacitor, it needs only a small amount of power to charge it to 200 volts.

It requires about 2000 volts to reliably trigger a small flashtube. So we turn to our old friend, the transformer. But wait! Didn't I say that DC electricity won't go through a transformer? That's generally true, but a *suddenly* applied DC surge will pass through for an instant. An instant of trigger voltage is all a flash tube needs to fire.

Bounced flash was used to illuminate the child and the mobile. Flash exposure was carefully calculated not to "burn out" all detail of the window drapes and the shadows caused by the daylight. How to mix flash with daylight is explained in Chapter 7. Photo by Helmut Gritscher, Peter Arnold, Inc.

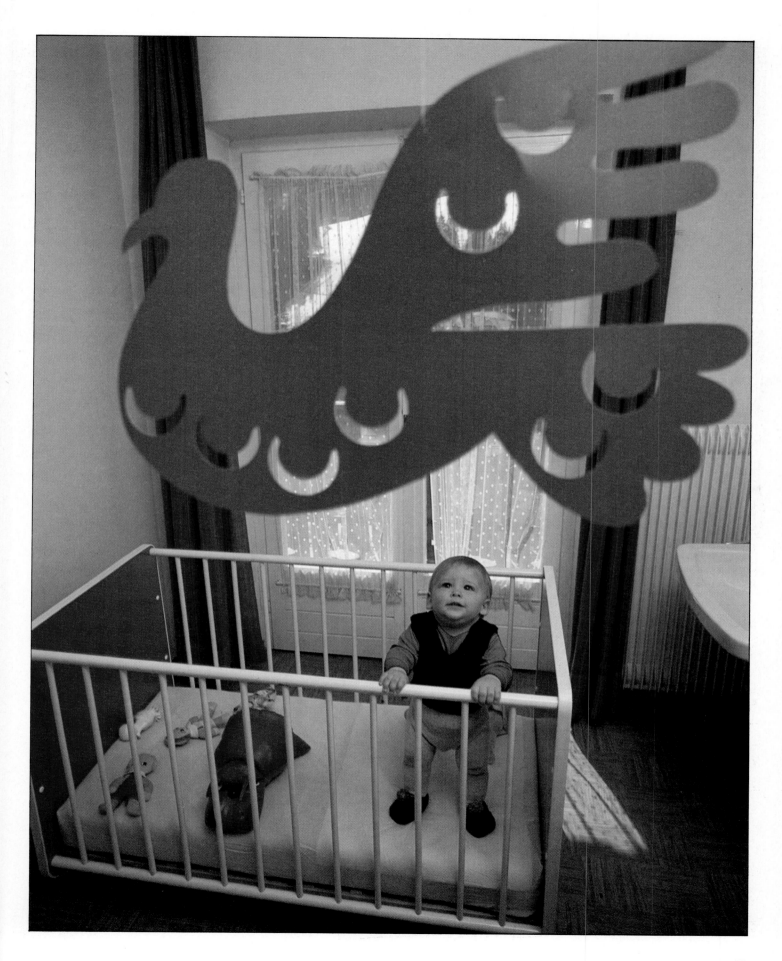

When the electrical contacts of the flash system are closed in the camera, the trigger capacitor is connected across one side of the trigger transformer. The transformer is designed to boost the capacitor output about tenfold. As the contacts close, the current flows from the capacitor and through one side of the trigger transformer. The current causes a burst of about 2000 volts from the other side of the transformer. This triggers the flash tube. A flash-trigger circuit is similar to the ignition circuit in your car, only it's smaller.

The flash tube, power supply, main capacitor and trigger circuit are the only major parts necessary to make a working electronic

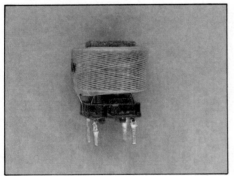

A tiny trigger transformer, much like an automobile ignition coil, is used to fire a flash tube.

flash. They constitute nearly the same system conceived by Dr. Harold Edgerton decades ago. One exception is the use of transistors in the oscillator. Edgerton's original designs predated the transistor and used mechanical vibrators.

## READY LIGHT

This simple electronic circuit is part of most modern electronic flash units. The ready light's job is to tell you when the flash is ready or, more accurately, when it is *nearly* ready to be fired again. Typically, it glows when the main capacitor is charged to about 80% capacity. To be sure of a full-capacity charge, wait a couple of seconds longer before firing the flash.

Some flash units have a series of ready lights that show you, step-by-step, just how much charge is in the main capacitor. Sometimes, an auxiliary scale near the lights indicates the resulting charges in terms of guide number (GN) or maximum shooting range.

The typical orange ready light that you see most often is a neon-gas glow lamp. Like flash tubes and neon signs, a glow lamp needs a certain amount of voltage across its terminals before it will light.

Usually about 90 volts will do. Once lit, it stays on until the voltage drops. In a flash, a proportion of the main capacitor's charge is taken off by a voltage divider. This provides the required 90 volts across the ready light at a pre-selected level of charge. This is usually about 80% of full capacitor charge.

Some flash units use regular incandescent lamps and others feature light-emitting diodes (LEDs) instead of neon lamps. Electronic *level-detector* circuits are used with these lamps to turn them on at the proper voltage level.

The circuitry necessary to provide automatic exposure control for an electronic flash unit is complex. But it takes up little space.

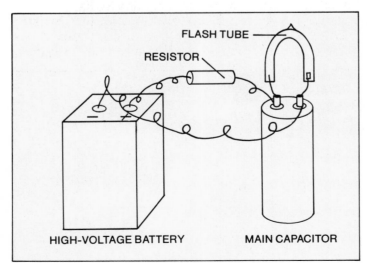

A supply of electricity, a capacitor and a flash tube are the main parts of an electronic flash. A resistor is not necessary to make the flash work. However, one is often used between the source of electricity and the capacitor to limit the capacitor-charging current to a practical level. The resistor also helps the flash tube to turn off more quickly.

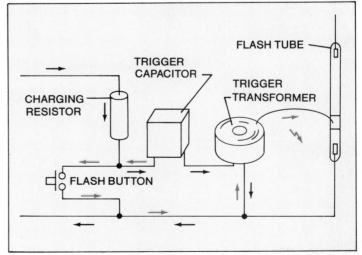

In a trigger circuit, the trigger capacitor charges through a resistor. Black arrows indicate flow of current. When you close flash circuit—by pushing flash button or camera-shutter button—capacitor discharges through trigger transformer in direction of red arrows. This fires the flash tube.

## AUTOMATIC FLASH

Not long after the first automatic-exposure cameras came on the scene, automatic-exposure flash units began to be available. The concept was a commercial success and soon there were many models to choose from.

The basic principle of measuring flash exposure is simple. Because flash light has both brightness *and* duration, both must be measured. The easiest way to do this is with a high-grade capacitor—one with virtually no leakage.

A photocell in the flash picks up light bouncing back from the subject. The photocell generates current that is proportional to the intensity of the light. The current flows as long as the flash con-

Automatic flash exposure is controlled with a quench tube (left) or a thyristor (right).

tinues. All of the photocell current flows into the special capacitor, charging it to a voltage that is proportional to the product of *flash brightness* and *flash duration.* When the capacitor charge reaches a certain voltage, it triggers the flash shut-off circuit.

Earlier automatic flash units were of the *quench-tube* type. They controlled the flash duration, and consequently the exposure, by "dumping" the excess main capacitor charge. This was done by triggering a special flash tube called a *quench tube* that was connected directly across the regular flash tube. The quench tube was covered to keep the light from escaping. It quickly drained the main capacitor and extinguished the flash.

Although this method of exposure control worked well enough, it wasted unused battery power. The next step was the development of the *thyristor* flash.

### CONFIDENCE LIGHT

Some automatic flash units include another indicator light that can be a big help. This is especially true if you are photographing in an unusual situation or location where you aren't sure the flash will produce enough light for proper exposure. Called a *confidence light,* or *sufficient-exposure indicator,* this handy feature is connected to the automatic-exposure

circuit. It lights briefly or flashes a few times whenever the exposure-control circuit terminates the flash. This indicates that the flash sensor satisfactorily controlled the exposure.

The exposure-control circuit shuts down the flash only when the photocell has received enough light back from the subject. If the camera is set up properly and conditions are average, the film should get correct exposure. If the confidence light does not light or flash, you are probably trying to operate beyond the distance range of your flash.

### THYRISTOR AUTOMATIC FLASH

Automatic flash really came of age with the advent of *thyristor* units. A thyristor is a solid-state component, much like a rectifier or transistor. Usually called *SCRs,* or silicon-controlled rectifiers, thyristors can carry large currents with little power loss. They are turned on by passing a small current through the device's *gate.* These handy devices are used in light dimmers and motor-speed controls, as well as in automatic electronic flash units. Even the high current that flows through a flash tube can be handled briefly by remarkably tiny SCRs.

The real trick with the thyristor is getting it to turn off after it has come on. The gate that turns it on

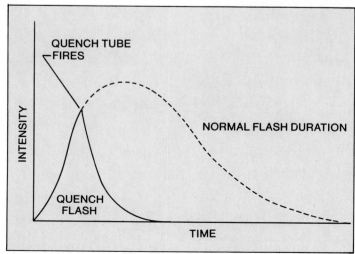

When the quench tube fires, it shuts off the flash abruptly, instead of allowing it to run its normal course.

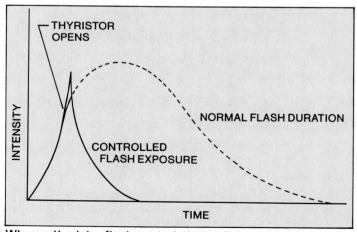

When a thyristor flash control shuts off the light, the charge on the turn-off capacitor usually causes a sharp, but photographically insignificant, blip of light to occur. This is shown by the spike in the diagram.

is useless for this purpose. But the whole purpose of putting the thyristor in a flash tube circuit is to shut the flash tube off at the proper time. Let's go through the action in a typical thyristor flash and see how it's done.

The thyristor is usually already turned on as a trigger pulse initiated by the camera's flash circuit fires the flash tube.

Flash light reflected from the subject causes the capacitor to charge through a *photocell* pointed at the subject. The brighter the reflected light, the faster the capacitor charges. When the capacitor is charged to a preselected level, a *level-detecting circuit* turns on a second SCR.

This SCR connects a small reverse-charged capacitor across the first SCR. The reverse charge shuts off the SCR and, with it, the flash tube. In some auto-flash units, the second SCR is replaced by a quench tube, but the action is the same. *Both* designs offer the same energy-saving operation. When the quench tube is used *this way* it *isn't* energy-wasting. It's used as a switch to connect the small reverse-charged capacitor across the thyristor, to turn it off. The remaining charge on the main capacitor is saved, as in any thyristor flash.

The unused portion of the charge remaining in the main capacitor is left intact. Only the amount consumed by the abbreviated flash burst has to be replaced by the batteries for another full charge. Of course, if the sub-

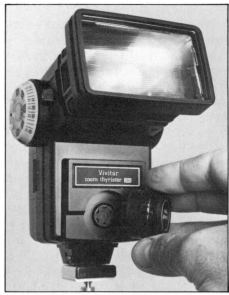

Variable-power controls are easy to attach to the flash units for which they are designed. They are also easy to use.

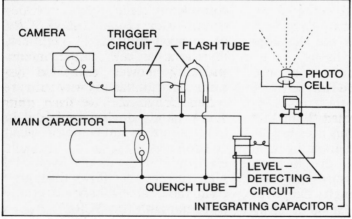

In an automatic-exposure flash unit, the quench tube is connected directly across the flash tube. The quench tube stops the flash at the appropriate time by using up the remaining charge in the main capacitor.

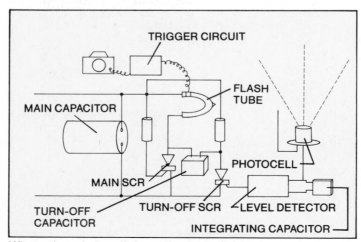

When the photocell in a thyristor flash receives enough light, a circuit fires the turn-off silicon-controlled rectifier (SCR). It, in turn, shuts off the main SCR, stopping the flash.

The camera hot shoe (arrow) is a sturdy and convenient location for the flash unit. It serves as both a permanent mount and a power contact for the flash.

ject is beyond the range of the automatic control, the integrating capacitor never fills sufficiently. The flash continues through its usual course, consuming most of the main capacitor charge.

## DEDICATED-FLASH UNITS

This term applies to a group of flash units that are, for all practical purposes, compatible only with camera models for which they are specifically designed. The use of dedicated-flash units on cameras for which they were not intended has been known to seriously damage the camera's electronic circuitry.

Several flash manufacturers offer units that adapt to the dedicated electronics on many camera models. This is done with interchangeable hot shoes or a selector switch. Some units only make use of some of the cameras' features. Nonetheless, they can be handy as spare units that can be used with a variety of cameras.

The major advantage of a dedicated-flash/camera system is that it helps minimize operator errors. This is because there is more direct "communication" between flash and camera. The flash can automatically set camera controls such as flash-sync speed and lens aperture. Typically, some of this is shown in the viewfinder's exposure display. When the flash is turned on and the ready light glows, the hot shoe informs the camera that the flash is ready to fire.

On some systems, the viewfinder indicator also serves as a confidence light by blinking when the flash is used within its proper operating range.

Some Olympus, Contax and Nikon cameras feature through-the-lens (TTL) control of flash exposure by means of the camera photocell. Certain camera models can measure the light coming through the lens *during* the exposure and relay this information to the flash via another hot-shoe contact. This feature is of particular value in close-up photography. Here, it is often difficult to be sure that your flash and its sensor's field of view coincide.

With any dedicated-flash system, it is important to read the instructions that come with the flash and the camera. This will help avoid damaging your equipment. Damage caused by using unauthorized equipment combinations is *never* covered by manufacturers' warranties. The resulting repairs are very expensive. In most cases of circuit damage, the camera is rendered inoperative.

Two things can prevent the interchangeability of dedicated-flash/camera systems. One is the hot shoe. The extra contacts that handle the special operations are placed in different locations in different cameras. The contacts of one maker's flash won't mate with another maker's camera.

There's another difficulty. Some systems have the flash unit supply power to control the camera while others have the camera supply the power that is modified by the flash so the camera knows what it's doing. In short, there may be total incompatibility between dedicated systems. That, in fact, is why they are called *dedicated*. The flash units serve one make of camera only.

## FLASH AND STROBE

Ever since its introduction, electronic flash has been popularly—but wrongly—called *strobe*. The correct use of the word strobe, which is a contraction of *stroboscope*, applies *only* to rapidly repeating flash systems.

Electronic flash gives you one image on film. Stroboscopic light gives you a series of motion-study images, which can be useful to the engineer and researcher, and beautiful to the layman.

This composite photograph shows a strobe in use. A superimposed multiple image of the action, the way it would be recorded on film, is shown.

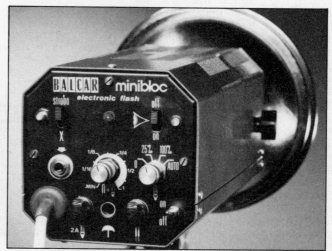

This is a typical strobe unit, with its array of controls. It can also be used as conventional flash.

This dedicated-flash hot shoe has two additional electrical contacts. They carry control signals that provide additional "communication" between flash and camera.

Flash was aimed slightly upward, so some direct light reached the group and some light was bounced from ceiling. Bounced light helped to limit brightness difference between those people closest to the flash and those farthest away. Photo by Dan Ludwig.

## THE INVERSE SQUARE LAW

The inverse square law describes the manner in which the intensity of a so-called *point source* of light varies with its distance. The illumination falls off as the square of the distance it travels. For example, as the distance of the source is doubled, its intensity is reduced to $1/2^2$, or 1/4. As the distance is tripled, the intensity is reduced to $1/3^2$, or 1/9, and so on.

The diagram shows how the inverse square law works. When you double the distance the light has to travel, the same amount of light has to cover an area four times as large. The diagram also shows why the law applies only to so-called point sources of light, and only to light that spreads out in a definite expanding beam. It does not apply to diffused light or to a light source that is larger in diameter than about 1/8 of the distance of the light source from the subject. It also does not apply to a spotlight that is focused to give a parallel beam of light.

With electronic flash, the inverse square law works well with undiffused reflectors at normal shooting distances. It will not work as reliably with bounce flash, with umbrella reflectors, or at very close shooting distances.

The guide numbers provided

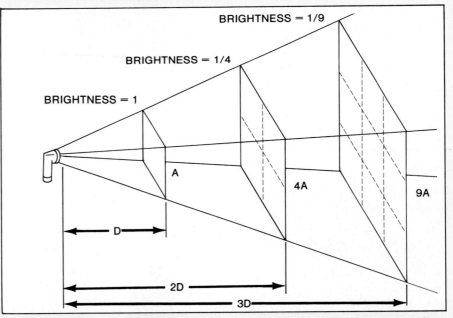

When the light from the flash has to travel twice as far, it has to cover an area four times as large. As a result, the brightest of the illumination reaching the subject is reduced to one-quarter. When the light has to travel three times as far, it covers an area nine times as large. This causes the brightness of the light at the subject to be reduced to one-ninth that at the original distance.

with your flash equipment are a practical application of the inverse square law. For example, let's assume your flash has a guide number of 110 for a specific film speed. At a distance of 5 feet, the correct lens aperture will be $f$-22. At 10 feet it will be $f$-11. The two $f$-stop increase compensates for the reduction of the illumination to 1/4 its brightness between the 5-foot and 10-foot distances.

## VARIABLE-POWER FLASH

Some flash units are designed to allow you to adjust the amount of non-automatic light output to fit special needs. The controlling device is a variable resistor that takes the place of the photocell. Turning the adjustment to a different setting changes the discharging rate of the capacitor and, with it, the length of the flash duration.

The control is usually calibrated in 1/2, 1/4 and 1/8 power, and so on, down to 1/64 power. Each step corresponds to one exposure-step reduction in light output. However, you will not necessarily

see perfect one-step variations in exposure on your film as you adjust this control. At brief exposure times, often as short as 1/40,000 second with automatic flash units, film no longer responds in even steps as it does at conventional exposure times. This peculiarity is called *short-exposure reciprocity failure.*

The amount of effective underexposure caused by very short exposure times differs with different film types. For details about reciprocity failure, refer to the data sheet for the film you are using. Exposure increase of about half an *f*-stop is generally needed

when the flash duration is less than about 1/10,000 second.

## SHUTTER CONSIDERATIONS

When you're photographing in natural or continuous artificial light, you control exposure by selecting the right combination of shutter speed and lens aperture. The burst of light from your electronic flash is usually shorter than any practical shutter speed. Because of this, you control film exposure with the lens aperture only.

In certain situations, when flash is used along with daylight illumination, changing the shutter speed *will* affect the *daylight* portion of your exposure. More about this later.

With electronic flash, the shutter must be *completely* open when the flash goes off. It should close immediately thereafter. At the instant the shutter is fully open, electrical *sync contacts* that are connected to your camera's X-sync terminal close a circuit. *(Sync is short for synchronization.)* A few millionths of a second later, the flash fires. Proper synchronization is essential for flash photography.

Two types of camera shutters are in common use today. They are *focal-plane* (FP) shutters and *leaf* or *between-the-lens* shutters. Both can be used with electronic flash.

**Focal-Plane Shutter**—The focal-

All flash units have an exposure-calculator scale to help you determine the correct aperture setting. These scales can vary from simple charts to complex circular dials. When using them, be sure to follow the instructions provided with your flash unit.

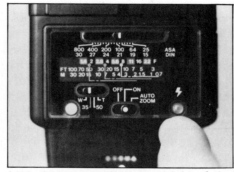
Little button on the lower right of the rear of this flash unit is the *Open Flash* button. It enables you to fire the flash independently of the camera shutter's sync contacts.

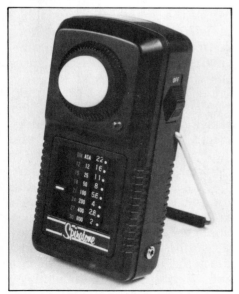
A flash meter measures both flash intensity and flash duration. It recommends the correct lens aperture for a specific film speed.

Some dedicated-flash units are intended for only one particular camera model or camera group. Others, like this one, are compatible with several different camera brands. The flash unit is connected to the cameras through special adapters.

A vertical-traveling parallel-blade focal-plane shutter, like the one shown, moves faster than a cloth-curtain shutter. This enables it to synchronize with electronic flash at a faster shutter speed.

If you get a partial flash picture (top) instead of a full image (right), you almost certainly had the camera's focal-plane shutter set for too fast a speed. The entire image area was not exposed at the time the flash fired. Always be sure your shutter is set to a proper flash-sync speed.

plane shutter, widely used on 35mm SLR cameras, is part of the camera body. Because you don't have to buy a new shutter with each lens, the focal-plane shutter reduces the cost of interchangeable lenses.

There are two kinds of focal-plane shutters—the moving-curtain type and the parallel-blade type. Each is located in the camera, immediately in front of the focal plane or film.

In the moving-curtain shutter, a curtain of rubberized cloth or extremely thin metal is supported at each end by a roller. The curtain blocks the light coming through the lens except for the brief moment when it is open to make an exposure on film. When you release the shutter, the curtain quickly unrolls horizontally from one roller onto the other. As it unrolls and travels to the other side, it uncovers the film.

A brief moment later—the time depends on the selected shutter speed—a second curtain follows the first across the film plane. Its function is to block light from the film as it travels to the other side.

Both curtains travel at the same speed. Shutter speed—the total time any one point on the film is exposed to light—is determined by the difference in the starting times of each curtain.

When set at slow shutter speeds—usually 1/60 second or slower—the first curtain completes its trip before the second one starts. Thus, the entire image area is exposed for a brief moment. This is the condition you need for correct electronic-flash exposure.

When you select a speed faster than the fastest sync speed recommended for the shutter, the second curtain begins to cross the image area before the first has reached the end. This means that at faster shutter speeds the image area is never completely open at one time and the film is exposed by a traveling slit.

At top speeds, the curtains may be no more than about 1/8 inch apart. As a result, the film is exposed 1/8 inch at a time. With electronic flash, such a shutter speed would give you a slit of picture about 1/8 inch wide. The remainder of the film frame would be unexposed.

Parallel-blade shutters work in much the same way. Two sets of collapsible metal blades are mounted in front of the camera's film plane. When you release the shutter, one set of blades folds up to expose the film and the other set unfolds to cover it. The blades move vertically and a little faster than curtain shutters. The maximum shutter speed at which the image area is completely open is higher—usually 1/125 second.

The electronic flash fires when the first curtain or set of blades of a focal-plane shutter has completed its trip. If the right shutter speed has been selected, the film area will be completely open and the flash will expose the entire frame.

If you have set too fast a shutter speed, a portion of the film will be covered by the second curtain or set of blades and won't receive light. When this happens, you will get only a part of a photograph, instead of the complete one you were expecting.

**Leaf Shutter**—The leaf shutter is part of the camera's lens assembly. It is frequently used on non-interchangeable-lens 35mm cameras, medium-format SLR lenses and view-camera lenses.

Leaf shutters have a set of thin, overlapping metal blades. The blades are pivoted so they can be swung back and forth by the timing mechanism to open or block the light path to the film. Regardless of the shutter speed you select, the blades always open completely before they begin to close again. Because they are located within the lens, these shutters affect the light falling on all portions of the film simultaneously. This one characteristic makes them ideal for use with electronic flash and flashbulbs.

**Which Shutter Is Better?**—The

leaf shutter has an advantage. You can change shutter speeds almost at will to increase or decrease the effect of existing light on your photographs without affecting the flash portion of the exposure. With a focal-plane shutter, the fastest speed you can use with flash is limited.

If you want a leaf shutter, you'll either have to buy a comparatively expensive medium-format or view camera, or stick with a non-interchangeable-lens camera.

## SYNC CONNECTIONS

For successful exposures with electronic flash and flashbulbs, it is essential that the flash is triggered at precisely the right moment during the shutter opening-closing cycle. This timing is known as *synchronization*. The timing differs for electronic and other types of flash.

The electrical connection between your camera and flash is often made through a *PC connector,* or *PC terminal.* Some cameras have two of these small, cylindrical

connectors. The terminal for electronic flash is marked X. The other connector, usually marked M or FP, is for use with flashbulbs only. The two terminals are *not* interchangeable.

Most SLRs and many other 35mm cameras have a *hot-shoe* connector for flash attachment. Some cameras have both PC and hot-shoe connectors. Usually, the hot shoe is on top of the penta-prism housing.

A hot shoe not only provides the electrical sync connections for the flash, but is also a handy place to attach the flash for easy shooting. Hot shoes tend to be more durable and troublefree than PC terminals and cords.

The hot shoe is usually connected directly to the X terminal, for use with electronic flash. Some cameras have a small hidden switch within the hot shoe to disconnect it unless a flash is in place. If your camera has no such switch, don't touch the electrical contact in the hot shoe when you're using the PC connector. If you do, there

The most widely used sync-cord connectors are PC connectors.

Some blade shutters have an X-M sync lever. The M setting is intended for use with flashbulbs only. Always use the X setting with electronic flash.

Cameras with focal-plane shutters sometimes have two PC-cord sockets. One is marked FP and the other X. With electronic flash, use the X contact only. The other one is intended for use with flashbulbs designed specifically for this kind of shutter.

Flash enabled me to take this bright picture in very dim daylight. A nearby background was chosen, so that some detail would be recorded in it. At a casual glance, this could be mistaken for a sunlit shot. With a flash on your camera, you can take pictures almost anywhere, as long as you stay within the recommended distance range.

## HOW TO USE
## FLASH GUIDE NUMBERS

### DIRECT INDOOR FLASH

Flash manufacturers publish a guide number (GN) for each electronic-flash unit. The GN is based on the light output of the flash and the design and efficiency of the reflector. The guide number varies with the speed of film being used. A GN allows you to calculate the lens aperture setting at a specific flash-to-subject distance. If the flash is mounted on the camera, the distance is from the camera to the subject. The formula is:

$$f\text{-stop} = \frac{GN}{Distance}$$

Example: If your flash has a GN of 99 feet and the subject is 9 feet away,

$$f\text{-stop} = \frac{99}{9}$$

$$= f\text{-}11$$

### BOUNCE FLASH

Measure or estimate the total distance the flash must travel—from flash unit to bounce surface to subject. Use the guide number to find the aperture setting. Then open the lens by about two more f-stops to allow for the light absorbed and scattered by the bounce surface.

### OUTDOORS

Guide numbers are based on indoor use, where there are nearby reflective walls and ceiling. When shooting outdoors, without these reflecting surfaces, open the aperture by at least one f-stop.

### CONVERSIONS

When the guide number is given in terms of feet, you must use feet in your distance measurement. When the GN is given in meters, measure the distance in meters. To convert one to the other, remember that 1 meter equals 3.3 feet.

To convert a published guide number for use with a film of different speed, use this formula:

$$New\ GN = published\ GN \times \sqrt{\frac{new\ ASA\ speed}{published\ ASA\ speed}}$$

## TESTING THE GUIDE NUMBER

A GN is an approximation based on using flash in a typical indoor environment. You may want to establish a guide number for use in different conditions. Place a typical, average subject a measured distance from the flash. With the published or converted GN, calculate the aperture setting. Bracket two f-stops in both directions in half stops. Record the aperture setting for each exposure, preferably by placing a card with the f-number written on it in the picture area. When you have selected what you consider the best-exposed photo, calculate the guide number as follows:

$$GN = f\text{-stop} \times distance$$

Example: The subject is 15 feet from the camera and flash. The picture with the best exposure was made at f-4. The guide number appropriate for your purposes will be 4 x 15 feet, or 60 feet.

---

is a possibility of annoying little shocks from the shoe. Many camera hot shoes come with a small plastic insert that prevents you from coming into contact with the connections. Keep it in place when you're not using the hot shoe.

Not all flash units present a shock hazard at their sync connections. Some use another thyristor to close the trigger circuit and have only 3 to 5 volts going to the contacts. These units cause less wear to camera sync contacts.

### REFLECTORS AND LENSES

Flash tubes are relatively fragile devices and, as mentioned at the beginning of this chapter, they also carry hazardous voltage levels. For these reasons, flash tubes are usually protected so they can't be bumped or touched. Most portable flash units protect the flash tube with a *reflector/lens* combination. A few units, called *bare-tube flashes,* enclose the tube in a clear-glass shroud.

Reflectors and lenses are designed to redirect the flash tube's light toward the subject in the most efficient and desirable way. Flash reflectors are made in complex shapes to disperse the light evenly over the area to be covered. Most flash units are designed to illuminate the area seen by a 35mm lens for a 35mm camera.

A well-designed reflector alone can do a good job of distributing light. However, many flash designs also include a textured plastic lens to further help control the light pattern of the emerging beam.

Particularly interesting are the reflectors in some European flash units. These use dimpled surfaces to provide more uniform illumination.

### CALCULATOR SCALES

There are various types of calculator scales for flash units. All of them do essentially the same thing. They provide a handy way of finding the correct lens aper-

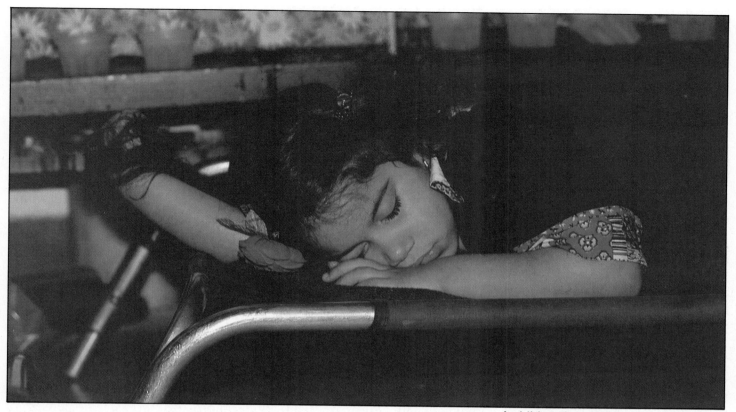

A child at sleep can be a charming subject for a photograph. However, the light level under such conditions is generally low. If you were to suddenly switch on bright lights, the child would be sure to wake up and spoil your chance of a good picture. Flash is the answer. If the child does react to the flash, it won't be until after you have made the exposure. Photo by Ginger Chih, Peter Arnold, Inc.

With a flash on your camera, you can take spectacular pictures like this anywhere, regardless of the existing light level. You need a quick eye and a ready trigger finger. The best moment is always extremely fleeting. Sometimes it pays to watch the activity you intend to photograph before you start to shoot. Familiarize yourself with the entire sequence of events. Photo by Jerry Wachter, Focus on Sports, Inc.

ture, based on flash power, film speed and flash-to-subject distance. Some units simply provide a chart of selected distances and apertures for one or two film speeds. Others have a circular or straight slide rule that can work with just about any combination of film sensitivity and subject distance.

Automatic flash units indicate the maximum and minimum flash-to-subject distances at specific aperture settings. Examining several units will help you make an intelligent choice between the different designs.

## MEASURING FLASH OUTPUT

To be able to use a flash unit, you must know how much light output it provides. There are several ways of measuring and expressing the "muscle power" of a flash. Some are useful for only certain kinds of flash units; others have a more general usefulness. Let's look at the different ways of expressing flash power and see what they mean.

**Watt-Seconds**—The oldest method, and one that is still used to rate large studio flash units, is the *watt-second* rating. This is a measure of the electrical energy stored in the main capacitor of the flash. However, this rating has little direct relationship to light *output*. Differences in reflectors and flash-tube efficiency influence the light output greatly. If all other variables are kept constant, then higher watt-second ratings mean more light.

In spite of these limitations, the watt-second system is the method of choice for rating studio flash. For versatility, studio flash units are often of *modular* design. That is, they are made in modules or sections so they can be interconnected in different ways for different jobs.

For more light, you can connect several main-capacitor modules together and use them to power a single flash tube. You can also con-

nect several flash tubes to a single capacitor. By observing the watt-second ratings of the flash tube and the capacitors you connect to it, you can avoid overpowering the flash tube.

Studio flash units offer a wide choice of reflectors and other light-control accessories that affect the brightness of the illumination. A studio photographer expects to make tests with the different combinations to determine the proper exposure settings.

Watt-seconds can be determined by the equation:

$$WS = C \times kv^2/2$$

In the above, **WS** is watt-seconds, **C** is the capacitance of the main capacitor in *microfarads* and **kv** is the energy stored in the capacitor, expressed in *kilovolts* or thousands of volts.

Thus, a typical small flash unit having 330 volts, or 0.33 kv, across a capacitor of 330 MFD capacitance will have a power rating of 16.5 watt-seconds.

**Beam Candle Power Seconds (BCPS)**—Also known as *beam-candela-seconds,* BCPS units offer

a far more accurate method of expressing the light output of a flash. An accurate meter is positioned at a known distance from the flash. The flash is tested in a room with dark, non-reflecting walls, so only the characteristics of the flash, and not the reflective features of the room, are measured. This method works reliably because it takes into account all the losses in the reflector, diffusers and the flash tube.

Unfortunately, not all flash manufacturers rate their units in BCPS units—particularly in advertisements. So you can't always use this number to compare different units. Also, the BCPS rating doesn't take into account how wide the reflector is spreading the flash tube's light. Most flash units are designed to cover the area seen by a 35mm lens on a 35mm camera. Units that spread the light more, to work with lenses of wider angle, obviously provide less light to any point on the subject.

**Guide Number (GN)**—The most meaningful number for comparing flash units is the *guide number.* It

For a simple subject like this, you can use on-camera flash. However, to get the best possible result, try experimenting with off-camera flash from various directions. The black background helps keep the viewer's attention on the flowers. Photo by Ed Judice.

is directly proportional to the light output of a particular flash. With a simple calculation, the GN enables you to determine what aperture to use to get correct exposure with a specific film speed at a certain distance.

A guide number refers to units of distance—either feet or meters. In the United States, guide numbers are quoted in feet. The guide number for a specific film speed is the product of the flash-to-subject distance and lens aperture that give good exposure. When you divide the flash-to-subject distance into the guide number, the quotient is the *f*-stop to use. Conversely, if you divide the GN by the *f*-stop you want to use, you will get the correct flash-to-subject distance.

A specific guide number applies to one film speed. With an increase in film speed, the guide number becomes larger. When you compare guide numbers in advertisements, be sure to note the film speed specified. Often, smaller flash units are made to appear more attractive by listing their guide number for a relatively fast film.

The conditions under which one manufacturer determines a guide number may be different than those used by another. There are several carefully written standards for testing flash equipment. They come from ANSI (American National Standards Institute) and ISO (International Standards Organization). However, these standards aren't binding on equipment manufacturers. You will rarely see any mention of the use of these standards in an advertisement or catalog. You may see a claim like "realistic" or "conservative" guide number. But these are only subjective, and not quantitative evaluations.

Guide numbers are exactly what their name implies—guides, and no more. Published guide numbers are a good place to *start your testing*. Be willing to do a bit of bracketing to fine-tune the re-

## FLASH CALCULATOR SCALE

| ASA DIN | 64 19 | ASA DIN |
|---|---|---|
| Feet 42 | 2 | 13 Meters |
| 3-30 | 2.8 | 1-9 |
| 2-22 | 4 | 0.6-6.5 |
| 1.3-15 | 5.6 | 0.4-4.5 |
| 10 | 8 | 3.3 |
| 7.5 | 11 | 2.3 |
| 5 | 16 | 1.6 |

A well-designed calculator scale on the flash unit can give you vital flash exposure information in an easy-to-read form.

The three values you are interested in are film speed, flash-to-subject distance and lens aperture. Calculator scales differ in design, but they all have the same purpose—to give you basic flash information. Here's how the accompanying calculator works:

By adjusting the movable knob at the top, you set the speed of the film you're using. Here it's set to ASA 64 and DIN 19. In the new universal speed-rating system, this is ISO 64/19°. When you set the film speed, you also automatically set an *f*-number scale. Here, it ranges from *f*-2 to *f*-16.

The outer scales show you flash-to-subject distances. One scale is in feet; the other in meters. You can easily read off the lens-aperture setting for proper exposure at a specific distance. For example, at a distance of 10 feet (3.3 m), you should use *f*-8. At a distance of 5 feet (1.6 m), the lens aperture should be *f*-16.

The three colored bars indicate the flash unit's three automatic exposure ranges. For example, the yellow bar indicates that, when you set your flash for automatic operation and your lens aperture to *f*-4, you'll have an automatic exposure range from 2 to 22 feet. If you set the lens to *f*-2.8, the automatic flash range will extend from 3 feet to 30 feet.

sults to your taste. When you have a guide number that suits *you* and is dependable for *you,* it can be a very useful tool. The best guide numbers are those you determine yourself. They depend on your type of subjects, in your usual environments and using your evaluation of what constitutes "correct" exposure. You are, after all, the final judge of your photographs.

## FLASH METER

A flash meter is not indispensable, but it is a handy instrument to have around. Skillfully used, it can save you a lot of film. However, professional photographers will generally agree that there is no substitute for exposure bracketing in all but the most average situations.

A flash meter has to measure both the brightness of the light *and* its duration to produce a

meaningful reading. The way this is usually accomplished in a flash meter is similar to the way it's done in automatic flash units.

The meter has a photocell that generates a current proportional to the intensity of the light striking it. The current continues for as long as it receives light. Some flash meters measure the photocell current for a total of 1/60 to 1/125 second to include the effect of existing illumination on your exposures. Others only measure the burst of flash and have circuitry that reduces the effect of continuous light.

Whichever method is used, the photocell current charges a high-grade capacitor. The resulting charge in the capacitor at the end of the measuring period indicates the product of the brightness of the light and the duration of the measurement. This means that the charge is proportional to the

exposure value of the illumination.

The charge is measured by either a meter circuit or a circuit that converts the charge to a digital indication. In either case, the charge in the capacitor is converted to a number that is usable by the photographer.

Some flash meters have two photocells; others have only one. When there's only one cell, it does all the work. If there's a second cell, it sees the first instant of light from the flash and turns on the measuring photocell. Flash meters usually have a manual pushbutton for setting off the flash and for taking available-light measurements.

## OPEN-FLASH BUTTON

It is sometimes desirable to set off your flash without actually exposing film. You may want to verify that the flash is working properly, check to see where the light is aimed, or meter it with a flash meter. Also, many situations occur in which it's handy to trigger the flash independently of camera sync contacts.

For these reasons, most flash units have an *open-flash button.* Sometimes it is labeled **TEST** or is combined with the ready light as

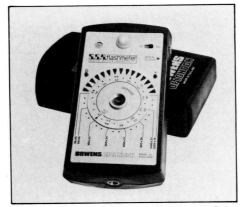

Designers of flash meters use a variety of methods for making meter readings. Before you use a new meter, be sure to read the instructions carefully.

one unit. The switch is connected directly across the sync cord or hot-shoe contacts. When you press the button, you trigger the flash in the same manner the camera would.

## ULTRAVIOLET AND INFRARED RADIATION

Flash tubes produce invisible ultraviolet (UV) and infrared (IR) radiation in addition to visible light. Although these wavelengths are useful for some specialized photographic applications, they are unwelcome in everyday shooting.

Ultraviolet radiation can be a

problem for the photographer because most films are sensitive to it. It can cause an image-softening haze effect on b&w film and a bluish color imbalance in color slides. Fortunately, most flash units filter out much of the UV by means of a special coating on the flash tube and a plastic lens covering.

Some substances, particularly certain dyes, absorb invisible UV radiation and re-radiate visible light. The re-radiated light is often of a remarkably different color than the appearance of the original object in normal light. This phenomenon—known as *fluorescence*—can give the unwary photographer disappointing photographs. It is virtually impossible to predict which clothes and fabrics will fluoresce. The only satisfactory answer is to make test pictures, and then use appropriate filtration to minimize the unwanted color shift.

Long-wavelength infrared radiation generates heat, which you can feel by placing your hand over the flash lens as you trip the switch. Firing the flash too often in quick succession can overheat the flash tube and damage it.

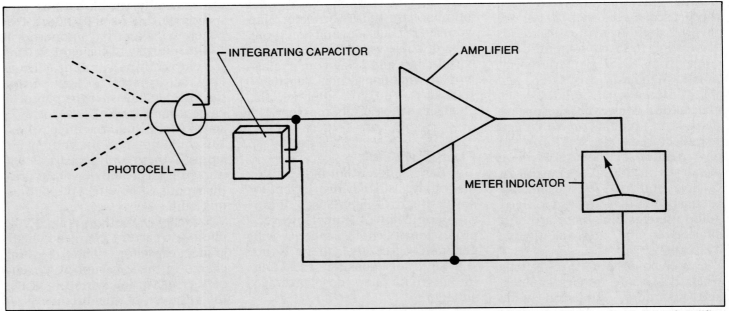

Charge transmitted by flash meter's photocell to integrating capacitor is not sufficient to drive indicator mechanism. Amplifier is used to supply the needed energy.

# How to Select and Test a Flash Unit

Flash units differ greatly in how much light they can supply. There's also a wide variety in special features, size, weight and cost. To be sure to get what best suits your needs, select your flash equipment carefully.

For some users, compactness and portability are a major concern. In situations requiring pocket-size camera equipment, a large and cumbersome flash unit would not be appropriate.

Your flash unit is an important part of your photographic system. Used properly, it can contribute significantly to the success of your pictures. Give your flash selection the same careful consideration you give to the purchase of a camera.

Begin by eliminating those units that obviously won't suit your needs at all. Sometimes the final choice can be a very subjective one—you simply like the "feel" or "look" of one unit more than all the others.

In this chapter I'll tell you about the most important features and characteristics to look for.

Wide variety of shoe-mount flash units is available. If you need more light output, select a more powerful unit.

Flash units with a hot shoe are easy to use. Electrical contacts are made when the flash unit is mounted to the camera shoe. No separate cords are needed.

## HOW MUCH POWER?

The first thing you should determine is how powerful a flash you'll need. Sometimes we'd all like a pocket-size flash that could light an entire auditorium. But we must compromise.

Generally, light output is proportional to the size and weight of a flash unit. This is one reason there are so many different sizes to choose from. If you want a lot of light, be prepared for heavier flash equipment.

Hand-in-hand with more light output is battery size and life. More light requires more electrical energy. This means you will be buying larger and heavier batteries and carrying them in a more powerful flash unit.

How much flash power will you need for most of your shooting? If you generally use slow films with speeds ranging from ISO 25/15° to ISO 64/19° and like to use small aperture settings such as $f$-11 or $f$-16, you'll need a relatively powerful flash. If you favor using long-focal-length lenses, you'll need a flash powerful enough to cover the greater shooting distances.

Let's assume you're photographing in bright sunlight, which causes deep shadows. How much flash power will you need to lighten the shadows sufficiently to put some detail into them?

You'll get a good non-flash exposure in sunlight using a shutter speed of the reciprocal of the ASA film speed at an aperture setting of $f$-16. For example, if you're using an ASA 64 film, a sunlight exposure of 1/60 second

at f-16 is close enough. With many cameras, 1/60 second is the fastest shutter speed you can use with electronic flash.

A rule of thumb for fill lighting, which brightens and thus adds detail to shadow areas, is that the flash exposure should be about half the daylight exposure. (Fill light is discussed in Chapter 7.) In some cases, one fourth as much fill exposure will do. Let's say you want to use half-intensity fill. This means that, with your daylight aperture setting of f-16, you'll need a flash that'll give you one half of correct exposure at f-16. Or a fully correct exposure at f-11.

When you know this aperture setting, together with your flash-to-subject distance, you can easily work out the flash guide number you'll need.

If your camera has a flash-sync shutter speed of 1/125 second, you can open your lens to f-11 for correct sunlight exposure. This wider aperture enables you to move farther from the subject and still get the fill-flash effect you want.

The chart on page 46 shows typical flash-power ratings you'll need for flash fill outdoors under different conditions.

If you're planning to use accessories such as umbrella reflectors, you'll need additional power. Part of the light is lost by absorption and scatter.

Ask yourself: "What is the least amount of flash power I will be satisfied with?" Remember, more power means more weight, higher initial cost, and higher energy drain per shot. You must have enough power to make the pictures you want. But you don't want a unit that's so heavy that you usually leave it home because it's too much bother to carry.

## POWER SOURCES

There are three basic types of power sources for your electronic flash. You can choose throw-away dry batteries, several types of rechargeable batteries, and AC household current. Many flashes will accept all three types of power. Others can use only one or two.

**Alkaline Cells**—The most common source of power for electronic flash equipment is the throwaway alkaline cell. Ordinary carbon penlight cells may give you some service but they are generally unreliable under the heavy demands made by flash. Alkaline batteries give the best performance. You can purchase them almost any-

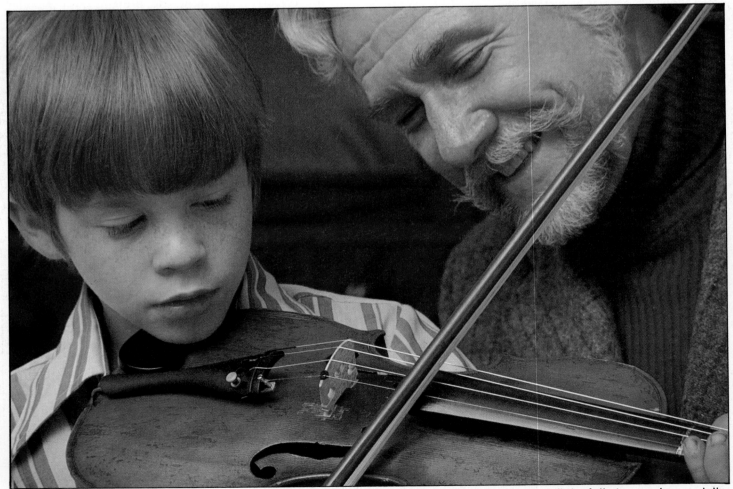

This photograph is well-lit and a good example of thoughtful composition. Just three elements tell the full story—a boy, a violin and a proud teacher. There's no distracting background. Photo by Ed Judice.

where. They can produce more flashes per set than other batteries of the same size.

Alkaline cells for electronic flash come in several sizes. They range from the tiny AAA cells through AA, C and D sizes. Many others are made but they are not commonly used in flash equipment. Alkaline cells are used alone, in pairs, or in batches of up to eight cells in different flash units.

**Nickel-Cadmium Cells**—If you expect to use rechargeable nickel-cadmium (nicad) cells someday, be *sure* that the flash you are planning to buy will accept them. Some models will be damaged or will not work properly with nicads. Incompatibility with nicads is usually a characteristic of low-cost flash equipment, although this is not always the case. Some relatively complicated and expensive units can't use them either.

A careful examination of the flash unit's instructions or specifications will tell you whether or not it will accept nicads.

**Built-In Rechargeable Batteries**—If you plan to use only rechargeable cells in your flash, you can buy units that have them built right in. Not only nicads are used. Several kinds of lead-acid rechargeable batteries are also built into flash equipment.

The main appeal of built-in batteries is the reliability of the electrical connections. The ends of replaceable batteries sometimes develop thin but troublesome deposits that can interfere with current flow to your flash. If these deposits are not removed, they can build up to the point where your flash won't operate. Replaceable batteries require simple but necessary maintenance to keep them serviceable. More on battery care in Chapter 10.

You must remember that once you exhaust the charge in a built-in battery, the flash is out of action until you recharge the battery. You can't simply slip in a replacement battery. Also, if one or more

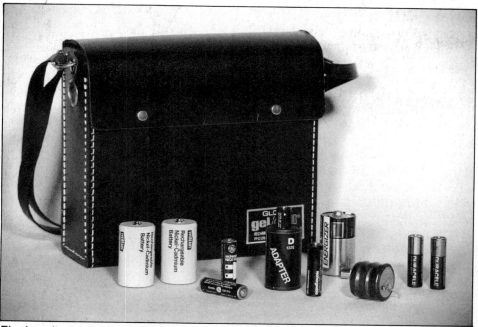

Flash units are powered by a variety of batteries, from large rechargeable power packs to tiny disposable cells. Each power source has its advantages as well as disadvantages, as indicated in the chart on page 34.

Alkaline battery.

Nickel-cadmium battery.

Dry lead-acid battery.

High-voltage battery.

Gelled lead-acid battery.

High-voltage batteries are carried in shoulder or belt packs, as shown. Some packs contain voltage-regulating circuitry to match the voltage with the needs of the flash unit.

33

cells become defective, you will probably have to take the flash to a repairman for service. Some built-in batteries are relatively easy to unsolder and replace. But many of the smaller flash units are tricky to disassemble and service.

**Booster Batteries—**A few flash units offer an accessory shoulder pack with a set of batteries larger than the ones in the flash unit. The larger batteries enable you to get more shots and a shorter recycling time between shots.

**High-Voltage Dry Batteries—**These venerable energy sources date from some of the earliest portable flash units. They are indispensable to photographers whose work demands short recycling times. If used regularly, these batteries can power a very large number of exposures. However, they tend to lose capacity in storage and aren't cost-effective unless you use them often. You're wasting expensive battery power if you let a high-voltage battery sit and age.

There are several types of high-voltage batteries for flash application. They range from 250 to 510 volts. The most popular is the 510-volt size. In some flash units, the main capacitor is charged directly from the battery. In others, a regulator circuit drops the voltage to 330 volts to match the main capacitor's rating.

**Rechargeable High-Voltage Replacement—**If your type and amount of photography make high-voltage batteries impractical, you don't have to trade in the flash for a different type. For some flash units, you can get replacement modules shaped exactly like the high-voltage batteries. The modules contain rechargeable batteries and the step-up circuitry to boost the voltage to the right level. To recharge the module, plug the unit into an AC outlet. The modules are expensive, but less so than new flash equipment. Later on, if you need to go back to using high-voltage batteries, you can still do so.

**Other Rechargeable Batteries—**Relatively high-powered flash units sometimes use lead-acid rechargeable batteries instead of nicads. There are some differences in price, weight and performance between lead and nicad batteries. However, usually you don't have a choice between them in any particular flash unit. The flash works with only one or the other.

The gelled and dry lead-acid batteries are the two most commonly used types. They have largely replaced wet lead-acid batteries that were once in widespread use in flash equipment. More on batteries in Chapters 4 and 10.

**AC Power—**Some flash units are constructed so you can power them through an extension cord plugged into a standard AC wall outlet. If you expect to do a lot of studio-type photography, in a fixed indoor location, AC-operation has definite advantages. AC power costs less per shot than battery power and the recycling time is usually shorter. On some units, the AC cord is standard equipment. With others, you have to purchase the cord separately.

If you plan to use the flash in countries that use 220-volt AC household power, buy a unit with a voltage-selector switch. This way you can change the flash from 110- to 220-volt operation. The switch may be on the line cord or on the flash unit.

## BATTERY CHARACTERISTICS

| Battery Type | Advantages | Disadvantages |
|---|---|---|
| Alkaline | Available nearly everywhere. Reasonably high number of flashes per set. Low cost per set. | Longest flash recycle time. Not rechargeable. |
| Nickel-Cadmium | Faster recycle time than alkalines. Low cost per flash. Rechargeable. | Fewest number of flashes per charge. Possible temporary loss of capacity if misused. |
| High-Voltage Dry | Fast recycle time. Greatest number of flashes per set. | Expensive to buy and run unless used frequently. Not available everywhere. |
| Gelled Lead-Acid | Fastest recycle time of all. Low-voltage batteries. Large number of flashes per charge. No loss of capacity unless badly abused. | Heavy. Rechargeable only about 500 times. Must not be left in discharged condition. Replacements not always available at photo stores. |
| Dry Lead-Acid | Generally the same advantages as gelled lead-acid batteries. Discharges very little in storage. | May be difficult to find replacements. Sometimes difficult to recharge if run down completely. |

## MANUAL OR AUTOMATIC FLASH?

The main consideration for many photographers is the choice between manual and automatic flash. If you already have a manual flash, you may be aching to try an automatic unit. However, many photographers use manual flash almost exclusively. The results can be just as good, although automatic flash can make shooting simpler and faster in many cases.

**Manual Flash**—Manual flash units are usually of a simpler design than automatic units. All you are paying for is raw power and durability. Theoretically, manual flash units should break down less often because they have fewer circuits. Whether this is true in practice is difficult to say.

Large manual flash equipment is designed for the professional or the more ambitious amateur. It is usually constructed to withstand rugged use. Many units feature interchangeable heads or reflectors, and variable-power output. With many, you also have a choice of several different batteries to power the unit. Among the large professional units are those made by Graflex, Norman, Hershey and Lumedyne.

Some studio flash units that are powered exclusively by AC household current fall into the manual-flash category. In Chapter 9, I'll discuss the special needs of the studio flash user.

**Automatic Flash**—There are many automatic-exposure flash units to choose from. Most modern automatic flash units are of thyristor design, although some are still quench-tube controlled. Thyristor units, as explained in the previous chapter, are preferable because they conserve battery power and usually recycle faster between shots.

## DEDICATED FLASH SYSTEMS

Dedicated flash, you'll recall from the last chapter, is a type of flash designed to interact with a specific camera's exposure system and viewfinder display. The convenience and relatively foolproof operation of dedicated flash could make it an attractive choice for you.

Several flash manufacturers are offering *all-purpose* dedicated flash units. By means of interchangeable adapters or selector switches, these flashes will operate either part or all of the camera's automatic features. Be certain to read the flash unit's specifications carefully before buying, so you know for sure exactly what dedicated features you will be getting. Typical features are automatic selection of the fastest X-sync shutter speed for flash and a ready light in the camera's viewfinder.

## RECYCLING TIME

This important consideration is often overlooked. It tells you how long you must wait between flashes for the main capacitor to fully recharge. If your photographic needs call for full-power exposures only a few seconds apart, you'll need a rapidly recycling unit.

Press and wedding photographers, for example, have traditionally relied on manual units powered by high-voltage batteries because they recycle very quickly. Because high-voltage batteries are very expensive, more and more photographers are switching to handle-mount thyristor units. Handle mounts have more power than smaller units and the thyristor circuit gives them relatively fast recycling times and reasonable battery life.

Be aware that the advertised recycle times for any flash are usually what you can expect with fresh batteries. This interval may double, or increase by even more, before the batteries are exhausted.

## NUMBER OF FLASHES

How many photographs can you expect to take with one set of batteries or on one charge with re-

Handle-mount flash units often have the batteries and the electronic components integrated into the handle. Others, like this model, have a separate shoulder pack.

The most powerful portable flash equipment is often offered as power-pack components that can be combined to give different power levels. Some units can be adapted for use with the household AC supply instead of batteries.

## DEDICATED FLASH

Although most dedicated flash units do basically the same thing, they have different features that often prevent them from being used on other makes of cameras.

For example, in the Minolta XD camera system the hot shoe has one contact for the dedicated-flash function. When a flash in this system is ready to be used, the ready light is on and the flash sends a signal of about 1-1/2 volts to the contact. This turns on the camera viewfinder's *ready* indicator.

When you release the shutter, it opens and the lens stops down to the aperture you had set on the adjusting ring. When the flash has fired, the voltage on the dedicated contact turns off and the shutter closes.

In the Canon A-1 system, the hot shoe has *two* dedicated-flash contacts. One sends voltage from the camera to the flash. If the ready light is on, the flash draws current through the contact to tell the camera it's ready. This signals the camera to select a shutter speed

A dedicated flash made by a camera manufacturer specifically for his cameras is usually not usable with other cameras. Units like this, intended specifically for one camera, generally offer the largest number of dedicated features.

of 1/60 second and turns on the viewfinder's ready indicator.

When you release the shutter, voltage from the flash goes to the camera via the second contact and causes the lens to stop down to an aperture setting *selected by the flash.*

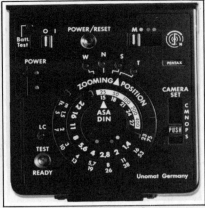

This flash will operate the dedicated functions of the most popular brands of SLR cameras. You select the camera type by sliding the switch on the right side to the appropriate position. The letters, from top to bottom, represent Canon, Minolta, Nikon, Olympus, Pentax and Standard. The standard setting is for certain other cameras, as specified in the instructions provided with the unit.

Other dedicated camera/flash systems, such as the Contax 139 and Olympus OM-10, also feature sufficient-exposure indicators in the viewfinder.

---

chargeable cells? Many small flash units will expose only a roll or two of film at full-power. Some units will give you more. Of course, you'll get many more exposures if you keep within the automatic-control range on a thyristor unit. You can usually expect to get more shots with alkaline cells than you can on one charge of rechargeable nicads. To be sure you won't run out of power while photographing, always have an extra set of batteries handy.

## SEQUENCE SHOOTING

If you frequently use an autowinder or motor drive on your camera, you may want a flash that can keep up with the frame rate of the winder—at least for a few shots at a time. The usual way to make a flash recycle fast enough to work with a motorized film transport is to reduce the power setting. This also helps to prevent overheating of the flash.

You'll need a thyristor flash

On this flash, the two dots indicate the switch positions for the two automatic exposure ranges. The M setting is for full-power manual operation. The triangle indicates the switch position for rapid recycling. This is needed for use with a motorized film winder.

with a manual-power ratio-control dial. Some units mark one setting on the dial **MD** for *motor drive.* Flashes with these markings are usually advertised for use with motor drives. Some motor-drive flash units can expose up to a full 36-exposure roll at about four frames per second.

Other automatic flash units may

This picture is part of a high-speed flash sequence. It was made to study what happens when a drop of water falls. When this frame was exposed, the drop had already hit the water, causing the upward splash. Photo from Stock Boston, Inc.

Some flash units come with an accessory lens or diffuser panel that you can attach to the front of the flash to change the beam angle. You can even use this accessory with a zoom flash. This gives a wider angle of coverage than is available with the zoom feature alone.

work well enough for short bursts of about six shots at a time. More shots use up too much of the main capacitor's charge. When this happens, the flash is likely to misfire—that is, not fire when you want it to.

## BEAM ANGLE AND SHAPE

Beam angle is a measure of how wide the light of the flash spreads out. Most flash units do a good job of uniformly lighting the field of view seen by a 35mm lens on a 35mm camera. Some do a better job than others, of course. If the angle of view of your lens is wider than the beam, your photographs will show signs of uneven illumination.

If you need a flash to use with a wide-angle lens, you have to be selective. Some flash units cover the field of a 35mm lens just the way they are. With others, you have to attach an auxiliary plastic lens or diffuser panel. Often this is included with the flash, although sometimes you must purchase it separately.

If you like to use lenses of different focal lengths, you should consider the advantages of a flash unit with an adjustable beam angle. Keeping the beam angle no wider than needed helps you make the most efficient use of the light output of the flash. It enables you to use smaller lens apertures or slower films.

This flash head has a built-in zoom lens. By sliding the lens attachment forward or backward, you can alter the beam angle to suit the covering power of camera lenses of different focal lengths.

There are several ways to alter the beam angle. One, just mentioned, is to add an auxiliary lens. This technique is generally used to spread the beam. However, some lenses will narrow the beam to match the view of a telephoto lens. You can also get units with either built-in or accessory "zoom" lenses that you can set for several different beam angles. You can adjust such a lens so the flash-beam angle is appropriate for a medium telephoto, a standard lens and a medium wide-angle lens. For some flash units, a clip-on lens is available to extend the coverage to the angle seen by a 24mm lens.

## AUTOMATIC FLASH EXPOSURE

The automatic exposure control on a flash works only over a certain distance range. If you get too close to your subject, the control circuitry can't turn off the flash fast enough to prevent overexposure of the film. If you're too far away, the flash stays on until the main capacitor is exhausted but

This low-cost flash unit has only one automatic-exposure range. For any given film speed you can use only one lens-aperture setting.

Olympus T32 electronic flash offers a selection of three automatic settings, at three different lens apertures. This gives you some creative control of your photography. You can select a large lens aperture to throw a background out of focus, or a smaller aperture for greater depth of field.

you don't get enough light on the subject.

The simplest automatic flash units have only one automatic setting. This means that your choice of *f*-stop depends on the speed of the film you are using. The faster the film, the smaller the aperture you can use.

For more versatility, you may want a flash with two, three or even more *f*-stops to choose from. It's handy to have a choice of apertures. You can select a big aperture when you want to shoot from a long distance or put the background out of focus. You might want to stop down your lens for more depth of field. Having several automatic ranges to choose from gives you this flexibility.

Some flash heads tilt vertically and swivel horizontally. This gives you extensive bounce-lighting control when shooting both horizontal- and vertical-format photos.

Some flash units have lamp heads that can be tilted independently of the remainder of the unit. This makes bounce lighting easier.

The operating range of a flash is different for each setting of the aperture-selection control. The maximum shooting distance for a given *f*-stop is never more than the flash's manual guide number divided by the aperture. For example, a Sunpak Auto 221S has a guide number of 72 feet with ISO 100/21° film. The guide num-ber—as I pointed out in the last chapter—is the product of the aperture you select multiplied by the flash-to-subject distance. The specifications for this flash indicate that the maximum automatic shooting range with ISO 100/21° film at *f*-2 is 36 feet, because 2 x 36 = 72.

## BOUNCE-FLASH CAPABILITY

Most indoor snapshots made by amateurs are taken by on-camera direct flash. The camera-mounted flash is pointed directly at the subject. More creative lighting is possible with off-camera flash, as I'll describe in the next chapter.

*Reflected flash,* or *bounce flash,* is another way of widening and improving the lighting effects your flash can give. Any flash unit you can operate off camera is OK for bounce lighting.

You can aim the flash at a light-colored surface so the light reflected from the surface illuminates your subject. This increases the effective size of the light source. Shadows are opened up to reveal detail, and image contrast is lowered.

With manual flash, exposure calculations can be tricky because the brightness of the illumination is affected by various factors. More on this in the next chapter. Automatic flash is preferable, as long as you can aim the light where you want it while keeping the sensor pointing at the subject. This is essential. The flash doesn't need to know how much light is coming back from the wall or ceiling you're using as a bounce surface. It needs to know how much light is reflected by the subject.

An automatic flash unit that's ideal for bounce lighting will have the flash tube and reflector mounted on a hinged head. The sensor will be on the body of the flash so it remains pointed forward, toward your subject, at all times.

Some flash units swivel horizontally, some swivel vertically, and a few can move in both directions. How far they can move varies considerably from unit to unit. The more movement, the more versatile the flash.

## FLASH-UNIT HOUSING

You'll select a flash unit primarily for the features you need, and not for its housing. However, features and body styles are closely linked. Let's look at some different designs to see how they differ.

**Shoe-Mount**—There is a wide selection in this category. Shoe-mount flashes will attach to your camera's accessory shoe. Most have *hot-shoe* connections in their mounting foot to synchronize them to your camera. There may still be a few models that have a metal or plastic mounting foot and use a PC cord for the synchronizing connection.

Shoe-mount flashes range from low-power units operated by a single AAA cell to relatively heavy models powered by four to eight AA cells or built-in rechargeables. Some are linked to an accessory shoulder pack. You will find both manual and sophisticated automatic flash units in shoe-mount housings.

**Handle-Mount**—You can recognize this category of flash by its cylindrical handle. It's often called a *potato masher* because of its superficial resemblance to old-style wooden potato mashers.

Handle-mount flashes are generally more powerful than the shoe-mount units. They have more room to hold larger capacitors and flash tubes.

Most handle-mount flashes are completely self-contained, with the batteries and electronics all in one package. Some brands have the batteries and voltage-boosting circuit in a separate shoulder pack.

A handle-mount flash unit attaches to your camera by means of a bracket that screws to the camera's tripod socket. A quick-release clamp is usually included with the bracket for convenient off-camera use.

You don't have to fill all your color pictures with bright colors. Some of the best photos contain subtle, subdued colors. This bush rabbit in a rock formation reminds us how many animals blend with their natural surroundings. Photo by George Lepp, Bio-Tec Images.

**Large Professional Units**—This group's distinguishing feature is *power*. They all sport shoulder packs that carry the batteries, most of the electronics *and* the main capacitors. Notice that I said *capacitors*. There are usually several of them and they can be switched in and out of the flash-tube circuit selectively to control light output.

The flash head, which contains the flash tube, reflector and trigger circuit, is light and mounts on your camera like a handle-mount unit. This category of flash usually offers a choice of several flash-head styles for each make. You can even use two heads simultaneously on most models.

These units have more power than most non-professionals are ever likely to need. But if you must have *high* guide numbers, they're the way to go. Even

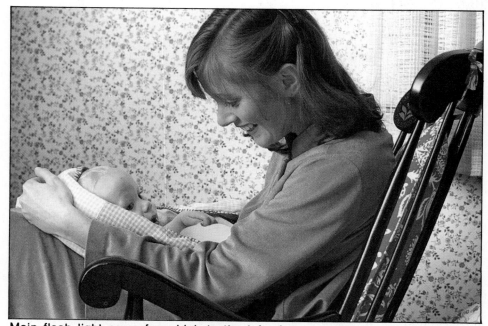

Main flash light came from high to the left of the camera position, lighting the mother frontally. This provided good modeling in the entire subject. A word of warning: Light from a flash is very bright. Don't flash directly at a small child's eyes from close up—no matter how good a picture you might miss. Photo by Ed Judice.

though you can get guide numbers as high as 330 (feet) with ISO 100/21° film, you have to sacrifice some of the motion-stopping ability of the flash to get this much power. Because of the large capacitors, flash duration is increased to about 1/400 second when they're used at their highest power settings.

**Studio Flash—**This category is dealt with separately in Chapter 9.

## ADDITIONAL FEATURES

The following additional features can increase the versatility of a flash unit and add to the enjoyment you get from using it. Many of the features are available in both manual and automatic flash units.

**Calculator Dials And Charts—**With a manual flash, you use a guide number to determine the proper aperture to use for your exposure. Although guide numbers are easy enough to use, they can be a distraction when you have other photographic details on your mind.

It's much more convenient to use the calculator dial that is placed on most flash units. Basically, the dial is a slide rule that automatically makes the calculations for you. You set the film speed on the dial and read out the aperture opposite the appropriate flash-to-subject distance number. Some calculators are straight scales; others are circular. Both work in the same way. Some flash units

have just a chart showing typical film-speed and aperture settings.

Automatic-exposure flash units also have calculator dials, but they give you more information than you get on manual dials. Most often, the minimum and maximum shooting distances are shown for each aperture range available on the flash. Some calculators are arranged so you can see only the aperture number you need, all the others being covered. This type of dial helps to prevent mistakes.

A lighted calculator is available on several flash units. This is useful when the existing light is dim, as it often is when you have to use a flash. Typically, you push a button to light the dial.

An interesting type of calculator is all-electronic, as typified by the one on the Rollei Beta-5 flash. You enter the film speed and other variables with pushbuttons and then see the aperture settings for the flash-to-subject distance on a digital readout.

**Specialized Ready Lights—**The difference between ordinary ready lights and specialized ready lights is in the amount of information they give. A conventional ready light lets you know when the main capacitor reaches a certain level of charge—usually 80% to 100% of full charge. Specialized ready lights are a set of several lights,

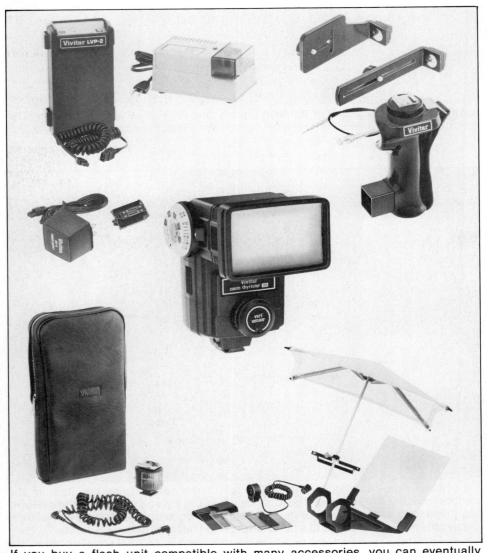

If you buy a flash unit compatible with many accessories, you can eventually create a versatile electronic-flash system.

To increase number of flashes you can get from power supply and shorten recycling time, use accessory battery packs or boosters. The Bogen Power Handle, shown here, is a booster-battery container as well as a convenient flash grip.

each of which comes on at some specific level of charge. They tell you more about the amount of charge remaining in the capacitor. Whether this information is of much practical value depends on you. Their main value is in letting you get the last bit of life from your batteries. You can tell more accurately whether or not you have enough energy left in the capacitor for "one more shot."

**Confidence Lights**—These are a handy feature and should be put high on your "want" list. They can help you avoid underexposing a lot of film. They are particularly handy if you use bounce lighting often or if you like to experiment with diffusers.

The confidence light glows for about a second each time your flash unit's automatic-exposure control shuts off the flash. This happens only when the flash photocell has seen enough light coming back from the subject for adequate exposure. If you're too far away from your subject to illuminate it sufficiently, the confidence light will not come on, indicating underexposure.

Some flashes also have a beeper that sounds when the confidence light glows. This way, you get the message without looking away from your viewfinder.

**Automatic Shutoff**—One sure way of getting *fewer* than the expected number of flashes from a set of batteries is to leave the unit turned on after you finish taking pictures. Another way is to have the unit's ON-OFF switch inadvertently jostled ON as it bounces about in your camera bag. Several makes of electronic flash deal with these problems very effectively by having a built-in timer that shuts off the battery a short time after the last shot is made.

The shut-off time varies between 8 and 45 seconds, depending on the make and model. The main capacitor holds enough charge to take another shot—at least it will for a minute or so. If you fire a flash within this time, the battery will turn on once again and recharge the capacitor. If the capacitor discharges too far, you can operate the ON switch to charge it up again. This feature can save you batteries, but is not essential.

**Open-Flash Button**—When you push this button, the flash fires independently of the camera contacts. The button is useful for testing the flash without exposing film or for making multiple-flash exposures while the shutter is held open with the B setting. It adds very little to the cost of a flash but a lot to its versatility. I recommend it. However, not all flash units have one.

## TESTING YOUR FLASH

After you buy a new flash—or any other piece of photographic equipment—it's a good idea to test it for proper operation before using it for important photography. Not only will this confirm that the flash is operating properly, but it will also encourage you to

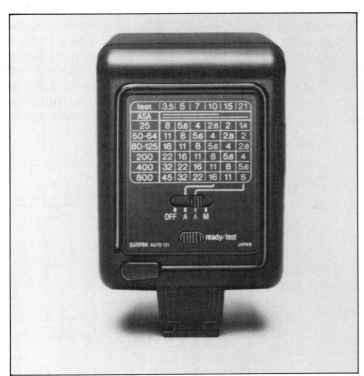

This chart helps you find the correct aperture setting for a flash picture. All you need to know is the speed of the film and the distance of the flash from your subject. For example, when you're using an ASA 200 film and have your flash 10 feet from your subject, the lens aperture should be set to *f*-8.

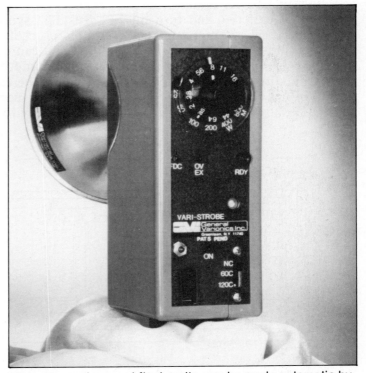

High-powered manual flash units can be made automatic by attaching an accessory head. The automatic head shown features a unique overexposure indicator light.

take the time to read and understand the instructions. By the time you finish the tests, you'll be thoroughly familiar with your new flash.

**Recycling Time**—The recycling time is usually the time it takes for the flash ready light to come back on *after* a full-power flash. When left unused for extended periods, capacitors in flash equipment temporarily lose some of their efficiency and will waste some of the energy that is trying to charge them. Therefore, when a flash is *first* turned on it always takes a few seconds longer for the main capacitor to charge. If the flash is new or hasn't been used for a month or so, it takes even longer.

Restoring the capacitors to their proper condition is called *reforming* them. All it takes is to turn on the flash for a few minutes and occasionally trip the flash. Many flash instruction manuals have specific recommendations for reforming, but there's no magic to the method. Giving the capacitor a little exercise will do the trick.

To test the recycle time, install a *fresh* set of batteries and turn on the flash. If it is an automatic-exposure unit, set it for *manual* operation. When the ready light comes on, fire the flash with the OPEN FLASH button. Repeat this for five flashes or so. After the last flash, count the number of seconds it takes for the ready light to come on again. Unless your flash instructions say otherwise, the interval between the last flash and when the ready light comes on is the recycle time.

Be aware that there is a considerable difference between the recycle times you will experience when you use alkaline cells and when you use nicads. The nicads usually give you shorter and more consistent recycling times.

**Synchronization**—When a flash and camera are properly synchronized, the flash goes off at essentially the instant the shutter is completely open. Any other condition is unacceptable. Improper synchronization will result in poorly or partially exposed film.

If you have never used your camera with electronic flash before, make certain its X-synchronization is adjusted correctly. Even if you're a regular user of flash, you should periodically test your equipment. Flash contacts can wear and go out of adjustment.

Testing synchronization is a simple procedure and requires no film. You can do it any time your camera is empty.

Review the camera's instruction manual, if necessary, to see if there are any restrictions on which shutter speeds can be used with electronic flash. Remember that you have only a limited choice of shutter speeds compatible with flash if your camera has a focal-plane shutter.

When you have determined the range of shutter speeds you can use, set the shutter-speed selector for the fastest permissible setting. This will generally be 1/60 or 1/125 second with focal-plane shutters.

Place your camera on a tripod and point it at a blank wall. Set the lens at its widest aperture. Open the camera back. Connect the flash to the camera's hot shoe or PC connector. If you're using the PC connector, be *sure* to plug it into the *X-sync* terminal.

**Testing Focal-Plane Shutters**—Attach or hold a small strip of translucent material, such as a glassine negative envelope, across the film-plane opening. Do not use tape that might leave a sticky deposit. Do not touch the shutter curtain or blades. They are easily damaged.

Turn on the flash and point it at the wall. While looking at the film-plane area, trip the camera shutter. You should briefly see a bright rectangle of light the full size of the image area on the glassine. If you see anything less than the full opening, either the synchroniza-

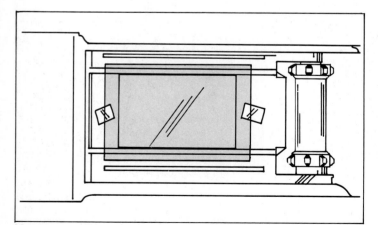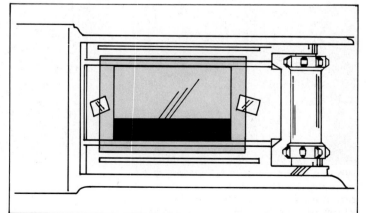

You can easily test whether a focal-plane shutter is properly synchronized for electronic flash. Place a piece of glassine negative protector, or similar translucent material, in the film plane of the camera. Point the camera lens at a light-colored surface. Look through the camera from the film plane toward the lens and fire the flash. If the full image area appears lit (left), it indicates that the shutter was fully open and synchronization is OK. If part of the image area is dark (right), the shutter is probably set for too fast a speed.

tion is off or you have selected too fast a shutter speed. If the shutter speed is correct, have the camera checked by a repairman.

**Leaf Shutters**—Leaf shutters can be checked without the glassine. Just look through the lens of the open camera, aimed toward the wall. When the flash goes off, you should see the full aperture. If you see any portion of the shutter blades, the sync is out of adjustment. Some leaf shutters have a sync-selection lever. If yours does, be certain it is in the X position.

Very rarely is a synchronization problem caused by the flash unit. The fault usually lies in the camera.

**Light Output And Guide Numbers**—To make accurate exposures, you need to know how much light your flash puts out. Usually, when a flash manufacturer states a guide number for a unit, the assumption is that you will be using it in a "typical" room. Such a room has an eight-foot high, light-colored ceiling and light-colored walls. This is an industry standard.

If you expect to do much of your shooting in a large room with a high ceiling or outdoors at night, you will have to establish your own guide numbers. But even if you photograph in a "typical" room, it's still a good idea to take a series of photographs with your new flash to verify or fine-tune the manufacturer's number.

Place the flash at some convenient distance from an average subject such as a seated person. Six to eight feet away will do. Measure the distance accurately. Load your camera with a slide film with a speed in the range of ISO 64/19° to ISO 100/21°. Divide the flash manufacturer's guide number by the flash-to-subject distance you are using to get the recommended lens aperture.

Take a series of photographs at half-step or full-step increments. Start with the lens at two *f*-stops wider open than the recommended aperture and end at a lens setting of two *f*-stops less than the recommended aperture.

To help identify the exposures in the processed film, write down the settings. Better yet, make a set of cards for your subject to hold, as in the set of photos on page 47.

Wait 10 to 15 seconds *after* the ready light comes on before making each exposure. The light output of a flash nearly always increases somewhat if you give the main capacitor a bit longer to charge. This is because most ready lights turn on when the capacitor is about 80% charged. The extra wait also makes your results more consistent and repeatable.

Have the film processed and examine the slides to see which one you consider best. When you've made your selection, multiply the aperture used to make that picture by the flash-to-subject distance. This gives the guide number for the flash conditions you were shooting in.

On one 36-exposure roll you should be able to test at least three different conditions, such as in a small room, a large room, and outdoors at night. The guide number for the small room will probably be nearly identical to the manufacturer's recommended guide number. The other two guide numbers will almost certainly be smaller than the manufacturer's, due to less reflected light adding to the exposure.

When a leaf shutter is fully open at the moment the flash fires, the shutter is properly synchronized with the flash. When the blades appear only partially open, the flash is not synchronized properly. Have your camera examined by a qualified repairman. Before you make this test, be sure to set the lens aperture wide open.

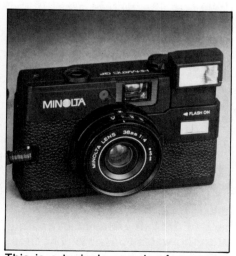

This is a typical example of a camera with built-in electronic flash. For use, the flash head is raised to the position shown. When not in use, the flash head is pushed down so it lies flush with the camera top.

An AC adapter enables you to use the household electricity supply and thereby saves the cost of batteries. With AC use, you often get shorter recycling times, too. To avoid damaging the flash unit, be sure to use the adapter exactly as specified by the manufacturer.

If you want to make the test with negative film instead of slide film, that's OK. But make your evaluation from the *negative,* and not from a print or enlargement. Remember that negative deficiencies can be partially corrected at the printing stage. Therefore, evaluation of a print would be meaningless.

**Testing With A Flash Meter—** You can also verify your flash guide number by using an incident-type flash meter. A dependable flash meter is a useful tool. However, unless you are quite familiar with the meter you will be using, you should still run at least a short series of test shots as a precaution. It doesn't take an entire roll of film to determine a guide number. A test series can be used to finish off a roll.

Place the meter on a tripod or have someone hold it so its integrating dome points at the flash about 10 feet away. Measure the distance accurately. Set the meter's film-speed dial to the speed of the film you're using.

Fire the flash and note the aperture reading on the meter. The guide number, in feet, is equal to the aperture reading times the distance. If you prefer to use *meters* instead of feet, that's fine. Just be sure to be consistent—don't mix meters and feet.

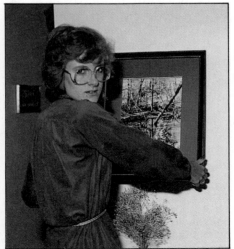

If you want to test your automatic-exposure flash, choose a subject of average reflectivity.

**Ready Light—** The ready light is supposed to tell you when your flash is ready to use. Basically, it does this—but *how* ready is another question. The output of a flash is usually *greater* several seconds after the ready light lights than it is when the light first comes on. The exact difference is best determined with a flash meter.

Set up the meter for incident readings. Take two readings. Make one when the flash was fired just as the ready light came on. Make the second of a flash made a *full minute* after the ready light glowed. Don't be surprised if there's as much as a *full exposure-step* difference between the two readings. Some flash units will show less difference, but a one-step spread is not at all uncommon. Make a note of the difference. It may come in handy later on, when you use your flash without the meter.

**Beam Coverage—** There are two things you need to know about the beam coverage of your flash. Does the beam spread out enough to cover the angle of view of the camera lens? Is the light evenly distributed? Your flash instructions should specify what focal-length lenses can safely be used with your flash without losing uniform lighting from corner to corner of the picture area. If the beam angle is adjustable for use with different lenses, each of the settings should be listed.

To see if the coverage is as wide as the owner's manual claims, mount the flash on or near your camera facing a coarse-surfaced matte (not shiny) wall. The wall should be far enough away so the flash beam and the camera's field of view overlap properly. About 10 feet should be a suitable distance. It is important to have the back of the camera as nearly parallel to the wall as possible. The light should have to travel the same distance on the left side of the field as it does on the right. The same applies to the top and bottom of field.

This flash unit was fired at a blank wall. The flash-to-wall distance was the same each time. The different-sized circles of light represent the *wide, normal* and *tele* flash-beam settings.

Load the camera with b&w film. Focus carefully on the wall and make a series of exposures for each lens/beam-angle combination you have. After developing the film, examine the negatives for uniformity of density.

Because you're photographing a flat surface, the distance from the flash to the outside edges of the scene will be a little greater than the distance to the center of the scene. As a result, the corners and edges of the negatives may be

slightly less dense than the central part. A small amount of this is to be expected and is acceptable. But only a *small* amount.

Check the negatives for *hot spots*—greatly overexposed areas. Hot spots usually show up near the center of the negative. Streaks or patterns of light and dark are also undesirable. Minor unevenness will generally remain unnoticed when you photograph average subjects such as people, objects and scenes.

**Automatic-Exposure Control**—If you purchased an automatic-exposure flash, you did so because you wanted it to do most of the work of keeping your flash exposures uniform. Testing this is easy. Once again, either a flash meter or, better yet, a series of test exposures will do.

Before we get into the mechanics of running the tests, you should be aware of one important fact. Just like their light-meter cousins, flash-exposure controls are brainless things. Both are calibrated to work properly with "average" subjects—any combination of light and dark items having an average reflectance of 18%.

Of all the light striking your average subject, 18% is reflected back to the flash control sensor and to the camera. As long as the sensor in your flash sees average subjects—and, as the name implies, they are commonplace—it should do a good job of maintaining uniform flash exposures.

Because your flash thinks it is seeing an average subject, by all means cooperate with it and test it with an average subject. Let's leave the "bride-in-white" shots for later on. A person in mid-tone clothing, seated on a couch, will do.

Load your camera with slide film of medium speed—ISO 64/19° or ISO 100/21°—or use the remaining shots on a nearly finished roll. Determine the proper lens aperture from the flash calculator dial. If your flash has several aperture selections, test a couple of the ranges.

Some flashes have many aperture selections. Testing three of these should be sufficient.

Place your camera and flash a convenient distance from the subject. About eight feet should be fine. Don't be closer or farther than the minimum or maximum distances indicated on the flash calculator dial. When the ready light is on, make an exposure at each of the selected aperture settings.

Examine your processed slides to see if the pictures are to your liking. If they are too light or dark, you can compensate by using a slightly different film-speed setting on the calculator dial. Usually, you will have to correct your settings by less than one step.

If your flash has a *sufficient-light indicator,* fire a test flash with the open flash button. The light should come on. If it doesn't, recheck all the settings and the flash-to-subject distance. If everything checks out and a second try fails to light the lamp, return the flash to your dealer.

You may want to take an extra shot or two near the minimum and maximum indicated control distances. Use your sufficient-light indicator to check the maximum range. Remember, the size and reflectivity of the room may cause the range to be a little different than indicated in the flash manual.

In a nutshell, checking out your new flash equipment is simply a matter of running it through its intended uses to find out when it performs to the manufacturer's standards and when to your own. These tests are very easy. It takes longer to explain them than to actually do them. After you've done the testing, you'll be much more familiar with your equipment and its best use.

## FINAL CONSIDERATIONS

What are you buying the flash for? Will it match one you already have? Or, do you want a unit offering features that your present

One large diffused light source, such as an umbrella flash, will often be ideal for shooting on location. It can save you carrying several lights. Umbrellas are discussed later. Photo by Elizabeth Crews, Stock Boston, Inc.

one doesn't have? Should it accept some of the accessories you presently own?

Maybe price is an important consideration. You may be able to pick up a demonstration unit or a discontinued model. Use some caution and avoid buying a flash made by a company that has gone out of business because parts and service may be unavailable.

A little planning and some shopping around will help you select a flash tailored to your needs.

# FILL FLASH IN DAYLIGHT

In color photography, especially of people, a lighting ratio of 3:1 is about right. This means that the highlight side of the subject must receive about three times as much light as the shadow side. Because the fill light is usually at the camera position and affects *both sides* of the subject, the actual brightness ratio of main light to fill light must be about 2:1. To achieve this ratio, the fill flash on or near the camera must provide one exposure step less light than the main illumination.

The two charts below indicate the guide numbers you will need to achieve this ratio with various film speeds and at different subject distances. Both tables are based on correct daylight exposure without flash. The upper table is for direct sunlight; the lower one for open shade conditions in which there are still distinct shadows.

To compensate for the light added by the flash, you should stop your lens down by about an additional half *f*-stop.

Both tables are based on a shutter speed of 1/125 second. For a shutter speed of 1/60 second, multiply each guide number by 1.4.

It is, of course, understood that you won't want to use a flash of different power for each shooting situation. The charts are intended to help you choose one flash unit that will be ideal for a *specific* set of circumstances. For example, if you *normally* use an ISO 64/19° film, and shoot outdoor portraits at six feet, you'd be best off with a flash having a guide number of about 48.

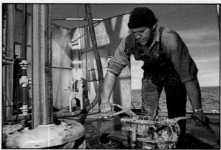

Top photo was lit by direct sunlight only. There are deep shadows, lacking all detail. Lower picture was taken in the same conditions, but a fill flash was added. Even the deepest shadows have detail. Fill flash is discussed in Chapter 7. Photos by Bill Gillette, Stock Boston, Inc.

## GUIDE NUMBERS (in feet) FOR FILL FLASH IN SUNLIGHT

| Film Speed ISO | Flash-To-Subject Distance | | | |
| --- | --- | --- | --- | --- |
| | 6 feet | 9 feet | 12 feet | 16 feet |
| 32/16° | 33 | 50 | 66 | 88 |
| 64/19° | 48 | 72 | 94 | 112 |
| 125/22° | 66 | 99 | 132 | 176 |

## GUIDE NUMBERS (in feet) FOR FILL FLASH IN DIFFUSE DAYLIGHT

| Film Speed ISO | Flash-To-Subject Distance | | | |
| --- | --- | --- | --- | --- |
| | 6 feet | 9 feet | 12 feet | 16 feet |
| 32/16° | 17 | 25 | 34 | 44 |
| 64/19° | 24 | 36 | 48 | 64 |
| 125/22° | 34 | 50 | 68 | 88 |

Frost on this spider's web is lit effectively by an on-camera flash. You have to be observant to get pictures like this. The delicate frost usually doesn't last long after the sun comes out. Photo by Hans Pfletschinger, Peter Arnold, Inc.

To verify or determine a guide number, take a series of photographs of an average subject, at a known distance from the flash. Take each shot with a different aperture setting. Place a card indicating the lens aperture used for each photo within the picture area. When film is processed, select what you consider best exposure. In this series, best exposure was made at $f$-4. If subject was 8 feet from the flash, correct guide number is 8x4, or 32.

# Flash Accessories

Flash accessories, like camera accessories, can make your photography easier, better and more enjoyable. Because there are so many different items that can increase the usefulness of your basic flash equipment, I'll divide them into distinct categories.

## Optical Accessories

Anything that influences the light path can be regarded as an *optical accessory.* The most common accessories of this type are lenses that spread or concentrate the flash beam to match the field coverage of a particular camera lens.

If most of the light is confined to the area you're photographing, little will be wasted in lighting areas outside the picture area. This will make your illumination as efficient as possible. There are situations, however, in which you'll want to deliberately scatter the light beyond the picture area. There are attachments for doing that, too. I'll discuss both types.

### BEAM-CONTROL LENSES

A simple lens can spread or concentrate a beam of light, depending on how it's focused. One thing you want to avoid is focusing an

Beam-control lenses like these are included with many flash units.

The only place you usually need light from flash is within subject area you're photographing. When you use a lens with a narrow angle of view, it makes sense to narrow the angle of light accordingly. This way, no light is wasted. This Metz attachment narrows the light to cover the field of view of a 120mm lens on a 35mm camera. Because all the light from flash is concentrated in the smaller picture area, brightness of the light is about twice what it would be without the attachment. This means you have a higher guide number.

image of the flash tube itself on your subject. For example, you don't want to see your flash tube outlined in vivid detail on your subject's shirt. You want uniform illumination over the entire scene.

The thickness of an ordinary glass lens would add a lot of weight to your flash unit. This is conveniently avoided by the use of a *Fresnel* lens as a beam-control accessory. Fresnel lenses are thin and lightweight, but do the job of a heavy glass lens. They can widen or narrow the flash beam. Enough optical aberrations are left in them to prevent them from focusing an image of the flashtube.

Because they are molded from plastic, it is relatively simple to make lightweight Fresnel lenses in a variety of patterns and focal lengths to meet many needs. They are made to work with 35mm-camera lenses from less than 30mm to over 100mm focal length.

The grandfather of all beam-control lenses is the Televorsatz attachment made by Metz to fit their handle-mount flash units. By narrowing the light beam, it greatly increases the guide number. The narrowed beam will work with lenses of 105mm focal length or longer in the 35mm format. This corresponds to a lens angle of view smaller than 24°.

For the *widest* angle of coverage, a slightly different plastic lens is generally used. It has hundreds of tiny, four-sided pyramids molded into its surface. This type of lens diffuses and spreads the light, rather than focusing it like a Fresnel.

**When To Use Beam-Control Lenses**—As already mentioned, for maximum use of the light from a flash unit, you should adjust the flash-beam width to match that of the camera lens you are using. You can move the flash closer to your subject to reduce the area covered, or back away to cover a larger area. However, if you want to keep the flash on or near your camera, you'll need an accessory lens that will change the angle of the beam of light from the flash.

Even though you can use any flash as-is with telephoto lenses, you can gain a full exposure step, or more, by narrowing the beam with a lens on the flash unit. With a wide-angle camera lens, you'll have to spread out the light to get

corner-to-corner illumination on the subject.

To get correct exposure with beam-control lenses, the calculator dial on the flash unit must be adjusted accordingly. This adjustment is sometimes automatic as a beam-control lens is brought into position. In other units, the adjustment must be made manually.

For special effects, you can break the rules to get the result you want. For example, try using a narrow flash beam with a wide-angle lens on your camera. The outer edges of the photograph will be dark and you will get a harsh-looking spotlight effect. It may be just the effect you need.

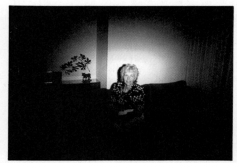

You can use a narrow-angle flash with a standard or wide-angle camera lens to deliberately create a spotlight effect.

If you do just the opposite—use a wide-angle flash with a telephoto lens—the main effect will simply be reduced light output. With less light, you can use a large lens aperture, which is often desirable if you want to have the background out of focus. In a light-colored room, the spread-out light beam will bounce off the walls and help fill the shadows with light, to create a softer lighting effect.

It is important to note here that you get to use a larger aperture only when you are using your flash on *manual*. In the automatic flash mode, the beam-adjusting lenses affect only the *maximum shooting distance.*

**Zoom Lenses**—Instead of using a different plastic lens for each beam angle, some flash units have built-in or accessory *zoom* lenses. One approach is to use two Fresnel

## FRESNEL-LENS DESIGN

REGULAR PLANO-CONVEX LENS

FRESNEL PLANO-CONVEX LENS

The Fresnel-lens principle makes it possible to design a powerful simple lens with minimal size and weight. Basically, a Fresnel lens is a compressed version of a regular lens. It is made up of concentric lens sections, each of which is a thin counterpart of a much thicker lens of the same focal length. At any specific point along its diameter, the Fresnel has the same curvature as a thick lens of the same focal length would have at that point. The sketches show this.

Fresnel lenses have many uses in photography, other than in flash equipment. Different designs are used for such diverse purposes as concentrating the light beam of a spotlight and providing uniform image illumination on the ground glass screen of a camera. Anywhere, in fact, where it is necessary to condense the size and weight of a simple lens without changing its desired function.

lenses to make the zoom. One of the lenses is mounted so it slides back and forth to any of three different positions on a track marked WIDE, NORMAL and TELE.

## DIFFUSERS

Diffusers soften the illumination. They do this by scattering the light by either transmitting it through or reflecting it from a suitable material. Light is also softened when the source is large in relationship to its distance from the subject being photographed.

A familiar soft light source is an overcast sky. The difference between it and direct sunlight is that the overcast sky is a very large source of illumination. It's all around you, not in one spot like the sun on a clear day. When light comes from a large source, the rays come from many directions. Some of these rays fill in shadow areas, making them brighter. This makes lighting contrast low and leads to good shadow detail in the photos.

Soft light isn't always desirable. It can be misused or used with the wrong subject, robbing it of neces-

A small diffuser attachment like this can increase the size of the light source somewhat and reduce the harshness of shadows. However, it's too small to soften the illumination significantly.

sary shadows that may improve the composition.

**Small Diffusers**—You can get a small amount of softening by attaching a small diffuser in front of your flash. The diffuser can be a milky or frosted panel or dome that scatters the light. A small diffuser does not *significantly* in-

Flash is ideal for capturing on film the spontaneous activities of children. You needn't ask them to pose or cooperate in any way. Just watch them and press the shutter button at the right moment. Photo by Erika Stone, Peter Arnold, Inc.

crease the apparent size of the light source. Therefore, it can provide only a limited softening effect.

Small diffusers are most effective when used close to your subject or in a small enclosed area where some of the scattered rays can bounce back from the surroundings to your subject. If you move your diffuser-equipped flash farther from your subject, it becomes a small and relatively contrasty source once again. Putting a diffuser of any kind on a flash reduces the light output due to the light absorbed and scattered by the diffuser. In a large room, the scattered rays from the diffuser become too weak by the time they bounce back to your subject to have any noticeable effect on your film.

A side benefit of a small diffuser is that it can make your model more comfortable by reducing the glare of the flash. The difference is much like that between bare and frosted light bulbs. Small diffusers are supplied by flash manufacturers and independent accessory companies. Or, they can be homemade.

A white handkerchief will serve adequately as a small diffuser. It may not look as impressive as a commercially made diffuser, but it works.

**Large Diffusers**—Large diffusers *significantly* increase the size of the light source. They also cause a reduction in the guide number, as you would expect.

One interesting large diffuser is the Air Diffuser from Altrex/New Ideas, Inc. It resembles a translucent 11-inch diameter beach ball. You inflate it the same way. The Air Diffuser attaches to just about any flash with a pair of elastic straps. It is constructed of frosted vinyl plastic that scatters the light from the flash efficiently. Deflated, it folds up and you can tuck it away in a pocket or in your camera bag.

The diffuser's large size will block the auto-exposure sensor on your flash. Unless the flash has a remote sensor, you'll have to switch your flash to manual operation and meter or calculate lens aperture manually. The Air Diffuser reduces guide numbers by only about half an exposure step.

Some types of diffusers are really large—up to several feet across. Such accessories are often more suited for studio use, even though some can be collapsed and easily carried about. Their use is covered in Chapter 9.

**When To Use Large Diffusers**—Large diffusers are useful whenever you need soft illumination. When positioned close to your subject, a large diffuser can subdue texture and give soft gradation around an object. Women are especially suitable subjects for soft, diffused lighting. You can position a light with a large diffuser as close as three or four feet from your subject's face. Position it off to one side of the face and place a white cardboard reflector on the opposite side. *Spill light*—light that comes from the flash but misses your subject—will strike the reflector and bounce back to lighten the shadow side of your model's face. This provides very soft illumination that is almost shadow-free.

A large diffuser is also handy for lighting small products or objects with one light. Dark shadows can make an object look confusing in a picture. The shadows may obscure important detail. Adding extra lights to solve this problem complicates your setup, can create unattractive multiple shadows, and takes more time. One diffused flash and possibly a reflector are frequently adequate.

Diffusers can also make your flash into an excellent *fill light* for controlling shadow density in multiple-light setups. I'll discuss this later.

The softness of the light given through a diffuser is affected by the distance between the flash and the diffuser. If the flash is very close to the diffuser, it won't light the entire diffuser surface. In effect, you'll have a relatively small light source and, consequently, relatively more contrasty light. This isn't necessarily bad—it gives you one more lighting control. You get maximum softness when the flash illuminates the entire diffuser.

## BOUNCE REFLECTORS

Bounce reflectors that attach to your flash unit come in many

You can control the softness of the light by the size and distance of your light source. For the photo at left, direct flash was used. For the center photo, a relatively small diffuser was used over the flash. Note the softer shadow outline. The right photo was made using a large umbrella flash. The picture is almost shadowless.

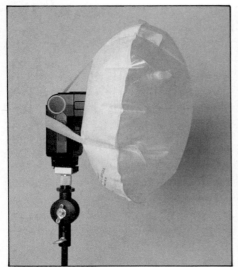

Air-Diffuser increases effective size of light source. It yields softer illumination than is possible with a smaller diffuser.

Larson Soff Shoulder is a portable umbrella reflector, mounted on a special flash bracket.

Bounce panel, attached to flash unit, is useful light softener. As long as you use same card, at same distance from the flash and same angle to it, diffused light coming from the card will be constant. Standardizing in this way can make your exposure calculations easier.

These two photos were taken in the same location. The light came from one source, from the same direction. The upper photo was made using undiffused flash. For the lower photo, a portable umbrella reflector was used.

styles. They all do much the same thing—spread the light from the flash.

Many reflectors increase the apparent size of the light as well, giving a softer light. Like diffusers, bounce reflectors are made by both flash and accessory manufacturers.

Bounce reflectors usually produce softer light than the smaller diffusers. Once again, the amount of softness depends on the size of the reflector and the flash-to-subject distance. Many reflectors are flat, white panels that attach to your flash.

Depending on the type of the reflector, you may have to point the flash head upward or to the rear so the reflected light is directed toward the subject. If your flash doesn't have a tiltable head, you can fashion a "scoop" from aluminum foil to direct the flash light toward the reflector. Leave the auto-exposure sensor pointed forward.

In addition to flat bounce reflectors, you can get several other types of reflectors. Altrex/New Ideas' Air-Brella, like the Air-Diffuser described earlier, is an 11-inch inflatable bag. The Air-Brella attaches to your flash with a pair of elastic straps. You have to allow 2 to 2-1/2 steps more exposure when using this accessory to make up for the light loss due to beam spread and absorption.

Ewa's Flash Converter is another inflatable bounce reflector. This pie-shaped accessory comes with various interchangeable parts enabling you to use the reflector with fixed-head flash units or those with movable heads. The interchangeable parts have openings that let you control the degree of softness of the light.

**When To Use Bounce Reflectors**—Bounced flash is a very soft, low-contrast light because the large and diffuse bounce surface becomes the effective light source. The bounce surface is larger than the window of the flash.

Whether you use a bounce attachment or bounce the flash light from a wall or ceiling, the lighting effect is similar to that of an overcast sky. And, the larger the bounce surface, the softer the lighting will be.

Beware of misusing bounce flash. If you get too close to your subject while bouncing the light from the ceiling, the light will come from almost directly overhead. This can cause dark, dead-looking eye-sockets in a portrait. You can avoid this problem by using a portable bounce attachment.

Some flashes have attachments or adjustments that enable you to direct a portion of direct flash at your subject. A bit of direct flash will put sparkle in your model's eyes and add highlights to lips.

The amount you have to change the flash guide number varies with

the reflector design. An adjustment of two steps is typical, though. I'll discuss bounce-exposure calculations in the next chapter.

**Portable Umbrella Reflectors—**
Umbrella reflectors began their photographic career as large studio equipment. Many are now available in smaller sizes, such as 36-inch diameter. Even these relatively small umbrellas require a light stand for their convenient use.

More recently, manufacturers such as Vivitar and Larson have offered even smaller and truly portable umbrella reflectors, designed to work with portable flash units. They produce soft bounce-lighting effects similar to those given by other bounce reflectors. They have other advantages, too. Umbrellas are easy to carry because they fold up for storage when you're not using them. In addition, they are often less wasteful of light than other bounce-lighting methods.

## COLOR FILTERS

Electronic flash produces light with a color temperature of about 6000K. This is nearly the same as average daylight, making it ideal for use with both b&w and color film. Sometimes, however, you may need to change the color of the light. It's easy to do by placing a color filter in front of the flash tube.

Filters are available in many colors and types. There are color-conversion and light-balancing fil-

For special effects, you can use filters to change the color of the flash lighting.

---

# FILTERS

**Color filters** basically pass light of their own color and block other colors. Here are some examples:

| FILTER COLOR | TRANSMITS | ABSORBS |
|---|---|---|
| Red | Red | Blue & Green (Cyan) |
| Blue | Blue | Red & Green (Yellow) |
| Green | Green | Red & Blue (Magenta) |
| Cyan | Blue & Green (Cyan) | Red |
| Yellow | Red & Green (Yellow) | Blue |
| Magenta | Red & Blue (Magenta) | Green |

Generally, the use of a color filter calls for an increase in exposure. With photographic filters, this increase is indicated by a filter factor. Increase exposure in the following way:

| FILTER FACTOR | OPEN LENS APERTURE: | THIS IS SAME AS DIVIDING GN BY: |
|---|---|---|
| 2 | 1 f-stop | 1.4 |
| 4 | 2 f-stops | 2 |
| 8 | 3 f-stops | 2.8 |
| 16 | 4 f-stops | 4 |
| 32 | 5 f-stops | 5.6 |

Example: If you put a red filter with a filter factor of 8 on your flash and your usual GN is 100, your new GN = 100/2.8 or 36.

**Neutral-density filters** have no color, only a neutral gray density. They are given density numbers instead of filter factors. This is how density values work:

| DENSITY | FILTER FACTOR | EXPOSURE REDUCED BY |
|---|---|---|
| 0.3 | 2 | 1 f-stop |
| 0.6 | 4 | 2 f-stops |
| 0.9 | 8 | 3 f-stops |
| 1.2 | 16 | 4 f-stops |
| 1.5 | 32 | 5 f-stops |

---

ters for use with color films. Deep red, green, blue and yellow filters can be used for contrast control on b&w film.

Plastic flash filters are sold in sets or included with some flash units as standard equipment. You can also use old color-printing filters. For creating special effects, colored acetate or theatrical gels do a good job. Suitable materials can be found at art-supply shops or theatrical suppliers. There is no need for perfect optical quality for a flash filter. All you want to do is absorb some color of light. Sometimes, colored filters are packaged along with other flash accessories as a complete kit.

You can use flash filters to accomplish much the same thing that regular camera filters do, but at less cost. You can also do some lighting tricks that you can't do with just one filter on the lens.

For example, when you're using flash in daylight, the appropriate use of filters on the flash, the camera lens, or both, can create a variety of color effects.

Like filters for your camera, a flash filter changes the color of light passing through it by selectively transmitting the color of the filter and absorbing other colors. A typical example: A green filter absorbs red and blue light while passing green light relatively unhindered. Because little or no red light passes through a green filter, none of the transmitted light reflects from a red subject. A red subject photographed in green light will look black or very dark.

By using several flashes at once, each with a different colored filter attached, you can create exciting lighting effects.

You can simulate fire with a red or orange flash concealed in an

Sync cords are available in various forms—coiled or straight, thick or thin, short or long.

When you connect two sync cords, knot them loosely, like this. If a little tension is then accidentally applied to the cords, they won't easily pull apart.

The upper adapter lets you connect a flash with a PC cord to a hot-shoe camera. The lower adapter allows you to connect a hot-shoe flash to a PC cord.

unlit campfire. A blue-colored flash can give the impression of coldness.

When you are shooting b&w film, colored flash can help you balance or accentuate tonal values in the photographs. Subjects of the same or similar color as the filter used will reproduce lighter in the photograph. Complementary or opposite colors will photograph darker. If you photograph a woman's face with orange or red light, her skin tone will lighten and blemishes will tend to be subdued. A green light will add robustness to a rugged man's portrait by darkening the skin tone.

You can also use colored light to subdue or eliminate stains on aged documents or photographs you want to copy. Simply use a filter of the same or a similar color as the stain.

The amount of exposure correction you need with regular photographic filters is indicated by filter factors. Non-photographic filters and gels don't have specified filter factors, so exposure correction must be determined by experimentation. The effect of a particular filter will depend on the colors in the subject and the deepness of the filter's color. With any moderately dense filter, try about two to four steps extra exposure as a starting point. To be sure of getting one correctly exposed photograph, it's worthwhile using a little extra film and bracketing exposures.

## OTHER OPTICAL ACCESSORIES

In addition to filters in color, you can also get filters in various densities of neutral gray. The only effect these filters have on flash output is to *reduce* the light. This can be handy when you have to photograph something at close range and the flash guide number calls for a small aperture your lens doesn't have, such as perhaps *f*-45. These *neutral-density* (ND) filters are usually made for use on your camera lens, so they cost a bit more than flash filters.

Some flash-filter sets include ND filters. You can also use pieces of smoky gray plastic on the flash. They are available at some plastic supply houses. Ask to see small pieces in their cut-off bins. You can also retire a scratched camera filter to flash use, if it's large enough to cover the flash window.

Most other optical accessories are for use with studio flash units. One such accessory that also has limited use on portable units is a set of *barn doors.* Spiratone markets barn doors that fit some of their portable flash units.

Barn doors consist of hinged metal flaps that attach to the sides of a lighting unit. You can move them to block portions of the beam selectively to keep the light from falling where you don't want it. Barn doors and other such accessories are generally used in a studio. Their use is discussed in more detail in Chapter 9.

# Electrical Accessories

This section includes all the devices used to *trigger* electronic-flash units. They are particularly important whenever you need to operate your flash off-camera or use more than one flash at a time.

## SYNC CORDS

A sync cord is an electric cable containing two or more wires, or *conductors,* used to connect your flash to the camera or some other triggering device. It allows synchronization between shutter and flash. Sync cords come in many styles and lengths.

You have a choice of coil cords, which are springy retractable cords like those on telephones, and conventional straight cords. Coil cords are handy for short lengths—say, three feet or less. They stay neat by automatically taking up the slack instead of dangling in an uncontrolled manner.

With longer cords, or when you have to connect several together to reach a remote flash, straight cords are better. They'll lie flat on the floor and not tug at the connections, which sometimes causes them to come apart. Conventional

straight cords are also less expensive. Straight cords work fine when you are working with light stands. It's a simple matter to tuck the extra cord out of the way under the stand.

Most flash units come with a short sync cord. Some include a handy length of coil cord. The cord mates with a female PC or other type of connector on the flash. It usually has a male PC connector on the other end for attaching it to your camera.

Accessory cords are most often sold with PC connectors on both ends or with a PC connector on one end and a two-bladed socket or plug—similar to those you plug into a wall socket—on the other. Don't *ever* plug a sync cord into a wall outlet. There is no reason to do so. You could forget and connect the other end to your camera and seriously damage it.

For reasons unknown to me, there's some variation in fit between some makes of two-bladed plugs and the matching sockets on certain flash units. When you buy a new sync cord of this type, be sure to take the flash along to make certain they match.

Sync cords are also made to fit the connectors on press-camera and view-camera lenses. In some cases, you need a small adapter that fits a PC cord on one side and your camera on the other.

Sync extension cords also come with a male PC connector on one end and a female one on the other for adding length to your regular flash cord. These cords sometimes include a reel for storage, to keep the cord neat.

### SYNC-CORD ADAPTERS
Some flash units don't have a PC cord or are not equipped with a hot shoe. Some cameras only have one sync connector or the other. If you want to use a flash with a camera that doesn't have the right connector, you'll have to get an adapter that has the required connections.

One adapter fits hot-shoe flashes and has a PC cord to connect to your camera. Another has a PC connector and a mounting clip that you slip a non-electric flash shoe into.

### DEDICATED-FLASH CORDS
Dedicated-flash units require special sync cords if you want to use all of the dedicated features with off-camera flash. Some flash manufacturers make special sync cords to mate their dedicated-flash units to specific cameras. The cables have three or four wires to carry the signals between flash and camera.

Altrex/New Ideas, Inc. offers a line of dedicated sync cords for the most popular dedicated-flash/camera systems. The cords are constructed so you can operate two or more flash units at the same time by stacking additional cords on two-sided shoe connectors. Some flash manufacturers offer special Y-cords to accomplish the same thing. Use the cords as specified by their manufacturers.

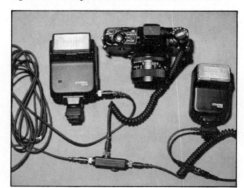

Some dedicated-flash/camera systems have their own special sync cords for operating several flashes at once.

### Y-PLUGS
Y-Plugs are small connectors that permit you to connect several PC cords together so you can trip more than one flash from your camera at the same time. They work, but there are some limitations you must observe.

First of all, each flash you add to the Y-plug adds to the energy your camera's sync contacts have to carry. They can take only so much load and every added flash subtracts from their expected life.

You must realize that there is a lot of difference between the trigger circuits of different makes of flash units. You can't indiscriminately hook two of them together on a Y-plug and expect them to work. Unless they are of the same make and, preferably, the same model, there's a good chance that they won't operate when connected together. If there is any doubt, have a repairman check your units for compatibility. It's a simple test that will take only a moment.

## Photoelectric Slave Triggers
Another way you can fire several flash units at once is to use *photoelectric slave triggers,* also known as *slaves* or *remote flash triggers.* These handy devices avoid the use of electric cables between flash units. They let you use as many flash units as you want at one time.

Each slave contains one or more photocells. When the slave sees a burst of bright light, such as the light from an electronic flash, it closes a circuit that will trip any flash connected to it.

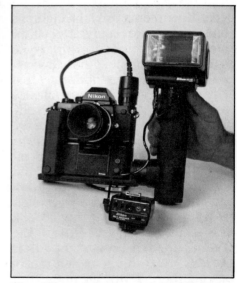

The Nikon infrared remote-triggering unit connected to this flash and camera has two coded channels. It's nearly impossible for unwanted flashes to trigger this slave unit.

Photoelectric slaves like these enable you to eliminate long and potentially troublesome connecting cords between your flash units and the camera.

## HOW TO USE A SLAVE

One way to use a slave is to put a small flash on your camera and place your main flashes—each equipped with a slave—where you want them. For best results, the photocells should point approximately toward the camera position. This will make the triggers as sensitive as possible to the small flash. When you fire the small flash at the camera, all the slaved flashes should go off. The small flash doesn't *have* to be mounted on your camera, but it *must* be synchronized with the camera's shutter. You could also use a larger flash to set off the others if you want more light coming from the camera position.

If you don't want any light to come from the camera position and you don't want to run a sync cord to one of the other flashes, you have another option. Most slave-trigger photocells are nearly as sensitive to invisible, near-infrared wavelengths as they are to visible light. Because most films have little response to infrared radiation, you can put an infrared *passing* filter over the master flash and only the slave units will be affected by its energy. A Kodak Wratten 87 filter or one of the several plastic infrared filters stocked by Edmund Scientific in Barrington, NJ will do fine. Your slaves won't work quite as far away from the master flash as before, but they shouldn't lose much range.

Flash in far room was set off with slave unit. However, slave sensor was attached to 20-foot extension cord and placed in same room as camera-connected flash. This was necessary, because the four-layer sound-proof window transmitted only about 25% of the light, and also because the window was relatively small. Accurate slave triggering through window would have been difficult or impossible. Diagram shows setup. Although the photographer could have attached cord directly to camera, he chose to use slave because it enabled him to move about the room freely without having to look out for camera-connected wires. Photo by Alan Magayne-Roshak, courtesy University of Wisconsin, Milwaukee.

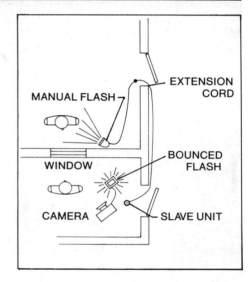

## SLAVE SENSITIVITY

The maximum distance between the camera's triggered flash and a slave depends in part on the make and model of slave. It also depends on the power of the "master" flash and the reflectivity of the surroundings. Generally, typical slaves should be usable at a distance in feet equal to the guide number of the flash for ISO 25/15° film. Once again, this is only a typical response. Different units will have different sensitivities. When in doubt, test the setup by using open flash before exposing film.

Several brands of slave triggers feature sensitivity adjustments to compensate for the effect of ambient light. They are also available with a variety of different sync terminals. You can get slaves with PC, household or hot-shoe terminals. Some slaves have two different terminals to increase their versatility.

## POSSIBLE PROBLEMS WITH SLAVES

The worst problem with photoelectric slaves is that they can be set off by *anyone's* flash. If you are taking photographs at an event where there are other flash photographers, their flashes will be setting off your units and running down your batteries.

This setup required separate placement and balancing of several lights. This is difficult to do with flash because you can't see the effect you're creating. If you're not used to working with artificial light, I advise you to start by practicing with tungsten lamps or use flash with modeling lights, so you can see the effects your lights have. Multiple-lamp setups are discussed later. Photo by J. Stummeier, courtesy of Ferderbar Studios, Milwaukee.

To produce the large highlight areas on the lobster, a large-area diffused light source was located over the lobster. A small light source would have generated small spot reflections, or catchlights. Photo courtesy of Ferderbar Studios, Milwaukee.

Some slaves have adjustable shades so you can aim them at only your camera position. This won't help much if you have someone shooting over your shoulder. Your only consolation is that his shots will probably all be overexposed by your slave-activated flash units.

### OTHER PHOTOELECTRIC SLAVES

Some flash units have built-in slave triggers that you can turn on or off as needed. Others are strictly slave flashes and have no sync cables or terminals. A third kind of slave, more recently introduced, is the *coded* photoelectric slave.

A coded slave is *tuned* to fire *only* when it sees the light from a *particular* electronic flash. Usually—but not always—the master flash is a very low-powered unit fitted with an infrared filter. It has a special circuit that flashes the flash tube *twice* in very quick succession each time it is triggered.

Each slave unit has a clock circuit that starts timing when the slave sees the first flash. The clock disables the photocell for a moment—from 1/3 to 1 millisecond (thousandth of a second). At the end of this period, the clock reactivates the photocell for an instant so it can look for another flash. If the slave sees a second flash immediately, it triggers. If it doesn't see one soon enough, the clock resets itself and waits for another pair of flashes.

The beauty of coded slaves is that it is almost impossible for other flashes to set them off. If two flashes do happen to go off at the right interval, the slave will fire, but there is little likelihood of this happening. Also, the flash from a full-powered unit may even be too long in duration to properly trigger a coded slave's circuitry.

Slaves of this type usually have two channels. A switch on the infrared master allows you to select channel one or channel two. Each

This radio-controlled transmitter is a triggering unit for a receiver mounted on a remote flash.

slave is equipped with a similar switch. You can set up each slave for a different channel and fire them alternately or you can set both unit switches for the same channel and use them simultaneously.

### RADIO-CONTROLLED SLAVE TRIGGERS

There are several types of radio-controlled slave triggers to choose from. You can code each master/slave pair individually to prevent interference from other photographers using similar equipment. Of course, you can also get additional slaves, all tuned to work with the same master unit. Some radio slaves, sometimes called *radio-frequency* or *RF* slaves, can be connected to your camera so it can be tripped remotely as well. These units are handy for surveillance and wildlife photographers. RF triggers can work from as far away as 150 to 500 feet from the master.

## Sound Triggers

Sound triggers are for firing a flash at the same time a sound-producing event takes place. They're *not* for firing several flashes in unison with a master flash. For example, with the short duration of a thyristor flash you can photograph a bursting balloon or a breaking light bulb.

To get the maximum motion-stopping speed from your thyristor flash, it should be set for automatic or variable-power operation.

If you are using your flash in the automatic mode, place it at the closest possible distance from your subject. This will produce the shortest flash duration and the sharpest image of the moving subject. When feasible, you should set the variable-power control for 1/64 power and figure your exposure using the reduced guide number.

If you have only limited use for a sound trigger and don't want to invest in one, you can rig a workable substitute yourself. All you need is a cassette recorder or other audio amplifier and microphone and a few other small parts. See the accompanying box.

A sound trigger gives you reasonably *predictable* control over *when* your flash will fire during the sound-producing event. Take a series of photographs of similar events such as bursting balloons. Delay the flash more for each shot. You will have a sequence showing how the bursting process works.

Sound travels at about 1000 feet per second in air. You can use that fact to delay the firing of your flash by about 1/1000 of a second for every foot the microphone is moved away from the event.

You can check to see if the microphone is set to give the delay you want—following the above guideline—without wasting any film. With the balloon experiment, darken the room and pop a balloon with a pin or knife. When the flash goes off, you should *see* what the bursting balloon looks like. Your eyes will store the image long enough for you to decide if it's good enough to photograph.

Get another balloon ready, set the camera on B or T and open the shutter in the darkened room. Pop the balloon and you have the photograph. Close the camera shutter before turning on any room lights.

Speeding bullets are beyond the

The first and last picture in this series were exposed in the conventional way. The center exposure was made with a sound trigger, just as the bubble burst. Photo by Roz Gazo.

## HOW TO MAKE YOUR OWN SOUND TRIGGER

Connect a cassette or tape recorder to a silicon-controlled rectifier (SCR) in the way shown. Attach a microphone to the recorder and set it to RECORD. No tape is needed except in a cassette recorder, where the cassette serves to release the record lock. Place the microphone near the sound-emitting action you want to photograph. Set your flash to 1/64 power and adjust the RECORD VOLUME to a level that will set off the flash when the sound is made.

You can test the volume setting by making an appropriate sound—such as snapping your fingers—and seeing if the flash goes off. It's important not to set the volume too high, so the flash is not set off unintentionally by another sound. Automatic level-control recorders are too sensitive to use for this purpose. Darken the room, open your camera shutter on B and wait for the sound to trigger your flash and expose the film.

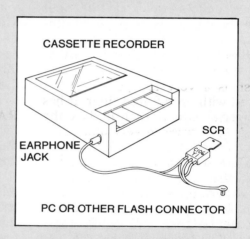

CASSETTE RECORDER

EARPHONE JACK

SCR

PC OR OTHER FLASH CONNECTOR

In this unusual photograph, the dewdrops act as small lenses, depicting sharp images of the flowers situated behind them. It was important to light the flowers in the background separately and to take care not to cause too much glare on the drops themselves. Photo by Hans Pfletschinger, Peter Arnold, Inc.

To take this sequence during a game of jacks, a motor drive was used, together with fast-recycling flash. This enabled the four consecutive exposures to be made in about one second. See the accompanying text for special precautions recommended for this kind of flash photography. Photos by Maron Meeks.

motion-stopping ability of the conventional flash unit. Because many bullets travel at 1000 feet per second, or faster, a special sub-microsecond flash (less than one millionth of a second) is needed for satisfactory results.

## Autowinders, Motor Drives and Flash

Many cameras can be used with automatic film winders or motor drives. An autowinder enables you to take photographs in quicker succession than you could while manually advancing the film. It gives you one less job to do, leaving you more free to concentrate on picture taking.

Winders and their even faster cousins, motor drives, are particularly useful for photographing sports and action. A motor drive will help you capture an entire photographic action sequence.

When you want to use flash with an autowinder or motor drive, you must take some precautions. First, the flash must recycle fast enough to make effective use of the mechanical automation. Second, you must make sure that the type of flash you are using will not be damaged by the heat buildup caused by fast, repetitive firing. Be sure to carefully read the instructions provided with your flash unit.

To fully exploit the advantages of a rapid-fire autowinder, you'll need a thyristor-controlled automatic flash unit—preferably one with a manual motor-drive setting. The best camera to use is one that has a viewfinder ready light. Using this, you can check whether your flash is sufficiently recycled for continued shooting.

A motor-drive setting on a thyristor flash gives 1/8 to 1/16 the power of the manual flash setting. You can generally make 5 to 10 rapid-sequence exposures on this setting before exhausting the charge in the flash unit's main capacitor. Some units will give fewer shots; others will flash almost continuously. To get the most shots in the shortest time, use a rechargeable battery or a high-voltage dry battery to power the flash.

## Electronic Flash System Accessories

A system camera—one that has many accessories made specifically to work with it—is more versatile than a camera that has few, if any, custom accessories. The same is true of electronic flash. Several flash manufacturers offer almost as many flash accessories as there are accessories for some system cameras. Some accessories are available from flash manufacturers only; others are available from accessory manufacturers.

Accessories for flash *systems* are made for use on a *specific* manufacturer's flash units. Sometimes the accessories will work with several models from one manufacturer. Other accessories will work with only one flash model.

Some of the less complicated accessories can be adapted by a repairman to fit other makes of flash. But the choice of adaptable accessories is limited.

### REMOTE SENSORS

Remote sensors are the most useful system-flash accessories. They control your automatic-exposure flash in the same way the built-in sensor does. A remote sensor is handy because it can be aimed independently of the way you point the flash. It gives you the extra freedom of movement

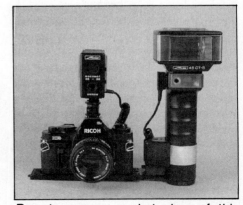

Remote sensor on hot shoe of this camera allows you to aim flash in any direction while the sensor always points at subject along with your camera.

you don't have when the sensor is in the flash unit. With a remote sensor, you can take the flash off the camera and aim it in just about any direction. This enables you to use bounce lighting or diffusing accessories and still have automatic-exposure control. The sensor, when attached to your camera, remains aimed at your subject.

With some flashes, you don't actually buy a remote sensor. You get an extension cable into which the flash unit's regular sensor fits. The other end of the cable plugs into the flash. Other flashes, which have non-removable sensors, use a fiber-optic *light pipe*. One end of the light pipe clips on over the sensor. The other end of the pipe can be snaked around to aim where you want it.

Some remote sensors offer such expanded capabilities as extra aperture ranges and adjustable sensor-beam width.

Each of the remote sensors in the following discussion works differently and has different applications.

**Fiber-Optics Probe—**This is the simplest and smallest type of remote sensor. As previously

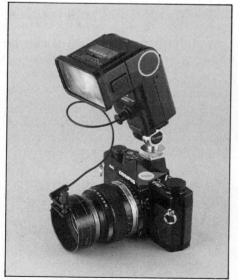

This Vivitar remote fiber-optic sensor is attached to the lens hood. In that location, it is particularly useful for close-up photography because it is easy to aim accurately at a close-up object. The sensor is not usable at distances greater than about eight feet.

mentioned, it is a fiber-optic light pipe. One end snaps over the flash unit's regular sensor. The pick-up end, which is quite small, clips onto the rim of your lens or lens shade. You should handle fiber-optic probes carefully.

This type of accessory is intended primarily for accurate control of close-up lighting.

Before attaching the probe to your lens, check and see if the front of the lens rotates as you focus. If it does, roughly focus on your subject before attaching the probe. If you mount the probe first, you may turn the lens too far while focusing and take up all the slack in the cord. This could damage the fibers.

The Vivitar MFS-1 remote sensor, which works with several flash models, is a fiber-optic probe. To get an accurate exposure, close the lens down four *f*-stops from the number called for by the flash calculator dial. For example, if the flash calls for an aperture setting of *f*-4, set your lens to *f*-16.

The MFS-1 is only a few inches long, so you can't expect to hold your flash up at arm's length and still have the probe reach your camera. This attachment was intended only for close-up application. The farthest you can use it from your subject is eight feet.

**Removable Sensor—**With some flash units, you don't have to buy a new sensor to have a general-purpose flash with remote-sensing capability. Instead, you can buy a special extension cable that plugs into the sensor's jack on your flash unit. You plug the regular flash sensor into the other end of the cable. Because you are working with the same sensor you usually use, there should be no change in flash operating characteristics.

You can use this kind of remote sensor with your flash for all kinds of general photography. The extension cable is long enough to reach from your camera to any reasonable flash position. A maximum of four to eight feet is typical.

You will be able to use bounce lighting, an umbrella reflector, and make close-ups.

**Expanded-Capability Sensor—**This last category includes remote sensors that actually *replace* the one built into your flash. For the most part, they are larger than the other types of remote sensors. They have their own aperture-range selectors, calculator dials and other controls, such as built-in manual-power-ratio dials.

The sensor's controls take over the flash adjustments when you plug the cable into the flash. Usually, the remote sensor's controls will give you more aperture ranges to choose from. Often, the sensor will give you a wider range of flash-to-subject distances to work with.

Several remote sensors—most notably those from Vivitar and Metz—feature photocells with adjustable angles of view. They are useful when you use your flash with a telephoto lens on the camera. You can get more accurate automatic-exposure control by matching the sensor's field of view to that of your camera's lens. A narrower angle helps prevent the sensor from being influenced by light reflected from things you're not photographing.

You have to be most careful with narrow-angle flashes and sensors. Their fields of view *must* coincide, otherwise you can't expect to get reliable exposure control. Some remote sensors, such as the Metz unit, feature a thumbscrew adjustment for aiming the photocell. This unit also has a set of folding peep sights to help you aim it accurately.

Here's a good way to line up your camera, flash and remote sensor so they all overlap: Aim the camera at a subject about 20 feet away. The subject should be centered in the viewfinder. Using the open-flash button, fire the flash. If the light isn't centered on the subject, make the necessary adjustments to the flash. Finally, adjust the sensor so it aims at the same

point. One way to check the alignment is to have someone stand about 20 feet away from you—if that's the distance you're using—and look to see if the sensor is pointing at him when you have the camera aimed at him. It's not easy to line up a sensor perfectly this way, but it doesn't have to be aligned perfectly to work.

These sensors are only usable with their manufacturer's top-of-the-line handle-mount flash units. They are, of course, more expensive than other types of sensors but offer you more versatility. If you take the time to practice with them, they can be very useful tools.

## BATTERY PACKS

Battery packs are used for carrying a large set of batteries around without adding excessive weight to the flash unit. Larger sets of batteries will give you more flashes per set and, in some cases, shorter recycle times. Battery packs come with a shoulder strap, belt clip or both for easy carrying off-camera. Some packs use different batteries than your flash normally uses. Others use the same kind but more of them to give you more flashes. A cable connects the battery pack to your flash.

Battery packs are one accessory that you can often have modified inexpensively to fit other flash units. Leedal, Inc. makes rechargeable battery packs for their flash units. They will also modify packs and adapters to fit certain other makes of flash. Or, you can have a dependable repairman do the job.

Strictly speaking, the Leedal rechargeable packs are more than just a set of batteries. The packs also contain a transformer and other parts to boost the output up to several hundred volts. They are powered by gelled lead-acid batteries and have a capacity of from 125 to 750 exposures—at a 100 watt-second charge—depending on the model. There are three sizes to choose from.

High-voltage dry battery packs *can* be adapted to work with other flash units if all you need is a different connector. There are, however, different types of high-voltage packs. Interchangeability is not economically feasible unless the one you want to use is similar to the one made for your flash.

## BATTERY CLIPS

These inexpensive gadgets are supplied with some flash units. They hold four AA cells. If you

Battery clips like this are handy for quick and easy battery changes. Some battery clips have permanently installed, rechargeable nickel-cadmium batteries.

frequently have to replace your flash batteries in the middle of a shooting session, an extra clip, already loaded with fresh batteries, can speed things up.

## RECHARGEABLE MODULES

Many flash units that use alkaline batteries will also accept rechargeable nicad batteries. Manufacturers often offer preassembled sets, or modules, of rechargeable batteries. Because nickel-cadmium batteries give you fewer flashes per charge than you'd get from a set of alkaline batteries, you may want to have at least one spare module on hand if you do a lot of shooting in a short time.

The main difference between

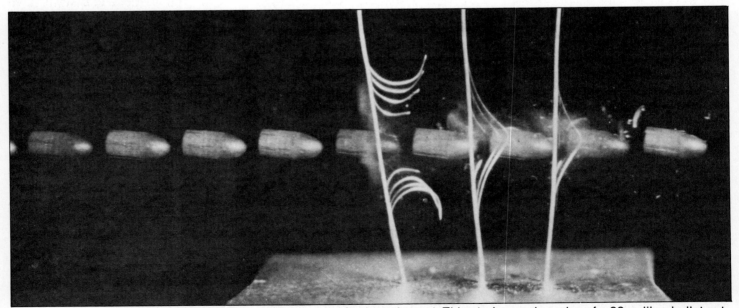

To stop a bullet in flight, you need special ultrahigh-speed flash equipment. This stroboscopic series of a 22-caliber bullet cutting three wires was taken by David B. Eisendrath, Jr. Notice that the successive flashes show not only the progression of the bullet, but also the motion of the broken wires—especially the first one.

different types of battery modules is the time it takes to recharge them. The most common rate is 12 to 14 hours, or overnight. You can also get fast-charge modules that charge in three hours, one hour or as short a time as 15 minutes, depending on the charger design.

Regular slow-charge nicad batteries will *not* work properly in fast chargers. They will be damaged if you try to charge them too fast. Fast-charge batteries are designed to heat up suddenly when they reach full charge. The special charger senses the temperature rise and shuts down when the batteries are charged.

If you want to use batteries with a particular charging rate, say 15 minutes, be sure to buy a flash that offers this choice. Some battery modules are shaped so they won't fit other makes of flash.

The two black plug-in units are battery chargers. Some batteries are designed for a slow charge of several hours; others can be charged in a much shorter time. There are slow chargers and fast chargers. It's important to use the right one for the batteries you are using.

## AC ADAPTERS

If you do a lot of flash photography at a studio or other indoor location, you can save money on batteries by using an AC adapter. It allows you to plug your flash into a wall receptacle.

There is a lot of difference between the various makes and models of AC adapters. Many are no more than a cord with a plug on each end. Others have a transformer built into the wall plug or somewhere along the cord.

You can get AC adapters for 115- or 220-volt operation. Some adapters have a switch that enables you to use the same model for either 115 or 220 volts. Some adapters also function as a charger for the built-in flash batteries.

Many AC adapters give you a shorter recycle time than you get with batteries. Still others have a much longer recycle time. All adapters are *not* created equal, so take time to read about the features before buying one.

Another use for an AC adapter is for *reforming* your flash unit's main capacitor after the flash has been unused for some time. This was described in the previous chapter. The adapter will do the job more economically than battery power.

### VARIABLE-POWER MODULES

If you want direct, manual control of the light output or duration of your flash, you should have a *variable-power module*. Some flash units have this feature built in. With others, you need a separate accessory.

Basically, a variable-power module is a variable resistor that is connected in place of the automatic-exposure photocell on your thyristor flash. A dial on the module lets you select the amount of light output you want. This is done by controlling the duration of the flash just as it's done in automatic-exposure operation.

The dial is marked in power ratios—1/2, 1/4, 1/8 and so on. Adjacent settings represent one exposure step. The flash duration decreases as you select lower-power settings. The actual flash duration is usually specified at only full- and minimum-power settings.

Modules are useful when you need the maximum possible motion-stopping ability and are willing to use a large lens aperture to get it. They are also handy when you want to do some rapid-fire flash shooting with a motor drive or autowinder. The more

you reduce the power, the quicker and more often you can fire the flash.

## Mechanical Accessories

Mechanical accessories add another kind of control to your lighting. They help you aim your flash units where you want them with minimal fuss. These accessories include all the things that hold, lift, tilt and otherwise physically control or restrain the flash.

### FLASH BRACKETS

A flash bracket is a device for mounting the flash on your camera so you can handle both as one unit. A bracket usually includes a convenient hand grip. Many grips have a hole through which you can lead a cable release. The release will operate like a gun trigger.

Although many cameras have a hot-shoe connector for attaching a flash, not all cameras do. Nor do all flash units have a hot shoe. A flash bracket enables you to connect your flash and camera physically. Use a PC cord to connect the flash and camera electrically.

Flash brackets do more. Even if both your camera and flash have hot-shoe connectors, a flash bracket can help you add variety to your lighting. It can give you a choice of flash positions. It enables you to place your flash farther away from the lens axis. An off-camera position almost always improves the appearance of your photographs and helps eliminate the "got'cha" look you often get in photos made with on-camera flash.

Some flash brackets are adjustable. They can swivel or telescope in and out. Others feature a quick-disconnect clamp so you can easily remove the flash and hold it in one hand for a different lighting effect.

**Macro Bracket**—When you move in really close to your subject—less than 18 inches or so—the usual flash position may not be right.

One electronic flash, held high above the camera, was used to capture the action of this gymnast. An attractive pose like this usually lasts for just a fraction of a second. To make good action photos, you must be alert. Photo from Focus on Sports, Inc.

Most indoor sports photographs are made with on-camera flash. However, if you have the cooperation of the organizers of an activity, you may be able to set up a more complex lighting arrangement. This is especially true for events in which the interesting action takes place in a known limited area. The high jump is a typical example. Photo from Focus on Sports, Inc.

The word *strobe* is commonly—but wrongly—used to mean electronic flash. The word really refers to rapidly repeating flash used to make picture sequences like this one. Stroboscopic light captures consecutive moments in an activity. If subject is moving across picture area, the sequence can be recorded on a static piece of film in a camera. However, if action takes place in one spot, it's necessary to find some way of transporting the film steadily across the film gate in the camera while the stroboscopic flash is firing. Photo by Andrew Davidhazy, courtesy of the Rochester Institute of Technology.

The light may not line up with your camera's point of view. The light may hit only the top of your subject or else look down on it from a steep angle, leaving the underside in shadow.

There are several brackets available that help solve the problem of close-up lighting. They enable you to mount two small flash units, one on each side of the lens. Usually, you can rotate the bracket so the light can come from each side or from above and below.

## LIGHT STANDS

Use light stands to hold your flash units exactly where you want them for off-camera use. Most stands have fold-up legs and several telescoping sections for compactness and ease of adjustment. Some stands are lightweight and easily portable. Others are much heavier. It's important that you select stands that are heavy enough to safely support your flash units. If the stands are too light, they're likely to tip easily and cause damage.

Folding light stands are sturdy, yet light enough for a child to handle.

Stands for background lights are useful for more than backgrounds. You can use them for general lighting in your home studio or for small setups. These Smith-Victor stands are inexpensive and sturdy.

Placing a ball-and-socket bracket or a swivelling bracket between your light and light stand provides good aiming capability.

You can also use tripods as light stands. If you have an extra tripod, it may work fine. It doesn't have to look like a light stand—the important thing is that it's sturdy enough.

**Ball-And-Socket Bracket**—Light stands are made to work with a wide variety of light sources. Because different lights or flash units are of different sizes and are mounted differently, light stands usually come without mounting fixtures. You have to supply the right mounting hardware to fit your flash. That's where ball-and-socket brackets come in.

They are adjustable swivels for mounting different accessories onto stands. Basically, they are small versions of tripod panheads. To fit a light stand, one end should have a light-stand socket and setscrew. The other end should have a shoe-mount clip or tripod screw to fit your flash. Other connectors are also available.

Ball-and-socket brackets are handy for close-up photography. You can use one on your camera's hot shoe to let you aim the flash downward to a nearby subject. Because there is no sync connection between the camera and flash when you put on a ball-and-socket bracket, you'll have to use a sync cord. A hot-shoe bracket is also handy for bounce lighting. If your flash doesn't tilt upward for bouncing light, a ball-and-socket will give you this capability.

Some brackets have an extra hole for attaching an umbrella reflector. However, most don't, so you'll have to specially look for this feature if you need it.

Because most flash-mounting accessories are made of metal, they can short circuit the hot-shoe contacts on your flash by bridging across them. When this happens, your flash will fire once and will not fire again until you correct the problem. On some flash units, the hot shoe is disconnected when you attach a sync cord. On others, the shoe stays "hot."

If the clip on the bracket has a hole in the center, it should clear the hot-shoe contact to let the flash work normally. If there is no hole, put a piece of sturdy electrical tape or other thin plastic material into the bracket's clip. The plastic will prevent the clip from shorting the hot shoe. Be sure to inspect and replace the tape periodically, because it will wear with time.

## Modeling Lights

The short duration of flash illumination does not give you an opportunity to evaluate the lighting effect on the subject. It takes some experience to be able to predict the results you'll get with a particular lighting setup. Modeling lights can be a great help.

Modeling lights are incandescent or tungsten-halogen lamps mounted above or near the flash tube. They give continuous illumination from the flash position, letting you adjust the flash for best effect. Because most modeling lights are AC-powered, about the only place you'll find them is on studio lighting units. I'll discuss how to use them in Chapter 9.

There are two portable flash units that do offer a modeling light. The Spiratone Spiralite SR is a combination AC- and battery-powered flash unit. It has an accessory modeling light that attaches to its accessory clip. The modeling light is AC-powered. This means, of course, that the flash is dependent on the AC supply when you want to use the modeling light.

Lumedyne makes a tungsten-halogen modeling light for their 200 and 400 watt-second portable flash units. Because the modeling light is powered by the flash unit's battery, using it reduces the number of flashes you can get per charge. However, with the largest battery they offer, you can run the modeling light for an *hour* and still get over 100 flashes at 100 watt-seconds of power. Needless to say, these are *large* portable flash units.

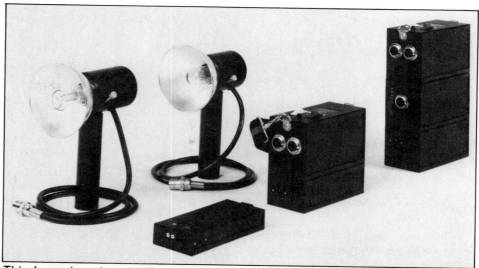

This Lumedyne is one of the few portable electronic flash units with modeling lights. Only large units like this have the battery power necessary to operate modeling lights.

The most suitable illumination for portraits of girls and young women is nearly always soft, diffused light. Photo by Ed Judice.

Since the days of flash powder, most flash photographs have been made with a single flash unit. Although most professional photographers own and use multiple-flash setups, they'll use a single flash if that's all the assignment requires.

Before you try multiple-flash techniques, you should be thoroughly familiar with the use of one flash unit. You can get adequate lighting in many situations with one flash and create many effects with it.

## Direct On-Camera Flash

This is the easiest and most basic way to use flash. You mount the flash unit on your camera's hot shoe or on a short flash bracket. If you're using a bracket, you'll need a sync cord to connect the flash to your camera electrically.

Direct flash involves pointing the flash source directly at the subject without reflecting the light from another surface. Direct flash from an on-camera position gives flat lighting with few shadows. It does little in the way of accentuating a subject's features or an object's texture and shape.

To accentuate features, light has to strike your subject obliquely, at an angle considerably removed from the camera viewpoint. This oblique lighting reveals shapes and causes interesting shadows to form.

On-camera flash is simple to set up. It works well enough for

Flash is the most practical way of making night pictures like this one. It's possible to make a variety of physical, optical and electronic devices designed to trip the shutter automatically when the animal is in the desired location in the picture area. Photo by Bill Schley.

making snapshots, for shooting fast-moving events such as sports, or for making simple photographic records. It is not the kind of illumination you would use if you want creative lighting effects.

You will have no difficulty aiming the flash when it's attached to your camera. Wherever you point your camera, the flash follows. Unless you get extremely close to your subject—which requires a different lighting technique—your flash is essentially pointed along the same axis as the lens.

An on-camera or bracket-mounted flash gives good results with many subjects.

A flash bracket gives you off-camera lighting effects with on-camera ease of handling.

When you use the flash unit off the camera, you can get more interesting lighting.

When taking vertical shots with your flash on-camera, you can get different lighting by holding the camera so the flash is either at the top, as shown here, or at the bottom.

You can use a diffuser to cut down and disperse the light from your on-camera flash. It won't affect your subject's appearance much. There won't be many shadows on your subject to soften. It will slightly affect the edges of your background shadows. A diffuser will, however, make your flash a bit less glaring to the subject facing it.

## BACKGROUND CONTROL

With on-camera flash, your subject will cast a shadow on a nearby background. If the flash is directly above your camera, the shadow will fall directly behind and a little below the subject's head and will be barely visible.

If your flash is mounted on a side bracket, the shadow will fall to one side of the subject. This is something to keep in mind when you rotate your camera for a vertical shot. If you turn it so the flash is *above* the camera, the shadow will fall behind the subject and be hardly noticeable.

If the flash is below the camera, the lighting will tend to look unnatural and the background-shadow will appear above the subject's head. You might want to ex-periment with a low flash position to take a dramatic theatrical portrait of an actor, but a low light position is *usually* not flattering or appropriate.

**Background-Light Falloff**—As you are well aware by now, the farther the light from your flash travels, the dimmer it gets. If you set your camera for the correct exposure for your subject, the background—being farther away—will be relatively underexposed. The farther back the background is, the darker it will photograph—not that a dark background is necessarily bad. It's just something to keep in mind. Sometimes you may want to have a dark background; sometimes you won't.

Even if you are using only one on-camera flash, you have some control over this background *falloff*. If you are three feet from your subject and the background is three feet farther back, the background is twice as far as the subject from the flash. Because of the inverse square law, the background will be underexposed by two steps. Under these conditions, a white background will photograph gray—a gray background will photograph even darker.

The flash was on the left in this shot. Notice that the shadows are falling to the right.

Here the flash was on the right. Notice that the shadows are falling to the left.

If you move back six feet from your subject, the background is nine feet from the flash and only about one step underexposed. If you shot from 12 feet, the background would be less than one step darker.

As you see, the relationship between the flash-to-subject distance and the flash-to-background distance has an effect on the relative darkness of the background. As you get closer to your subject with an on-camera flash, the background will become relatively darker.

**Shiny Backgrounds**—Watch out for shiny backgrounds. Windows, mirrors, metal or even glossy finished wood will reflect the flash. The trick in keeping these often disturbing reflections under control is to move them to where you can't see them.

To see how this works, face a large mirror so you can see yourself. Move to the side a couple of steps. Now you can't see yourself. When you can't see yourself, you wouldn't see the glare from your flash if you took a photograph from the same position. The same thing will happen if you take a photograph of someone standing in front of a varnished wall. Step to the side of your subject a bit and have the subject turn to face you. As long as the shiny wall or mirror isn't perpendicular to your viewpoint, the glare from your on-camera flash shouldn't be seen in your photographs.

You can also control the glare by using your flash off-camera on a tall flash bracket or on a light stand off to the side. Always be sure that the relative positions of background, flash and camera are such that the light from the flash cannot reflect back directly to the camera lens.

## WATCH THE FOREGROUND

Your eyes are naturally drawn toward light tones. Any bright spot appearing in a photograph is an automatic attention-getter. You want the subject of your photographs to have most of the attention. Therefore, it's best to keep distracting, light-toned objects out of the foreground unless you want them there for a specific compositional reason.

This is particularly true in photographs made with an on-camera flash, because foreground objects are closer to the flash than objects farther back. Close objects will receive more light and record lighter than objects farther away.

If you are composing a picture, there is no excuse for *burned-out*, or grossly overexposed, foregrounds. The easiest way to avoid them is to keep nearby objects out of the image area. Sometimes it's easy to overlook smaller items like foliage from a potted plant, especially when you're shooting through a wide-open lens. You can use your camera's depth-of-field preview feature to check for unwanted foreground items. When shooting with a handheld camera, look up from the viewfinder from time to time, to see if you're overlooking anything.

In some compositions, you may want to include foreground objects or persons. You could use bounce lighting or multiple flash units to get more uniform lighting. These techniques will be covered later in this book. But if you have only one flash and don't want to use bounce lighting—or can't—there are other ways of getting even illumination.

The idea is to reduce the amount of light in the foreground or increase the light in the background of the scene you're photographing. This compensates for

## AUTOMATIC FLASH CAN BE FOOLED

Automatic-exposure flash units are reliable when photographing average subjects—that is, subjects having average reflectivity. The exposure control in a flash is no smarter than the light-metering system in your camera. It reads light, but can't tell a light-colored subject from a dark one. Nor can it tell whether the background is near and bright or distant and dark. Highly reflective objects, even if they are small, can totally "fool" the automatic flash. When the scene looks non-average and out of the ordinary in any way, it's best to switch the flash to manual and use the guide number to estimate exposure. It's also a good idea to bracket exposures.

Speaker in left photo was photographed with a bracket-mounted flash set for automatic exposure. The subject was average, and exposure was OK. Identical equipment and same camera and flash settings were used to make the right photo. Picture is extremely underexposed. The reason? The reflection from the shiny brass plaque fooled the flash. The auto-exposure sensor saw a lot of light. Not realizing it was a useless reflection rather than useful image-forming light, it gave too little exposure.

the difference in flash-to-subject distances. If your flash has a tiltable head, you can *feather* the light— that is, tilt the unit upward to favor the background more. Feathering works best when you have a diffuser or bounce reflector on your flash.

If your flash isn't tiltable, you can shade the lower portion of the flash with a piece of cardboard to reduce the foregound brightness. Both techniques work, but it is easier to use feathering.

## REFLECTIONS IN EYEGLASSES

Eyeglasses, just like any shiny surface, can reflect your flash right back at you. To control the glare, you can have the wearer turn somewhat to the side so the reflection won't reach the camera lens. You can also have the subject lower the chin a little to tilt the glasses downward. But don't overdo it—don't let the eyeglasses drop to where they begin to obstruct your subject's eyes.

To see how much the subject must turn to get rid of the glare, make this test. Hold a small flashlight near your flash and shine it at your subject. Look through your camera and have the subject move his head in different directions. Observe the flashlight's reflection.

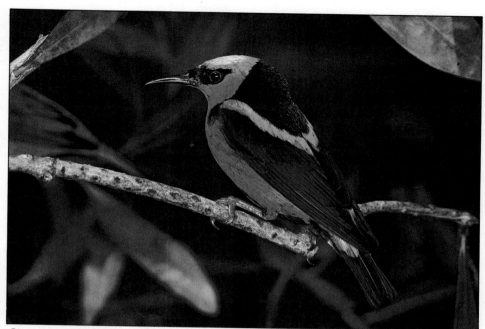

On-camera flash was used to photograph this Honey Creeper in the aviary at the San Diego Zoo. Photo by George Lepp, Bio-Tec Images.

When it disappears or becomes unobtrusive enough, photograph your subject from that position. Note that on-camera flash isn't particularly recommended for portraiture. But this technique will work in the same basic way with a remotely mounted flash unit.

Some portrait photographers avoid the whole problem of eyeglass reflections. They have the client borrow a spare set of *empty* frames, closely matching the regular glasses, from an optometrist. No lenses, no reflections.

## RED-EYE EFFECT

Whenever you photograph someone with an on-camera flash, there is some risk of getting color photographs with the *red-eye* effect. When the light is near the camera lens, it reflects from the back, or retina, of the eye at an angle that makes the illuminated reddish retina visible to the camera. This phenomenon occurs *only* when the light strikes the eyes nearly on axis of the lens.

The red-eye effect gives the subject's eyes an eerie glow. An effective remedy is to have your subject look slightly away from the camera.

You are most likely to see the red-eye effect when you use a small camera with a built-in flash or a pocket camera that uses flashbulbs or flashcubes on the camera body. You can get a flashcube extender that will raise the cube a few inches from the camera, to prevent red eye.

It's useful to remember that the red-eye effect is most likely to occur in dim ambient light, in which the pupils of the eyes are dilated, and with children and blue-eyed people.

Red-eye effect can happen when flash is close to camera lens and subject is looking toward the camera. If possible, use the flash off-camera. Or, don't have subject looking straight at camera lens. Red-eye effect tends to be worse when the existing light is dim and the pupils of the subject's eyes are dilated. Also, it is more likely to occur with children and blue-eyed people.

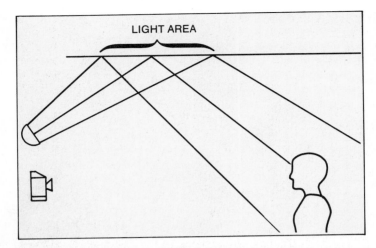

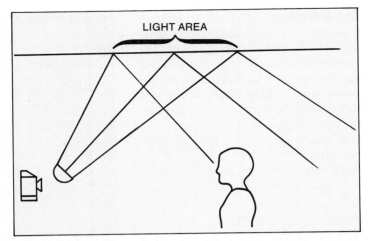

Above diagram shows how bounce flash from a ceiling works. Properly placed bounce flash will turn a patch of ceiling into a diffused light source. You have to position this source carefully just as you do any other light. The flash should be aimed at the ceiling well in front of the subject. Place flash unit so most of the light actually reaches the subject. It should not be reflected downward too sharply or back over the subject's head. Photo shows what you can do with good bounce lighting.

When you aim the flash at a patch of ceiling too close to the subject, two undesirable things happen. First, you lose a lot of useful light by deflecting it behind the subject. Second, the main illumination reaches the subject from too high an angle, causing unflattering deep shadows, especially under the eyes. Photo is not as attractive as the one at left. Photos by Maron Meeks.

# Bounce Flash On-Camera

If the light from your flash strikes a diffuse reflecting surface—*not* a mirror-like surface—before reaching your subject, this creates *bounce lighting.* As I said in the previous chapter, bounce lighting gives a *softer* effect than direct flash. The light striking your subject comes from a *large, diffuse* source. Any shadows cast on or by your subject will have soft edges. The scattered light lightens the shadows, giving them more detail and making them easier to print.

Unless you are using a bounce accessory like a reflector card or umbrella, you'll only be able to use bounce lighting effectively in rooms with 8- to 10-foot light-colored ceilings. Or you can use nearby walls as reflectors.

If you have a large professional-type flash, you can bounce light from higher ceilings. Colored ceilings or walls absorb more light than white ones. They also impart a color imbalance to color photographs.

For the best effect when bouncing from a ceiling, aim your flash so the central part of the beam strikes the ceiling well in front of your subject. This will provide frontal light, to give flattering and subtle shadows. If you aim your flash so it strikes just above your subject, most of the light will fall behind the subject. The light that does reach your subject will come from overhead. Direct overhead lighting can produce dark-looking eyesockets and is never flattering.

Bounce light from walls gives the effect of hazy skylight coming through a window. Try it. It's great.

Bounce lighting is good for portraits and can be used to good effect to photograph food and varied small products and objects. It's simple and easy to set up. The soft light finds its way into just about every dark corner of the subject matter, leaving no details hidden by dark shadows. It also helps to subdue distracting surface details, such as skin blemishes and pores, that are often accentuated by direct lighting.

Because bounce lighting is forgiving and can save many photographs that would look too harsh if lit by direct flash, it can be misapplied or overdone. Bounce lighting produces lots of *spill* light that is scattered away from your subject. Spill light can bounce off other surfaces and eventually reach your subject, to further reduce the lighting contrast and lighten shadow areas.

If bounce lighting is used in a very small room that has light-colored walls, such as some home studios, the reflected spill light can reduce the lighting contrast excessively. This is particularly true when you are using b&w film, which relies on tonal contrast. Color photos can rely on color differences to separate picture elements.

Watch for light fixtures and hanging plants that can get in the way of your bounced light and introduce unwanted shadow effects.

Flash was bounced off a wall on the left side. Light is soft but sufficiently directional to provide some modeling.

## DETERMINING BOUNCE EXPOSURE

Determining bounce-lighting exposure is a little more complicated than finding the exposure for direct flash.

For manual exposure control, begin by dividing your usual guide number by *two.* This allows for the light you lose by using a white

Sometimes, direct flash is too harsh (left). It can lead to distracting shadows and obscured detail. By bouncing the flash off a white cardboard reflector, a softer, more detailed and more pleasing image can be obtained (right). Photos by James Borowski.

73

wall, ceiling or card as a bounce reflector. The reflector absorbs and scatters light. The absorbed portion is lost. The light that is scattered lightens the shadows but contributes little to the overall exposure. Portable bounce reflectors that attach to the flash unit may require a different correction. I'll discuss these in a moment. Refer to the instructions packed with the reflector. Bracketing exposures is always a good idea when using bounce lighting.

To get the aperture setting, divide the *new* guide number by the distance from your flash to the bounce surface or reflector *plus* the distance from the bounce surface to your subject. This total distance is, of course, always greater than the camera-to-subject distance. As a result, you will always need to use a relatively large lens aperture when you shoot with bounce lighting.

An automatic-exposure flash is particularly helpful if you haven't had much experience with bounce lighting. However, the photocell sensor must point at the subject and not the reflecting surface. With automatic-exposure flash, use the *same* aperture setting as you normally use with direct flash. Your maximum shooting distance will be much shorter—usually less than half of what you'd get using direct flash. You can check whether you are within range for good exposure by using the sufficient-light indicator.

### PORTABLE BOUNCE REFLECTORS

When you want to use bounce lighting and there's no suitable wall or ceiling nearby, an accessory bounce reflector will be of great help. Several kinds were described in the previous chapter. They are portable and enable you to use bounce lighting in surroundings that would otherwise be unsuitable. Accessory reflectors are usually neutral in color so they won't distort colors. They range in size from a simple card a few inches

Many flash units have a flip-up *scoop* like this. When you're using bounce flash, it can help direct a small amount of direct flash toward the subject to lighten shadows and add sparkling highlights. On this flash, the wide-angle lens attachment serves as a scoop, when flipped up. To get the right lighting effect, tilt the scoop carefully.

across to an umbrella reflector with a 20-inch diameter.

Bounce reflectors are excellent for photographing small children and babies. The softness of the bounced light gives very pleasing results. You should *never* use direct flash on babies because their eyes are sensitive.

## Off-Camera Flash

If you can remove the flash from your camera and move it to different positions, you will have much more control over your lighting arrangements than you have with on-camera flash. With your flash mounted on a light stand, you can use bounce reflectors that would be too large and unwieldy to carry on your camera. A flash on a light stand will also let you change camera position to improve composition without disturbing the lighting arrangement.

### DETERMINING EXPOSURE

You calculate exposure the same way as with on-camera flash. With direct flash lighting, divide the guide number by the flash-to-subject distance. If you're using bounce lighting, divide your *bounce* guide number by the total flash-to-reflector distance plus reflector-to-subject distance. Ex-

If your flash doesn't have a built-in scoop, you can easily make one from a small piece of white cardboard.

It's easy to put a modeling light on a portable flash unit by attaching a penlight or small flashlight, as shown. It can help you aim a hand-held off-camera flash. When you attach the flashlight, be sure it aims in the same direction as the flash.

posure is *not* affected by the distance between your *camera* and your subject. This is one advantage of using off-camera flash.

Automatic flash can also be used off-camera. A remote sensor on the camera isn't necessary if you're using direct flash, but it is almost indispensable with off-camera bounce work. It will give you reliable exposures virtually independent of flash placement, as long as you don't exceed your equipment's maximum flash-to-subject range.

### HANDHELD OFF-CAMERA FLASH

Handheld off-camera flash is much like on-camera flash. You

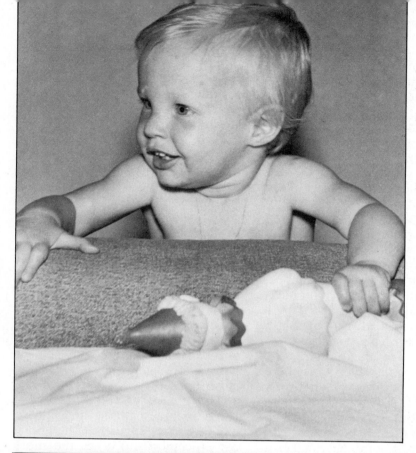

Often, part of the scene can also serve as a bounce surface. The white blanket in front of this child is a good example. There are similar bounce surfaces outdoors that you can use to soften shadows in sunlight. The most common are beaches and snow scenes.

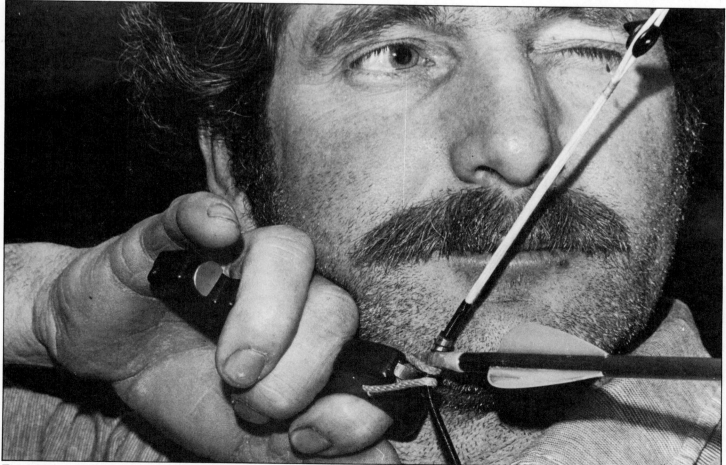

This close-up of an archer shows that a simple on-camera flash can sometimes give almost ideal lighting. When simplicity works, don't be tempted to make your lighting setup too complex. Photo by Roz Gazo.

can use either direct flash or bounce lighting, as you wish. A tiltable flashhead isn't needed for bounce lighting when you're hand-holding your flash unless you're using it in the automatic-exposure mode. In that case, the sensor still has to remain pointed at your subject, regardless of where you're pointing the flash.

A quick-release flash bracket is a definite asset. It enables you to snap your camera and flash together to free your hands for focusing and to remove the flash quickly and easily for shooting. A motorized film winder is also handy but is by no means a necessity.

Once you've focused and selected your aperture setting, unsnap the flash from your camera. A long coil cord is ideal for making the sync connection between camera and flash.

As soon as you move your flash an arm's length away from your camera, significant things start to happen. The lighting takes on a dif-

Flash was at camera position. Frontal light gives very little impression of texture. Because much of the light bounced back directly toward the camera lens, colors tend to be weak and desaturated.

With the flash off to one side, the texture of the material and the needlework is recorded clearly. Colors are rich and saturated.

ferent quality. For example, it starts showing up the little curves and valleys that add a third dimension to your model's features. Inanimate objects start revealing their form, too. Background shadows start moving to other positions. If you hold the flash directly over your head, the shadow often drops out of sight or at least out of the picture area.

If you have some difficulty visualizing what effects different flash positions have on your lighting, experiment with an incandescent lamp in a reflector, on an extension cord. You can also tape a flashlight or penlight to your flash head to help you place shadows.

When you're handholding the flash, try to get a "feel" for where the flash is pointing at all times. Otherwise, it's distracting to both you and your model for you to keep looking up at your flash to see where it's pointing. It takes a little practice to develop the "feel," but it's worth the effort.

## USE OF UMBRELLAS

Umbrella bounce reflectors have become very popular. They have many applications in the studio and on location and are relatively inexpensive. Not only do umbrellas produce pleasing and soft bounce illumination, they are also easy to aim.

Umbrellas are made in sizes ranging from less than a foot across to over eight feet in diameter. Most sizes are intended to be used on light stands because they are too cumbersome to control by hand. They also come in a variety of shapes, colors and degrees of gloss. Most flash units can be used with an umbrella. You might have to buy a mounting bracket for your flash, but many umbrellas are sold with their own ball-and-socket mount.

Although you can use an umbrella of any size, there are some guidelines for selecting an umbrella best suited to your needs. First, if you have a large flash, use a large umbrella. Your flash unit

mounts in front of the umbrella and partially blocks the light coming from it. You'll lose a lot of light this way if you use too small an umbrella.

As a general rule, the umbrella is best used at a distance two or three times its diameter from the subject. An umbrella of the right size will spread the light enough to cover your subject without having to move it back an inconveniently long distance.

As for shapes, umbrellas come in square and almost round—actually octagonal—versions. Square umbrellas produce more spill light and are less directional. Round umbrellas give you more control and can "surround" your subject with light when the umbrella is close enough.

The choice of colors and textures includes matte and glossy silver. Glossy silver has the greatest efficiency and gives the most contrasty light. A matte white umbrella has much softer light and is less efficient. Blue and gold umbrellas tint the light their colors, for warming or cooling the image. There are also black—yes, I said black—umbrellas. They are used as black reflectors, without a light, for darkening portions of your subject to increase lighting contrast.

This flash picture was taken on a bridge at night. There was no reflective surface behind the subjects, only distant black sky. The result is a black background that seems to isolate the subjects. There were also no reflective surfaces near the front and sides of the subject. To get correct exposure in these conditions, use about one-half to two-thirds the recommended indoor guide number.

One of the main attractions of electronic flash is its motion-stopping ability. Andrew Davidhazy used an on-camera flash unit to make this picture. To get shortest possible flash duration—and "freeze" motion of bird's wings on film—he set flash to 1/32 power.

Wasp was stopped in flight by a flash aimed at point of intersection of two laser beams set at right angles to each other. Flash was automatically set off when wasp entered intersection of the two laser beams. Flash was set for 1/64 power, to get shortest possible flash duration and, therefore, sharpest image. Photo by Tiffany DiBlasi and Michael Peres of the Rochester Institute of Technology.

**Determining Flash Exposure With Umbrellas**—Umbrellas, like other bounce reflectors, will give you light that is less bright than you'd get with direct flash. The amount of loss will vary between 1/2 and 3 exposure steps. The exact amount will depend on the color, size and shape of the umbrella. Light output is also affected by the distance between your flash and the surface of the umbrella. You can slide the shaft of the umbrella back and forth in the ball-and-socket bracket to change that distance. Generally, when you move the umbrella farther from the flash, the light spreads out less and is brighter. Decreasing the spacing between them spreads the light more and makes it less efficient.

Instructions packed with each umbrella will tell you approximately how much light loss to expect. But you should run some tests for more accurate results.

Begin by dividing the usual guide number by 2. Because an umbrella isn't a small light source, like the flash on its own, the inverse square law won't work as precisely for determining aperture

settings. You can get a good approximation of the right aperture by dividing your new guide number by the distance from the flash to the umbrella *plus* the distance from the umbrella to your subject. A flash meter would also indicate correct aperture.

One trick you can use once you've established the right exposure for several flash-to-subject distances is to tie a cord to the ball-and-socket bracket. Mark the cord with knots at 1/2 or 1 exposure-step increments. This way, you can use the cord as a measure to quickly position your flash for a particular aperture setting.

**Reflections**—Umbrellas, like all light sources, can be reflected from glossy surfaces in the subject area. The sight of the reflection of an umbrella and all its attachments can be distracting in a finished photograph. You can reposition your umbrella so the reflection moves out of the picture or to a less obvious place, or use another type of light diffuser. A square or rectangular bounce reflector may look more natural as a reflection. You can also use *tenting,* which is explained in Chapters 6 and 9.

## USING A FILL REFLECTOR

The two most important lights in any lighting arrangement are the *main light,* or *key light,* and the *fill light.* Even with a one-flash setup, you can have both by using a *fill reflector.* A complete treatment of multiple-flash setups is in the next chapter.

Your key light produces most of the illumination. Most important, it determines where the shadows will fall and thus sets the *mood* of the photograph. The positioning of your key light is critical if it is to flatter your subject's appearance.

**Portrait Lighting With A Fill Reflector**—For a foolproof portrait setup, place the flash and umbrella on a lightstand at an angle of about 45° above and about 45° to one side of your subject. The flash should be about six feet from your subject. This *key light* should point directly at the subject.

This light illuminates one side of your subject's face. The side away from the light will contain shadows. You will rarely want to photograph anyone with such one-sided lighting. You'll want some light on the shaded side for a more pleasing appearance, and to

reduce contrast. This is where the fill reflector comes in.

Place a 20x30 inch or larger piece of white cardboard or foam-core board on the side of the subject opposite the key light and about two to four feet from the subject. You can also use a nearby white wall as a reflector. Some light from the umbrella will fall on the board and bounce back to your model to light the shaded side. If you want more fill light, swing the umbrella more toward the fill reflector.

An umbrella makes it easier to control the brightness of the background. With its wide beam, you simply swing—or *feather*—the umbrella toward the background to lighten it, or away to make it darker.

Because there is so much stray light produced by an umbrella, or for that matter, by any type of bounce lighting, it is particularly important to use a good lens shade on your camera. If you don't, there's a good chance of picking up some image-degrading *lens flare*.

Lens flare is non-image-forming light that can obscure detail—especially shadow detail—in your photographs. Flare results when stray light is permitted to strike the camera lens.

# Bare-Tube Flash

A bare-tube flash has no reflector behind the flash tube. Some bare-tube units are designed to be converted to and from reflector-type flashes. Some have a removable reflector to make the conversion; others feature interchangeable flash heads.

A bare-tube flash sends light relatively evenly in all directions except directly down. The handle blocks light in that direction.

Bare-tube flash has been popular since the days when flashbulbs were the universal kind of flash illumination. The combination of direct illumination from the flash

source and ample fill from all the reflected spill light can provide lighting of a very special quality. However, you must be careful not to place the flash in front of the camera, where the unshielded light could strike the camera lens.

## THE BARE TUBE INDOORS

A bare-tube flash is almost always used either handheld off-camera or mounted on a light-stand. It is used both alone or in combination with other flashes—often other bare tubes.

The *direct* light from the reflectorless flash tube is crisp and contrasty, due to the comparatively small size of the source. This light causes the subject to cast hard-edged shadows. The other three-quarters of the light is *spill* light, which goes out in all directions. In small or medium-sized rooms, this light bounces off the walls and ceiling and produces lots of shadow-softening fill light.

You don't have to be careful about aiming a bare-tube flash. Generally, an equal amount of light is emitted from all sides.

If you're planning to photograph in a small room, you can have the flash on or near the camera. You can also mount a bare tube on a lightstand in the middle of the room. But be sure the flash is not

Bare-tube flash is a versatile tool. In a suitably reflective room, it combines a small directional light source that generates shadows with lots of bounce light to soften those shadows.

This is a good example of a photograph taken with bare-tube flash. Notice that there are shadows and catchlights to give the scene modeling and life, but no undesirable black shadows without detail.

in front of the camera, where its light can strike the lens.

You can put a photoelectric slave on the bare tube and a small flash on your camera. The main purpose of the small flash is to set off the photoelectric slave on your bare-tube unit. It should contribute little to the film exposure.

The spill light may pick up some colors from the reflective surroundings to give an undesirable color bias to color photographs. To lessen this effect, you can fashion a reflector card from white cardboard or even a Styrofoam cup and attach it behind the flash tube with tape or rubber bands. This can help bounce some of the spill forward instead of allowing it to reach a colored surface.

Because bare-tube flashes send light in all directions, you can use them with all kinds of camera lenses. Wide-angle lenses work well with these flashes. Even fisheye lenses can be used effectively with bare-tube lighting. With lenses having a very wide angle of view, you can expect to see some flare, because the flash itself is likely to show in the photograph. Sometimes you may be able to use lens flare creatively for dramatic effect.

**Determining Exposure**—Indoors or out, a bare-tube flash basically follows the inverse square law. Divide the guide number by the flash-to-subject distance to get the aperture setting to use. However,

a bare-tube flash is particularly affected by its surroundings. It is, therefore, advisable to run tests to see how the guide number is affected by the brightness and proximity of those surroundings. A flash meter is useful in this situation.

### THE BARE TUBE OUTDOORS

Because of the absence of reflective surfaces, bare tubes lose a lot of efficiency outdoors and give contrasty lighting. Your outdoor guide number will be about two exposure steps less than the indoor number for an eight-foot ceiling.

You can avoid much of the efficiency loss by attaching a suitable reflector—an old seven-inch press-camera flash reflector is ideal—to the flash to make it into a regular flash unit. This will raise your outdoor guide number by about 2-1/2 exposure steps.

# Open-Flash Techniques

As I explained in Chapter 2, the camera shutter has to be completely open when your flash goes off. This is taken care of by using your camera's X-sync connector and by selecting a suitable shutter speed.

You can also use flash without synchronizing it with the camera's shutter. Set your shutter to B and lock it open with a locking cable release. The area should be dark enough to not expose your film during the short time the shutter will be open.

With the shutter open, point the flash at your subject and set the flash off, using the OPEN FLASH button. This method enables you to use flash with an old camera that isn't synchronized. In a darkened room, you can fire the flash several times and photograph the same person in different positions, as "twins" or "triplets." The background must be dark or distant, otherwise each of the multiple images will appear transparent. You can also combine a time exposure in existing lighting with a flash exposure, using this technique.

### BUILDING POWER

This is a special application for open flash. Let's say you want to photograph a *stationary* object and your flash isn't powerful enough to let you stop down your lens for the depth of field you need. You can *double* the amount of light exposing your film by firing your flash *twice* while the shutter is open on the **B** setting.

As long as both bursts of light come from the same location and strike the same place, the effective light intensity doubles. You can close the lens one more *f*-stop.

This process can be carried further. If you need to stop down another step, set off your flash *two more times*. For another step, *four* additional flashes are needed. Note that to gain one *f*-stop you must always double the number of flashes.

In actual practice you may need five flashes for a two-stop gain and 10 for a three-stop gain. This is due to what is called the *intermittency effect*. It causes many successive short exposures to be less effective on the film than one continuous exposure of the same total duration. Do some testing—or bracketing—to see how your film and flash behave with this technique.

### "PAINTING" WITH FLASH

When you're faced with the task of photographing an extremely large area such as a building interior or a house exterior at night, and only have one flash unit, don't despair. You can probably still do the job. This technique is called *painting with flash*. It takes some careful thought and planning.

Painting is a way of having one flash do the work of many. You start out by studying the area to be lit. Set up your camera to show the scene as you want it composed. Select the aperture you'll need for the desired depth of field. Determine the flash-to-subject distance to use for this aperture.

One flash unit was used to *paint* this scene with light. The flash was fired successively four times to expose one film frame. Two flashes were used to light the outside of the arch. Another lit the inside area. A fourth lit the model. To avoid subject blur in the picture, the area around the model, and her background, had to be totally dark. Also, only one of the four flashes was permitted to strike the model. Photo by Maron Meeks.

For this effective multiple-image photograph of a man at work, each pose of the man was lit and exposed separately. The background for the man had to be black. Otherwise, each successive exposure would have lightened it more. This would have caused each of the man's images to appear transparent. The equipment in the foreground was exposed just once. Photo by Jim Stummeier of Ferderbar Studio, Milwaukee. Courtesy of the Generator Division of Kohler Co. and the Jacobson Agency.

We're used to seeing things lit from above. Light from below is generally used to create an eerie or dramatic effect. To make this self-portrait, photographer Alan Magayne-Roshak placed a single flash on the floor.

Double exposures are easy. Use a black background—light-absorbing black velvet is most effective. Darken the room. To safeguard against reflections from the background, use side lighting, not on-camera flash. When your subject is ready, set the camera to B and open the shutter. Expose twice with the open-flash button, carefully placing your subject—in total darkness—in the two desired positions. Close the shutter. In this example, the subject even changed to a T-shirt between exposures.

For a moment, pretend you have an unlimited supply of flash units just like the one you own. Figure out where you would place each one to light the room. Unless you want different areas to be lighter or darker, keep a *constant* flash-to-subject distance for each flash. Keep in mind that the light from each flash should slightly overlap the light from the one next to it to avoid an uneven look. Make a sketch of the flash positions.

When you're ready, set the camera shutter to B, darken the interior scene as much as possible, and open the shutter. It's best to have an assistant who can hold a dark card in front of the lens to keep out stray light between the flashes.

Walk quickly to each of the flash positions and trip your flash at each one. When you have fired from all of the positions, close the shutter.

**Precautions**—Put opaque tape over all your flash ready lights and other lighted dials and controls. If you don't, they may appear as streaks or spots in the photographs. You can count the seconds between shots to assure that your flash is fully recycled.

Wear dark clothing and avoid standing between the camera and the area you're lighting so you won't show up in the picture.

Aim the flash carefully so it doesn't spill glare toward the camera. It helps to conceal the flash behind furniture or other objects whenever possible. Your assistant can help to detect and point out incorrect flash positioning.

Painting with light takes some practice to do successfully. It would help to make some practice runs with Polaroid film before doing the final shot with your regular film. If you can, use two or more cameras at one time, each set for a different aperture. Bracketing this way will save you a lot of retakes and legwork.

## Your Flash as Part of the Photograph

Sometimes the glare from your flash in the photograph can add to the impact of the image. This can be achieved directly or by means of reflections.

### CATCHLIGHTS

Catchlights are reflections of a light source in your model's eyes. They add sparkle and life to a portrait. Some purists insist that one catchlight—no more and no less—appear in each eye. This is easy enough if you are only using one flash. It's more difficult when several lights are used. You can always retouch out the extra catchlights, but the notion about single catchlights is a matter of personal preference rather than a photographic necessity.

Catchlights on products or objects are called *accents* or *highlights*. They help to define and separate the different parts of the subject.

### SIMULATIONS

A flash equipped with a filter of an appropriate color can be used to simulate the glow of a fire. For example, you can place a flash with a red or orange filter inside a laboratory kiln or oven. Let it shine on a researcher as he reaches into the oven with tongs. It's very effective.

A properly filtered flash buried in an unlit campfire will look like the real thing.

There are many other possible applications. For example, you can use the reflection of your flash in the examination mirror on a doctor's forehead. It could create some deliberate lens flare to simulate a patient's-eye view of the doctor. No doubt you can find other ways of using your flash as a creative element in your pictures.

To simulate a campfire, you can use an appropriately filtered flash. In this photo, you see the glow of the "fire," rather than the fire itself. This is a good way to avoid excessive brightness in that area. Photo by Jim Stummeier of Ferderbar Studio, Milwaukee. Reproduced by courtesy of Ray-O-Vac Corp.

To make good formal portraits like this, one on-camera light is not enough. You need a set of lights, carefully positioned to achieve the desired effect. This is as true of flash illumination as of tungsten lighting. Photo by Alan Magayne-Roshak. Reproduced by courtesy of the University of Wisconsin, Milwaukee.

For a large studio set such as this, more than one key light is needed. In this scene, each people group and each boat had key lighting specifically intended for that part of the image. Multiple rim lights were also used. The photographer must be careful that no lamp appears within the picture area and that the light brightnesses are properly balanced. The fill light for the scene consisted of a large diffused source near the camera position, plus several reflector cards, carefully placed outside the camera's view. Photo by Jim Stummeier of Ferderbar Studio, Milwaukee. Reproduced by courtesy of Outboard Marine Corp. Drive Systems.

# Using More Than One Flash

Once you've gained some experience taking photographs with one flash unit, you may want to try using multiple-flash setups. Using several flash units opens new avenues of lighting control for you. You can do things that are impossible or, at best, difficult with only one flash. Let's look at how some of these things are done.

Working with more than one flash at a time isn't particularly difficult if you approach it step-by-step. The key to success with multiple-flash lighting is to *set up one flash properly* before adding others.

In many applications, one flash does most of the work. As I pointed out in the preceding chapter, the main or key light sets the mood of your lighting and supplies most of the illumination. This is true whether you're photographing people or objects.

When you build up your lighting step-by-step, do it methodically. Plan carefully and take notes on which results appeal to you and which don't. This way you can repeat a successful setup or learn from an unsuccessful one.

Because of the short flash duration, it's difficult to visualize the effects of a particular lighting arrangement, if you don't have modeling lights. This is particularly true if you are not experienced in using artificial lighting. You will find it helpful to experiment with incandescent lighting at first. A good set of floodlights is not very expensive. Or, you may be able to borrow a set for a while.

Tungsten studio lights give continuous illumination. If you want to achieve professional-quality lighting with several lamps, experiment with lights like these before you use electronic flash. Tungsten lights allow you to see the illumination effects you're going to get. With flash, you generally have to work "blind." You must know where to place your lights without the help of immediate visual feedback.

Key light was to the right of the camera position. It was illuminating the sculptor from the front. When you make a photo like this, it isn't enough to follow rules blindly. You also have to be visually aware. In this portrait there are several important components—two hands with tools, the stone being worked, the face and visor. Key light must do justice to each of them. Notice highlighting on the hands, texture in the stone, modeling and skin texture in the face, and absence of unwanted reflections from the visor. A bare-tube flash, with a paper diffuser in front of it, was used for fill. It was at the camera position, and provided detail in the shadow areas of the stone, the hands and the shirt. Photo by Alan Magayne-Roshak, courtesy of the University of Wisconsin, Milwaukee.

# Two On-Camera Flashes

Two flash units, mounted on the camera directly or through the use of flash brackets, can be used in a variety of ways. One important application is close-up or macro photography, which is covered in Chapter 8. For general-purpose photography, there are two basic ways you can use two on-camera flash units.

**To Get More Light—**If you aim two identically-powered flashes so they light the subject from essentially the same position, the subject will have twice the illumination it would have with one flash. Although you can carry numerous flash units on your camera, handling more than two can be cumbersome in practice.

Put one flash on your camera's hot shoe. Mount the other on the side on a flash bracket. You can use a Y-connector or a photoelectric slave to trigger the extra flash.

With double the light, you can close your lens aperture by one more *f*-stop than recommended by the flash guide number. To double the light again, you would need *four* flash units, firing from the same position. However, instead of using four flash units, you would be better off with a single more powerful unit.

If each of two flashes has the same guide number, you can get the effective guide number of both by multiplying the guide number by 1.4. You'll be able to close the lens down by a full *f*-stop. If one flash is less powerful than the other, use the guide number of the more powerful flash and close your lens by about 1/2 *f*-stop. I don't recommend a second main flash that has less than half the light output of the first. The smaller unit will not contribute enough illumination to have sufficient photographic effect.

**Bounce-And-Fill—**As I have mentioned several times, a single

bounce light produces a soft result. It's ideal in many instances, but it doesn't work for every job. A two-flash *bounce-and-fill* arrangement is more versatile. It will give you a good balance between three-dimensional modeling and softness.

The key light—the one that supplies most of the light and helps form the shadows you need for natural-looking results—is a bounced flash. It *must* be the more powerful of the two flashes. It has to supply more light to your subject than the fill flash. The effective guide number of the fill flash should be no more than half that of your key light. If your fill flash has an adjustable-power setting, turn it down to get the guide number you want.

Your key light should be aimed upward or to the side, as it would normally be for bounce lighting. Mount the fill flash so it points along the camera-lens axis. When you're photographing people, the direct fill light will also add sparkle to eyes and teeth.

If the flash you want to use for fill is too powerful, you can reduce its light output with a small diffuser or a neutral-density filter over the flash. Even a layer of white handkerchief over the flash will reduce the light by about half.

Using two flashes in a bounce-and-fill arrangement makes an excellent general-purpose lighting system. Use a Y-connector or photoelectric trigger to set both flashes off at once. Remember to watch both ready lights.

If you've set up your bounce-and-fill lighting as described, your fill light will contribute about 1/4 additional light. Close your lens aperture down a little, to allow for this.

## TWO FLASHES IN ONE

The bounce-and-fill technique can be achieved with a single flash unit. Many flash units either include or offer as an accessory an *eyelight panel.* This is a small reflector that catches a fraction of the

This flash unit has two flash tubes. The larger one can be tilted upward for bounce lighting. The smaller one, which always faces the subject, adds catchlights to eyes and reflective parts of objects. It gives them sparkle. The small, direct flash also brightens shadows caused by the bounce flash.

direct flash light from your bounce flash unit and aims it toward the subject as fill. Several flash units use built-in optics to do the same job.

The most unusual approach to one-flash bounce-and-fill lighting was first offered by Continental Camera in the model XF300 flash and later by other manufacturers. These units have two separate flash tubes. One is mounted in a swivel head and is no different than any other flash. You can use it as usual for both direct and bounce lighting.

The second flash tube is much smaller and points straight forward at all times. A switch lets you choose whether or not to fire this flash tube together with the main flash.

Both flashes are powered by the unit's main capacitor. Some special components in the smaller tube's circuit restrict the amount of power it can consume. This causes it to put out less light than the main flashtube. In the Continental flash, there is a three-step difference in light output between the two flashtubes. The difference

between the bounced main light and the direct fill light during actual use will, of course, be less because of the normal loss caused by bouncing the main light.

This unusual dual-flash-tube design, available at several price and power levels, may be the answer to your bounce-flash needs.

## Several Off-Camera Flashes

On-camera multiple flash setups are useful when you have to be mobile and can give better illumination than single-flash lighting. However, they do limit your choice of light placement. Keeping all your flashes on your camera or flash brackets also limits the number of flash units you can manage at one time.

When precise light placement or widely spaced lights are needed, you must mount one or more of your lights on light stands or other off-camera supports.

When you start working with your lights mounted on light stands, you can begin to take full advantage of artificial lighting's capabilities. You can use just about as many flash units as you want.

Your lights will stay where you put them. You can switch cameras or film. You can take a test shot with an instant camera. You can change the camera position slightly. Your lights will remain in place. If you change cameras, simply reconnect the sync cord and you're in business. If you should need your camera for other work, your lights can be left set up for later use.

As I've said before, you may find it helpful to experiment with incandescent lights before trying complex flash setups. Sometimes, particularly with highly reflective or transparent subjects, incandescent lighting is much easier to use. Many professional flash units have modeling lights that help you preview the effects you'll get with your lighting arrangements. More on these in Chapter 9.

### OBJECT SHAPE AND TEXTURE

Generally, you want to make the subject retain its three-dimensional appearance in the finished photograph. Sometimes you may want to alter the subject's true appearance to create a special effect.

For the moment, let's assume you're after realism. The lighting should make your subject look like what it is. It shouldn't play any tricks. If you're photographing a spherical object, such as a ball, make it look like a ball—not like a flat disc. A box should look like a box, not a flat card. For the most pleasing rendition of reflections,

---

**MULTIPLE FLASH: MANUAL OR AUTOMATIC?**

To get predictable and repeatable results with a multiple-flash setup, I recommend you set your flash units for manual operation.

If you used automatic flash, the results would be unpredictable. This is because *each* of the photocells could be affected by light from *each* of the flash units.

You may want to try automatic flash under these conditions just as an experiment. Under some conditions it may work. Frequently, it won't. You won't know whether you've succeeded or not until you've processed your film.

---

Three lights were used to photograph this violin maker. Effect of background light can be clearly seen. Other two lights were not so much key light and fill light as two key lights. One was used for the violins and the other for the man. Man was lit from left side. Flash that lit the violins frontally also provided fill light for the man. Photograph by Alan Magayne-Roshak, courtesy of the University of Wisconsin, Milwaukee.

Good example of a thoughtfully composed and well-lit photograph. Lighting gives dimension to the objects. Highlights provide sparkle and shadows have detail. Placement of the objects is pleasing. Background is unintrusive and appropriate. Photograph by Dennis Poeschel.

you should light shiny objects differently than textured ones.

Let's look at a few object types and see how to light them for the best effect. These are merely suggestions. You can modify them as much as you want to get the images you like.

**Spherical Objects**—If you light a spherical object properly, you will get softly curved highlights and shadows that will leave no doubt as to the shape of the object.

Place your key light slightly behind and considerably above the object and off to one side. This light will create one distinct shadow. You should be particular-

This is a ball. However, in the top picture, if it weren't for the lines on the ball, it would look just like a flat cookie. The lighting was diffused and from the camera position. In the lower photo, there's no doubt that the object is spherical. The key light from the left provided a highlight and shadow. A second light, from the right side, added a second highlight, to add to the three-dimensional effect. The light on the right was placed low, so it didn't lead to a second visible shadow. A third, diffused light was aimed from the camera position to provide some detail in the frontal shadows.

ly watchful for potential lens-flare problems any time you have lights behind the subject and pointing toward the camera position. Be sure the flash is aimed so that none of its light can strike the camera lens directly. Use a lens shade to help prevent lens flare.

Add some fill light from one flash on or near your camera. You can add a third light of about half the brightness of your key light, if you wish. Place it behind the object, on the side opposite the key light and lower than the key light. Position this light low enough that it won't be able to cause a shadow of its own.

Base exposure on either your key light or the supplementary light, depending on whether you want a relatively light or dark image. There's a lot of scope for experimenting with a three-light setup. If you don't use a flash meter, bracket exposures.

You can try both direct and diffused light for your key and supplementary lights. Diffused flash is a little easier to control. Generally it also produces more pleasing illumination because the borderline between the light and shaded areas is broader and less harsh.

**Box-Shaped Objects**—The flat surfaces of a cube, box, or similarly shaped object need a little help to make them stand out from one another when photographed. The basic technique is similar to that of lighting a sphere.

When you view a rectangular box from an oblique angle, you see two sides and the top. Each of these surfaces should be lit differently, so each appears as a different shade in your photograph. Generally, the top should be the lightest.

First, light the top from above and behind, as I described for the sphere. This light should be the brightest. Remember, brightness can be controlled by the power of the flash or its distance from your subject. If you want soft-edged shadows in the foreground, diffuse the top light.

Aim a second, less powerful flash at one side of the box at about table level. Place it low enough so no shadow is cast on the foreground.

Finish the setup with a third light—dimmer than the other two—at about table level to light the third side.

Three lights complete the job. No fill light is needed because you are deliberately building up the lighting for each side separately. Base exposure on the middle-toned side of the object, which should be about one exposure step less bright than the top side.

**Shiny Objects**—Shiny objects are often difficult to photograph with ordinary direct flash. When you set up lighting for shiny objects, think of them as mirrors. In addition to reflecting the flash, they also reflect surrounding objects. Light surfaces in the surroundings are reflected as light areas, dark surfaces as dark areas. Objects often have curved or complex surfaces that pick up reflections from all angles.

You can control the lighting on, and reflections from, shiny objects in several ways. One method used by studio photographers is to apply a non-shiny, matte coating to the object. This can be done with a commercial *dulling spray,* a brush-on make-up liner or some other similar material. However, often you may not want to put such a coating on an item to be photographed. For example, you certainly wouldn't want to treat the works of a watch this way. When you do use a matte coating, you have to carefully remove it again after you've finished.

When possible, deal with shiny surfaces by carefully controlling the lighting. The trick is to give the subject something to reflect that won't cause a confusion of conflicting tones. A large bounce reflector works well with many subjects.

The ideal setup for many types of shiny objects consists of a light tent. See also page 89.

## Y-PLUGS

With a Y-plug, you can fire two to four flashes simultaneously from the camera. However, all the flash units must be compatible with each other. They must have the same *sync voltage* and *polarity*. You can check the voltage across the two contacts of the flash sync cord with a voltmeter. Also note which contact is positive and which is negative.

Of course, the best way to guarantee compatibility is to use identical flash units. If you're not sure whether your units are compatible, play it safe. Connect one to the camera and trigger the others with slaves.

If you indiscriminately plug several flash units together, there's a good chance that one or more of them will be damaged. Or, the system may simply not operate.

With compatible flash units, there's little danger of damaging your camera's sync contacts by triggering no more than two flashes with the use of a Y-plug. Triggering more than two flashes may involve more current than the camera can handle. This is particularly true with flash units having 100 or more volts across the sync connector. Modern flash units having only about five volts across the sync connector are less likely to cause damage.

## LIGHTING RATIO

The lighting ratio indicates the difference in illumination between the highlight and shadow sides of the subject. It's not simply the difference in brightness between the key and fill lights, because the highlight areas are generally affected by *both* lights.

Suppose you are using a key light that leads to distinct shadow areas plus a fill light at the camera position that lightens the shadow areas. If these lights have the same brightness and are at the same distance from the subject, what will the lighting effect be? The highlight area will receive twice the light the shadow area receives. Therefore, the lighting ratio is 2:1.

If the key light reaching the subject were twice as bright as the fill light, what would happen? The highlight areas would get three times as much light as the shadow sections, so the lighting ratio would be 3:1.

With subjects like portraits, where the tonality of the subject—the face—is uniform all over, you can easily measure the lighting ratio with a reflected-light exposure meter.

What the best lighting ratio is, depends on the contrast the film itself will yield and on the final effect you want. To get pleasing contrast with detailed, but not deep, shadows in a portrait made on color slide film, a ratio of 2:1 to 3:1 is usually ideal. If you're using a low-contrast b&w film, the same subject might be lit with a 5:1 or 6:1 ratio to get the best result.

For most purposes, the fill should be diffused light near the camera's lens axis. The brightness and location of the fill light should be such as to cause no noticeable shadows of its own.

Dance action was "frozen" on film with double-rim flash lighting. One flash lit front of dancer, the other lit her back. This provided a dramatic effect. The figure is outlined by light and the shadows fall in the middle. Figure stands out well against black background. Left flash was fired from the camera; right flash was triggered by a slave unit. Photo by Alan Magayne-Roshak, courtesy of the University of Wisconsin, Milwaukee.

**Plaques And Other Flat Objects**—Whether the object you want to photograph is flat or has a moderately curved surface, a bounce-lighting setup will generally work well. Position your camera in front of the item you are photographing. Cut a large sheet of white background paper and tape it to supports directly in front of your camera. Cut a hole in the paper for your lens to see through. This shield will prevent the camera from being reflected in the object and at the same time serves as a reflector for the lights.

Place one or more flashes above or beside the subject and out of the picture area. Aim them at the paper. Be sure the camera lens is properly shielded, so no direct light from the flashes can strike it and cause lens flare. It'll help if you use an incandescent lamp near each flash, so you can preview the effect.

If the engraving on a plaque doesn't show up well, add some strips of dark paper or tape to the edges of the bounce-reflector

Diffused illumination brings out a lot of detail in the close-up photo of a watch (upper picture). The watch was in a small translucent tent, lit from the outside by two flash heads (lower picture). The green background for the watch is a small piece of cardboard. The exact lighting effect can be varied by altering the positions and distances of the flash heads.

If I had wanted some light to come *through* a semi-transparent object—as well as having top light—I could have used the light box that forms the base of this setup. With color film, the transmitted light must have the color temperature of the electronic flash used for reflected illumination—about 5500K. Also, the light-box exposure must be carefully balanced with the exposure of the flash from the top.

paper. Try the strips in different locations until you get the best separation between the shiny plaque and the engraving.

Instead of reflecting the light from a card, you can transmit it through a translucent material like a sheet.

**Clockworks And Similar Mechanisms**—Usually, bounce lighting will work well. You can bounce the light from the ceiling or some other white surface. The mechanism generally has no mirror-like surfaces, so there is no danger of your camera being reflected.

Straight bounce lighting may be a bit too soft to "separate" the parts of the mechanism adequately. If this is the case, place a few small, dark objects close to the mechanism but just out of camera range. In the proper location, they'll add nice dark shadings to parts of the mechanism and give a realistic appearance to the metallic parts.

**Complex Shiny Objects**—When you need to photograph a subject that is not only shiny but also has strongly curved surfaces, *tenting* is called for. Tenting is used frequently in professional studios. As you'll see in the next section, it can also be used successfully in your home with modest equipment.

**Textured Surfaces**—Consider whether you want to emphasize, subdue or record normally the texture of your subject. Texture is three-dimensional. Some lighting hides it; other lighting exaggerates it.

For a surface to look really textured, your key light should be directional rather than diffused. It should be positioned so its light strikes the surface at an oblique angle. Place the flash so the light skims across the surface. This will cause the texture to cast revealing shadows of itself.

Keep your key light far enough away from your subject so it will be lit evenly from one end to the other. To achieve this, a flash-to-subject distance of four times

the width of your subject is usually sufficient.

Add some fill light with a second flash placed as close as possible to your camera. As a general rule, if the key light is to the right of the camera, place the fill light just to the left of the camera lens. You can also mount the fill light on the camera hot shoe. As always, the fill light must put considerably less light on your subject than the key light does.

Texture of this object was brought out by cross lighting from the right. In upper photo, shadow areas are black and lacking detail. For lower photo, a diffused fill light at the camera position was added. This fill light obeyed three basic rules: It didn't cause shadows of its own. It didn't destroy existing shadows. And, it lightened shadows sufficiently to make detail visible.

The less fill you use, the more prominent the subject's texture will appear.

If you want to subdue the texture of the subject, move the key light more toward your camera position. Base exposure on the distance from the key light to the subject.

## Light Tent

A light tent is a versatile light diffuser that completely, or nearly completely, surrounds the object to be photographed. You illuminate the translucent tent from the outside to get completely uniform, virtually shadowless and reflectionless lighting. You can also adjust the lighting and the reflections from the object in such a way as to improve the modeling and detail in the object.

For totally uniform diffused lighting, light the tent from all sides. If you want a slight shadow effect, light one side more strongly than the other, to get a higher lighting ratio. If you want some dark reflections from parts of the object, place pieces of black paper or tape in the appropriate position on the inside surface of the tent.

For relatively large objects, you can make a light tent from white paper, folded into a conical or cylindrical shape. For small subjects, you can use a white plastic jug. Cut away the top and bottom of the jug and place it over the object. Two small flash units on opposite sides of this "tent" supply the lighting. The camera looks in through the upper opening.

Frosted acetate and drafting Mylar are ideal translucent materials for tenting.

## Portrait Lighting

In portraiture, lamps provide not only light but mood and character. There are certain standard arrangements and basic guidelines for portrait lighting. The possible variations of these are limited only by your skill and imagination.

The four basic lights for portraiture are:

Two 24-inch umbrellas were used for this portrait. One provided key light and the other fill light. Key light was to left of camera and a little higher than subject. The nose shadow does not reach the mouth. A shadow over part of the mouth is usually not flattering. A third light, from high and behind subject, highlighted hair. Photograph by Roland Lombard, Lombard Studio, Hartland, Wisconsin.

**Key Light**—It is the main light, that generates the shadows and gives the face *modeling*. It sets the basic mood for the portrait.

**Fill Light**—This is a soft light, generally near the camera viewpoint. Its purpose is to lighten the shadows sufficiently for shadow detail to record on the film. It should not cause shadows of its own.

**Background Light**—To separate the subject from the background, the latter must be of the right tone. You can control this partly by selecting a light or dark background material, and partly by the way in which you light the background.

**Hair Light**—This is a rim light that is usually applied from high and behind the subject. Its purpose is to put sparkle in the subject's hair or to provide a bright rim light on a shoulder.

It is generally advantageous to use diffused lighting for portraits. Either put reasonably large diffusers over your key and fill lights or use umbrella reflectors.

On the next page you'll see the effects of the four basic lights. If you want to achieve special results in your portraiture, such as high-key, low-key or high-contrast, you'll have to adapt your lighting accordingly. For a more detailed discussion of portrait lighting, see *How To Control & Use Photographic Lighting* by David Brooks, published by HPBooks.

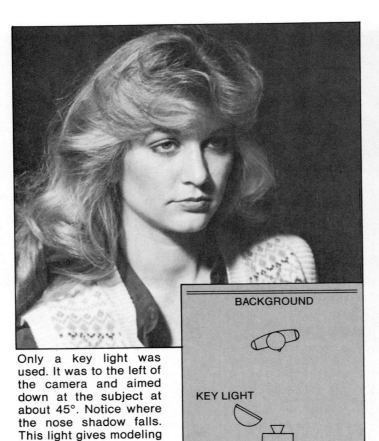

Only a key light was used. It was to the left of the camera and aimed down at the subject at about 45°. Notice where the nose shadow falls. This light gives modeling to the face.

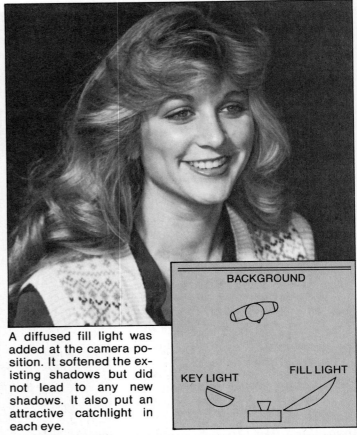

A diffused fill light was added at the camera position. It softened the existing shadows but did not lead to any new shadows. It also put an attractive catchlight in each eye.

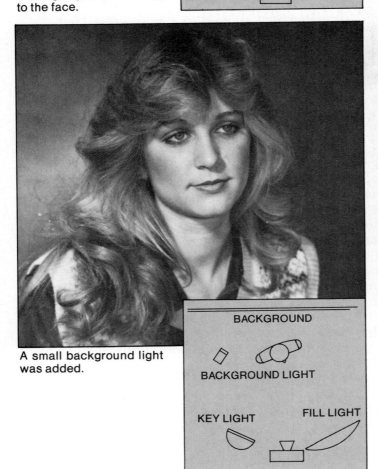

A small background light was added.

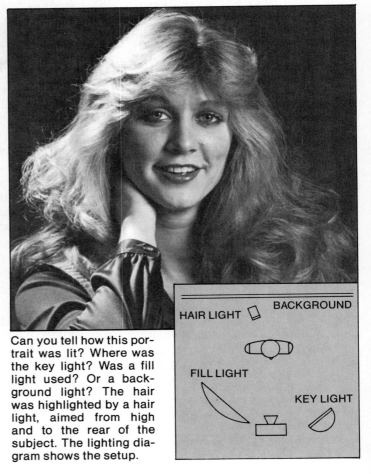

Can you tell how this portrait was lit? Where was the key light? Was a fill light used? Or a background light? The hair was highlighted by a hair light, aimed from high and to the rear of the subject. The lighting diagram shows the setup.

# HIGH KEY AND LOW KEY

A high-key picture is one in which nearly all tones lie at the highlight end of the scale. Most parts of the scene reproduce brighter than a middle gray. The subject should be bright, without large dark areas. For example, a blond person with a light complexion and light clothing would be a suitable subject. A dark-haired man with a black beard and dark clothing would be unsuitable.

The lighting should be soft, without deep shadows. The background should be light, and should be brightly lit.

*Small* dark areas are permissible in a high-key photograph. These might be the subject's eyes or lips, or a small piece of jewelry. Such dark spots can even help enhance the high-key effect of the remainder of the image—but they *must be small.*

The high-key effect is usually associated with lightness and cheerfulness. It is also regarded as ideal for feminine portraiture.

Low key is the opposite of high key. It consists almost entirely of tones darker than middle gray. Only small areas, like the white in the eyes, a white collar or a shiny piece of jewelry, may be bright.

The subject should be dark-haired—or wearing a dark hat—and should wear mainly dark clothing. The background must also be dark. As you may imagine, the low-key treatment lends itself mainly to male portraiture. The lighting is generally dramatic, with deep shadow areas, and relatively small but significant highlights.

A low-key image is generally associated with somberness or sadness, or with masculine strength and ruggedness.

Typical example of a high-key portrait. It's a photo in which most of the image—even the shadows— consists of light tones. Only certain subjects are suitable for high-key photography. This blond girl, in a light dress, and with a bright doll, is typical. Dark-haired people or dark clothing would not be suitable. The background must always be bright. Photographer Roland Lombard used a diffused key light to the left of the camera, facing the front of the girl's face. Two umbrella fill lights were positioned near the left and right side of the camera. Two background lights were used. Photo courtesy of Lombard Studio, Hartland, Wisconsin.

Dramatic double-rim lighting with no fill light produced a striking portrait of an African artist and his work. This is a typical low-key portrait. Dark tones dominate. Photo by Alan Magayne-Roshak, courtesy of the University of Wisconsin, Milwaukee.

Roland Lombard lit this full-length bridal portrait with two flashes. One was slightly to the left of the camera and about seven feet from the floor. The other was aimed toward the front of the bride, also at a height of about seven feet. The light on the right provided the modeling in the face and lit the front of the gown. The light at the camera lit the rear of the gown and filled the shadows on the face. Photo courtesy of Lombard Studio, Hartland, Wisconsin.

When Dennis Poeschel photographed his son, he wanted the lower part of the violin to fade to darkness. Using a relatively small light source, he could have done it with barn doors. When the light source is large and diffused, as was the case here, the darkening is best obtained by holding a card at an appropriate distance between light and subject. The best position for the card must be found by testing.

Two students were lit by two bare-tube flashes. One flash was in the room behind them and the other was to the left of the camera. Front light served as key light, the rear one as rim light for hair and shoulders. Because of nearby reflective walls and ceilings, each light also served partially as a fill light that lightened shadows. Photo by Alan Magayne-Roshak, courtesy of the University of Wisconsin, Milwaukee.

High-key diffused lighting is well suited to baby photography. To photograph his child, Roland Lombard used a key light on the right and two fill lights at the camera position. The background was brightly and uniformly lit.

Electronic flash is ideal for animals, which seem to be always on the move. Dennis Poeschel used two lights to photograph his Irish Setter. A 400-watt-second flash, high and to the left of the camera, provided key lighting. A 200-watt-second flash on the right reduced the lighting ratio. It kept shadow areas bright and put a sparkle in the dog's coat.

Three undiffused lights were used—one to the right, one to the left, and one from high and behind the dog. They gave sparkle to the coat. A diffused frontal light was added to soften the result. Photo by Dennis Poeschel.

# Mixing Flash With Existing Light

Existing light is the light you normally find at a scene, as opposed to the light you, as a photographer, bring to it. It can be the light from the sun, normal room lighting, a floodlit building, street lighting, or a candle. It is also commonly called *available* or *ambient* light.

Unless you're photographing something like the inside of a cave at night, there's always going to be some existing light present. Often it is not bright enough to add significantly to the exposure. Generally, you use flash when there's not enough existing light to adequately expose your film.

However, there will be times when the existing light makes a significant contribution to the total exposure. In this case, you must *balance* the flash brightness with the existing light brightness, to get the effect you want. For example, you can use flash as a fill light to control the contrast of a scene lit by existing light. In this application, most of the exposure comes from the existing light, such as the sun. The flash serves to brighten the shadows and reduce the lighting contrast.

Direct sunlight can cause harsh shadows (left). By adding flash illumination from the camera position, you can lighten these shadows (right). Flash exposure must be carefully balanced. It should lighten the shadows, but not be so bright as to destroy them altogether.

## SYNCHRO-SUNLIGHT PHOTOGRAPHY

Probably more photographs are taken in sunlight than with any other light source. Even though direct sunlight can be great for landscape photographs, it can be less than ideal for many other subjects. The sun in a clear sky is an apparently small point source of light that causes your subject to cast deep, hard-edged shadows.

It is often difficult to retain detail in these shadows. You can lighten them by the proper use of *synchro-sunlight*—the technique of taking photographs with a *mixture* of sunlight and flash. This handy method has been used ever since flashbulbs were first introduced. Its purpose is not to eliminate or overpower shadows, but only to lighten them, increase image detail and reduce contrast.

Electronic flash is easier to apply to synchro-sunlight photography than flashbulbs ever were. There are several reasons for this. First, noon daylight on an average sunny day and electronic flash have a similar color temperature—about 5500K. You can use both with daylight color film without corrective color filters.

A second advantage of electronic flash is its short duration. The flash portion of your exposures is unaffected by your choice of shutter speed as long as the chosen speed is equal to or slower than the camera's fastest flash-sync speed. This lets you control daylight and flash exposure independently. More on this in a moment.

### Fill Flash With A Focal-Plane Shutter

You have only a limited selection of shutter speeds on a focal-plane shutter that will synchronize with an electronic flash. This is described in Chapter 2. You must consider this in your approach to synchro-sunlight photography.

For sunlight shots, select a slow- to medium-speed film, such as ISO 32/16° to ISO 64/19°. With a faster film, you'll run out of aperture settings to choose from because your X-sync shutter speed will be 1/125th second or slower. Remember the old rule: A good sunlight exposure is f-16 at 1/ASA seconds, or the equivalent. At 1/60 second you will need an aperture setting of f-16 on ASA 64 (ISO 64/19°) film. A faster film

Sun is slightly behind and to the left of this shepherd. Without a fill flash at the camera position, shadow on his face and side of his body would have been black. You can see this by looking at the shadows in front of the sheep in the left background. The sheep didn't get the benefit of the flash. Their shadows are black. Photo by Peter Menzel, Stock Boston, Inc.

Shadow on the side of this man's face would have been dark and lacking detail without fill flash. To maintain the character of this sunlit scene, however, it was important not to give too much flash exposure. Otherwise, the shadows would have been totally eliminated. Photo by Alan Magayne-Roshak.

will call for an aperture setting your lens may not have.

First, set your camera for the *fastest* X-sync shutter speed available. Take a light reading and set your lens aperture for a correct daylight exposure—let's say it's *f*-11.

Next, divide the flash manufacturer's guide number for the film speed you're using by 11. This will give you the right flash-to-subject distance. If the flash is mounted on your camera, shoot from this distance. For a lighting ratio of less than 3:1, move the flash closer and set the aperture one-half to one *f*-stop smaller.

Because you are using the flash manufacturer's guide number outdoors, there are no useful surrounding reflecting surfaces. Because of this, the flash will give an underexposure of about one *f*-stop. This is ideal for fill flash.

If you must have a certain light-ing ratio and still be able to change your camera position, have a friend hold the flash or use a light stand. Use a long sync cord to trigger the flash. You could also use a zoom lens to change your subject framing without changing the camera position.

**Fill Flash With A Leaf Shutter**—As mentioned earlier, leaf shutters are used in many non-interchangeable-lens cameras. Some cameras with interchangeable lenses, particularly medium-format cameras, also use leaf shutters. Each lens has its own shutter.

Leaf shutters are the best type to use with flash because they synchronize at all shutter-speed settings. This is particularly handy for photographing with a combination of flash and existing light.

For the most accurate and repeatable results, use your flash manually. Compose the subject in your viewfinder. Determine the lens aperture setting, using the flash-to-subject distance of your on-camera flash and your normal guide number. Let's say the aperture is *f*-8.

Take a meter reading of your subject in daylight. Move in close enough so you measure the sunlit area, not the shadows. Select a shutter speed that gives good exposure with the aperture set at *f*-8. Set your camera to that shutter speed. Set the aperture one-half to one *f*-stop *smaller*. You stop down to allow for the additional light from your flash.

When you take the picture, the film receives good exposure from the sunlight plus some fill from your flash. Because you used the manufacturer's guide number *outdoors,* the flash contributes from one-half to one step less light to the subject than it would indoors. This is due to the lack of reflective surfaces to bounce spill light back

The girl in the chair was lit by flash. To preserve the daylight scene outside the window, the photographer had to balance the flash exposure carefully with the daylight exposure. Photo by Theodore DiSante.

into the photographed scene.

Because the shutter was set for normal flash exposure while the subject was receiving about half that amount of flash illumination, the shadow areas will be about one-step underexposed. The full sunlight exposure plus the one-step-under flash exposure gives you a 3:1 lighting ratio.

To get a lower ratio, open your aperture one step—to *f*-8 in this example. Set your shutter speed one step faster to keep the sunlight exposure the same. Making these changes will keep the sunlight exposure the same as before but will double the flash exposure. If the total exposure now gives you too light a picture, you can close the aperture by about a half *f*- stop to correct for this.

To get a higher lighting ratio, close the aperture half or a full *f*-stop and use a slower shutter speed.

This technique works well because the short flash duration synchronizes at any speed of the leaf shutter. As a result, you have independent control of the sunlight and flash portions of the exposure.

**Existing Light As Fill Light—** You can use synchro-daylight techniques just as easily to *increase* lighting contrast. For example, suppose you're photographing someone or something in a shaded area where there's no direct sunlight. The lighting is too uniform and flat for the type of picture you want to make. In this technique, you use your flash as the key light and the existing light as the fill light.

Take a meter reading, based on the existing light. Set the shutter for a speed that's usable with electronic flash. Set the aperture for 1 or 1-1/2 steps less exposure than a full normal exposure. Remember, the existing light is supplying only the fill light. So you want only about half or less of the normal exposure from it.

Let's say you're using an aperture of *f*-11. Divide your *outdoor*

This picture was taken on an overcast day. The light and shadows on the face were soft.

Here, flash was added. However, in this case the flash was not used as a fill light. It was used off-camera to produce subject modeling. The flash was the key light and the existing daylight served as the fill. Photos by Maron Meeks.

flash guide number—usually about 2/3 of the manufacturer's recommended indoor guide number—by 11 to get your flash-to-subject distance. Connect a long sync cord to your flash. Place the flash high and to the side of your subject, to give you the modeling you want. Be sure to keep the flash the correct distance from your subject. If the distance you calculated is inconveniently long, use your flash in the automatic mode. Set it for an automatic range consistent with an *f*-11 exposure. Make two additional bracketing shots, one at *f*-8 and the other at *f*-16.

You'll now have a photograph with the main light provided by

the flash and the shadow fill light given by the existing illumination.

By using your flash on-camera in dim light outdoors, you can illuminate a subject that would otherwise be greatly underexposed. Or it would be blurred in the picture due to an excessively long exposure time, or lacking in sparkle due to excessively soft lighting. To retain some background detail without overpowering the foreground subject, select a shutter-speed and aperture combination that will underexpose the background by no more than about one exposure step. Set your flash to an automatic range for the aperture you're using. Or, set your manual flash to an aperture about half an *f*-stop smaller than is indicated by the flash-to-subject distance and the flash guide number.

## OUTDOORS WITH FLASH AND FILTERS

Electronic flash produces light that is similar to daylight in color. Sometimes you may want light of a different color. To achieve this, put a colored filter over the camera lens, the flash, or both.

An orange filter over the flash can simulate the illumination of a setting sun on a nearby subject. Most of the exposure should come from the flash, otherwise the color will be diluted by the existing light. The filter will absorb some of the light of the flash. The exact amount depends on the color and density of the filter. Follow the filter factors provided with color filters.

If you're using colored gels that are not specifically made for photographic use, make test exposures. Base the exposure correction on the recommendations provided for a photographic filter of nearly the same color and density.

The equation below shows you how to convert a guide number for any specific filter factor:

$$\text{New GN} = \frac{\text{Old GN}}{\sqrt{\text{Filter Factor}}}$$

Good example of well-balanced flash and existing-light illumination. One flash was near the camera position. It lit the architect and also provided attractive highlights in the metal parts of the diving board. A second flash was slightly behind the architect, on the right side. It provided rim lighting on his left shoulder and arm to separate him from the background. The basic rules for this kind of photography are in the text: Use manual flash. Set the shutter to an acceptable flash-sync speed. Set the lens aperture for correct existing-light exposure. Adjust flash distance or power to give the amount of flash exposure needed. Photo by Alan Magayne-Roshak, courtesy of the University of Wisconsin, Milwaukee.

Photo of the "rolling" onion ring was made with electronic flash and tungsten lighting. First, several flash exposures were made on the same piece of film, with the ring in a different position each time. Then the same film frame was exposed to tungsten lighting. During a two-second exposure, the surface on which the onion ring was standing was slowly and steadily moved from left to right. The tungsten illumination was filtered to match the color of the flash. The end effect is to show the rolling ring as several distinct images, superimposed on a continuous blur. Photo by Bela Horvath, Ferderbar Studio. Photo reproduced by courtesy of Moore's Food Products and Scott, Inc. Agency.

For example, with a filter factor of 2, the new GN would be the old GN/$\sqrt{2}$, or the old GN/1.4.

**Creative Filtration**—To give your photos an abstract or unexpected look, there is a wide selection of colored filters that you can use on the camera lens, the flash, or both. By carefully combining filters, you can achieve color effects that are partly realistic and partly unrealistic.

Cokin Color Back Filters come in pairs. Each complementary pair serves a specific purpose. They enable you to change the color of a scene that's beyond the range of your flash, while keeping the color balance of your flash-lit subject accurate. One filter goes over the flash, and the other over the camera lens. The camera filter is designed to neutralize the effect of the flash filter. If you decide to put together your own filter pairs, you must do so with great care. For example, *any* green filter combined with *any* magenta filter won't do the job. They *must* have color characteristics that neutralize each other. If you want to try this kind of special-effect photography, I recommend that you use the specially made filter set.

The easiest way is to use a color filter on the flash and none on the camera lens. When the background is beyond the range of your flash, the foreground subject will be affected by the filter and the background scene won't. This will give you two distinctly different color effects in your picture.

Changing the color of the background, while keeping the foreground subject in its natural colors, is a little more complicated. It requires two special filters—one on the camera lens and the other over the flash.

These filter pairs must be specially matched in such a way that the effect of the one on the flash is cancelled out by the one on the camera. This gives you a flash-illuminated subject in true colors. Only the background scene, which is affected only by the filter on the camera lens, will have a color imbalance.

Cokin makes several pairs of Color Back Filters that fulfill the above requirements. If you want to match your own filter pairs,

When using Cokin Color Back filters, start with your near subject in the shade. Here, the flash has not yet been added.

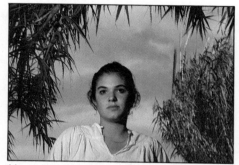

Here, the nearby subject was lit by flash. Daylight exposure was balanced for accurate rendition of the sky. No filters were used. Flash was off-camera, to provide some modeling in the face.

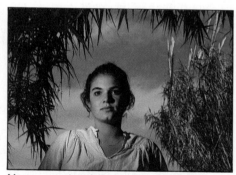

Now, a pair of Color Back filters was used. Notice how filter on the camera has changed the color of the sky. Filter on the flash helped to neutralize this effect on the nearby subject, so that she was reproduced in fairly accurate colors. Photos by Maron Meeks.

remember one important fact: Each of the filters must transmit at least some of each color of the spectrum. For example, a deep red filter that *only* transmits red would not do. You'd have to use a light red filter that transmits *mostly* red, but *also* part of each of the other colors.

Here are a couple of additional

tips on the use of these filter pairs: Be sure the existing light on the foreground subject is not strong enough to influence its color balance. Underexpose a little for the background, to get the deepest possible color there.

With creative filtration you can photograph persons in apparently surreal landscapes. The technique is easiest to apply to a single foreground figure against an expansive background. For example, picture a realistic-looking person in a reddish snowscape or on a blue beach.

Be aware that making this type of shot is considerably trickier than it sounds. It's best to bracket exposures when you first do it, and take good notes of exposure settings.

Place one filter on your flash, securing it with rubber bands or tape. Position your subject so his front is not lit directly by the sun. You want most of the exposure on the subject to be from the flash. Put your camera on *manual.* Take a light reading of the background scene. Some camera meters won't give an accurate reading through strongly colored filters. For this reason, you should take a reading without the filter on the camera lens. Set the shutter speed and lens aperture for correct exposure, as indicated by the meter. Be sure you select a shutter speed that will synchronize with the flash. Let's assume the exposure settings are 1/60 second at *f*-11.

Set the camera's aperture to *f*-11. Attach the filter to the camera lens. Divide the flash guide number by about 2 to compensate for the two filters. This number works for Cokin filter pairs. Other filters may require different compensation. Remember that the flash light goes through *both* filters to expose your film.

Divide the new guide number by *f*-11—the existing light setting. Place the flash at this flash-to-subject distance. Make an exposure at *f*-11, *f*-8 and *f*-16. Because accurate exposure determination with these filters is difficult, you

# FLASH IN COLD WEATHER

If you expect to do a lot of photography in extremely cold weather, you can have your camera *winterized* by a repairman. He'll clean the moving parts and relubricate them with "dry" lubricant—one that won't stiffen in the cold. There's one disadvantage—dry lubricants tend to cause your camera's moving parts to wear more rapidly. If you're not going to shoot for extended periods in very cold weather, forget about the relubrication. Most modern cameras work well enough if they don't get excessively cold.

Leave your autowinder at home in very cold weather—especially if it's very dry. Film becomes brittle when cold and dry, and the fast winder can cause film to break. It can also cause static electricity marks that look like crow's feet on the processed film.

Your biggest problem in cold weather is keeping your batteries working. Low temperatures slow down the chemical reactions that generate electricity. This causes batteries to work less effectively as they get colder. The cold does no permanent harm. Once the batteries warm up again, they come back to life.

The best way to keep your flash working properly when it's cold is to use a remote battery pack that you can keep under your coat or in an inside pocket. Use a cord to supply the power of the battery to the flash unit.

# FLASH IN RAINY WEATHER

An Ewa-Marine waterproof bag will keep your camera and flash dry.

Any flash unit can be rain-proofed easily by wrapping it in a transparent plastic bag.

Weatherproof Minolta Weathermatic 110 camera has built-in electronic flash. It is a compact and reliable companion for your bad-weather picture-taking excursions.

In rainy weather, keep your equipment dry and safe from damage and short circuits.

**Weatherproof Your Flash**—You can make your flash unit rainproof with a plastic bag. Use a transparent bag, and you won't need to cut an opening in it for the light to pass through. Manual operation is best, because light reflected back to the sensor through the bag can cause an automatic flash to give incorrect exposure.

The sync cord should come out of the *bottom* of the bag covering your flash. The other end of the cord, which is attached to your camera, should come out of the bottom of any bag that may be used to keep the camera dry. This will keep water from running down the cord and into your equipment, causing a short circuit.

**If Your Flash Gets Wet**—If you get more than a few drops of water on your flash unit, *switch it off!* Operating a wet flash can damage it and give you a nasty shock. A wet flash is also likely to misfire or not fire at all.

When you get indoors, remove the batteries. Wipe all water from the unit. Place the flash unit in a *warm* oven—about 125F (52C) maximum—for an hour or two. This will dry out those parts you can't reach and wipe. There is a less severe, but slower, way of drying out the flash. Place it in a closed container with a desiccant, such as fresh silica gel, for a day or two. When the flash is dry again, it should work as before.

**Keep The Camera Dry**—The safest way to photograph in the rain is to use a camera that's designed to get wet without suffering damage. The Nikon Nikonos IV is such a camera. There are other, less expensive, all-weather cameras. With some of these cameras you have a choice of several waterproof flash units. Others have built-in flash.

The Nikonos is designed mainly for underwater use. It handles as easily as a regular camera and is completely waterproof. Even its flash-sync connection is watertight.

A regular camera can be made rainproof by enclosing it in a heavy plastic bag. You can use a specially designed bag made for photography under shallow water. Or, you can wrap a regular plastic bag around your camera and secure it with rubberbands or water-resistant tape. The bag should be loose enough so you can focus and work the other controls. Cut an opening for the viewfinder and seal the bag tightly around the finder to keep the water out.

Protect your lens with a lens hood and a clear-glass, haze or UV filter. Secure the bag tightly around the lens hood, too. Wipe the filter dry whenever necessary.

You can buy a clear, tent-like bag that fits over both you and your camera. The bag is made for this purpose and has an elastic hole that fits snugly around the lens.

may want to bracket even more extensively.

Move the flash in closer and repeat the series of exposures. Record the distances. One of the combinations should look just about right on film. The next time you use these filters, use your notes to enable you to get good results with less film usage.

**Variations**—You can also use mismatched filter combinations for deliberate off-beat effects. Theatrical spotlight gels are inexpensive and come in many colors. They work fine on the flash window, but are worthless for use on your camera due to their optical imperfections. Most camera-quality filters have listed filter factors. Use them as a guide.

## ELECTRONIC FLASH AND INDOOR LIGHTING

You can combine electronic flash with indoor lighting just as you can with daylight. However, you must take special care when using color film. Most indoor light sources do not have the same color temperature as electronic flash.

**Color Indoors**—Color slide films are balanced to produce accurate color rendition under specific lighting conditions. Daylight-balanced films are designed for use in average daylight having a color temperature of about 5500K. Tungsten-balanced films are designed for use at a color temperature of either 3200K or 3400K.

Electronic flash has almost the same color temperature as daylight. It can, therefore, be used in conjunction with daylight. However, the color temperature of electronic flash is very different from that of most other *artificial* light sources. Thus, when such light sources are to be used together for photography, some corrective measures are necessary for good color reproduction.

When daylight-balanced film is exposed with electronic flash, color rendition will be satisfactory.

When the same film is exposed by tungsten light, the result will have a distinctly reddish imbalance. When daylight film is exposed to a combination of electronic flash and tungsten lighting, the parts lit predominantly by the flash will have a fairly correct color rendition while the parts lit mainly by tungsten light will appear distinctly reddish.

**Flash And Tungsten Light**—For the best results, all the existing light you'll be using should be of the same color temperature. You don't need to buy an expensive color-temperature meter. You can do nearly as well by checking the lighting in the area before taking your photographs.

There are two types of photographic tungsten lamps. One has a color temperature of 3200K and the other of 3400K. Type A color film is balanced for photography in 3400K light. If you use this film with tungsten light and flash, the *flash* must be filtered with a color-conversion filter. Try an 85 or 85B. Type B color film is balanced for use with 3200K light. If you use this film with tungsten light and flash, try the 85B filter on your *flash*. Be sure the filters you use are large enough to cover the entire flash.

It's useful to remember that reddish photographs are generally more acceptable-looking than bluish ones, particularly if people are in the scene.

**Flash And Fluorescent Lighting**—Color photography with fluorescent lighting is more complicated than with tungsten lighting.

Using electronic flash in combination with typical fluorescent lighting can be tricky. The two lights have very different color characteristics. To get reasonably balanced color reproduction from both light sources, use a filter over the flash and another over the camera lens. As explained in the text, green and magenta filter pairs for this purpose are produced by several manufacturers.

Photo was made with fluorescent light and electronic flash, using the filtration just discussed. Picture lacks the usual unpleasant greenish appearance of photos made in common fluorescent lighting. To keep the existing-light exposure reasonably short, photographer Alan Magayne-Roshak used ISO 200/24° film. Photo courtesy of the University of Wisconsin, Milwaukee.

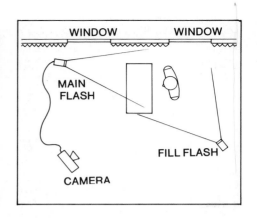

Key light from left simulates and adds to window light. Fill flash was used from right side. To maintain indoor/outdoor effect, don't overdo the flash. The key-light effect on the executive at his desk is good. He appears to be lit by daylight coming through the window. Electronic flash is particularly useful for this kind of photography because its light has the same color temperature as average daylight. Photo by Alan Magayne-Roshak, courtesy of the University of Wisconsin, Milwaukee.

Many fluorescent lamps give light with a somewhat irregular color spectrum. Some colors are deficient, while others are present in peaks consisting of narrow wave bands. This means that accurate color rendition is difficult, even with the use of corrective filtration.

Because fluorescent lighting is so prevalent today, photography with this kind of illumination has become common, and even necessary.

There are many different types of fluorescent lamps. Each has slightly different color characteristics. Color photographs made under most fluorescent lamps without filtration tend to have a distinctly green imbalance.

For best color results, the area photographed should be lit by lamps that all have identical color properties. The more the color of the light resembles daylight, the better. Often, you will find that an area is lit by lamps of different types, and different ages. Avoid taking color pictures in these conditions, when possible. It can cause one end of a room to have a totally different appearance than the other end.

Filter manufacturers such as Kodak, Tiffen and Singh-Ray offer filters to compensate for the pecularities of some fluorescent lighting. These filters are called by descriptive code numbers, like FL-D or FL-B, to make it simple to select the right one for the job. An FL-D filter is for fluorescent light on daylight film; an FL-B filter is used with Type B film. They give generally pleasing color correction with most fluorescent lamps. To use flash fill light, you need to filter your flash so its light matches the color of the fluorescent lighting.

Singh-Ray offers both camera and electronic-flash filters in several sizes. For the camera, there's the SR-D filter for daylight film and the SR-B for Type B film.

Place a Singh-Ray Flash/Fluorescent filter on your flash. This filter is green and helps your flash match the color of fluorescent light. Divide the flash guide number by 2 when using this filter. Determine your flash-to-subject distance in the normal way.

Meter the scene without the camera filter on the lens. Open your lens by an additional 2/3 f-stop to allow for the loss with the filter in place.

What you're doing is filtering the light from your flash so it nearly matches the color of the fluorescent lighting. Then you filter all the light that enters the camera to match the characteristics of your film. The combined filtration should give natural-looking color photographs.

Because of the characteristic flicker of fluorescent lights, a shutter speed of 1/4 second or slower is recommended to ensure consistent exposures. Be sure to use your camera on a tripod for exposures of this length.

**Fill Flash Indoors**—Set the camera for a full existing-light exposure, using an acceptable X-sync shutter speed. Let's say it's 1/30 second at f-2.8. To avoid overpowering the existing light, your flash must supply less exposure than this. That is, it should supply enough light for a normal exposure at about f-2.

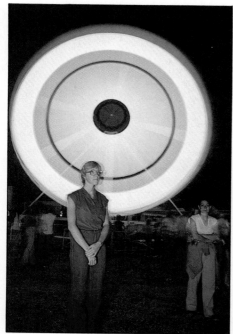

This isn't a flying saucer, but a rapidly rotating carnival ride. Camera was on a tripod. Existing-light exposure was about two seconds. At the end of the exposure, the model was lit by flash. The model had to stand reasonably still for the entire exposure. Otherwise, the illuminated background would have been visible through her in the final image.

Striking photo of a saguaro cactus skeleton was made in the Arizona desert. Without flash, the skeleton would have been silhouetted against the sunset. Photographer Steve Meckler chose to highlight the structure with on-camera flash.

If you have a variable-power adjustment for your manual flash, turn it down to a low enough guide number so you can use *f*-2.8 at the distances you'll be shooting from.

Whether you use automatic or manual flash, it's advisable to actually set your camera aperture to *f*-3.5 if the existing light calls for *f*-2.8. This will compensate for the added flash exposure. You may want to try some exposures at *f*-2.8, too. This will give you more shadow detail and a lighter background from the existing light.

**B&W Indoors**—When you use flash to supplement artifical lighting with b&w film, you needn't worry about corrective color filtration. Because you'll have only dim existing light to work with, you can use higher-speed films, such as Kodak Tri-X and Ilford HP5. That way, you won't get stuck with impractically small lens apertures.

## FLASH AND BLUR
## TO SHOW MOTION

One way to give the illusion of motion in a photograph is with deliberate image blur. Use a slow shutter speed, such as 1/4 or 1/2 second, and an aperture setting to suit the existing light. Your moving subject will photograph as a blur if the motion is fast enough. To add extra interest, set off your flash manually with the open-flash button near the end of the existing-light exposure time. To get a different kind of effect, you can set off the flash at the *beginning* of the exposure. Either way, you'll get a combination of blurred and sharp image. Select a flash brightness or distance that is compatible with your existing-light aperture setting.

This ring light—like most other ring lights—does not provide automatic exposure control. Good exposure depends on the use of guide numbers, testing, and exposure bracketing.

Mounted ring light surrounds the camera lens. It provides shadowless illumination. This Soligor AR-20 Auto Ringlight is one of the few units offering automatic exposure control.

Some flash units have special characteristics, designed for specific applications. In addition, there are special flash applications that can be achieved with regular flash equipment.

## Ring Lights

A ring-light flash tube and its reflector are circular, or doughnut-shaped. The reflector housing is generally threaded to fit regular filter-series threads on camera lenses. A ring light is nearly always designed to surround the camera lens.

Mounting the flash this way violates the general guidelines I have stressed through this book. Instead of being held away from the lens for better modeling, the ring light's axial position is intended to produce no shadows and, therefore, little modeling. This kind of light is ideal for certain purposes, as you'll see a little later.

Before I go into applications and techniques, let's take a look at some of the different ring lights you can choose from.

### POWER AND SIZE

The beam angle of most ring lights is 60° to 70°. This is wide enough for use with a 35mm wide-angle lens on a 35mm camera.

Power is the main thing to consider when you're shopping for a ring light. Many small units, powered by AA cells, are best suited for close-up work. Typically, their reflectors are about 3 inches in diameter and they thread onto a 49mm or 55mm thread.

Their power packs have an output of up to about 40 watt-seconds. Power packs are always separate from the reflector assembly. This helps lighten the load on the lens. With distance scales in feet, a guide number of 40 is typical for ISO 100/21° film. With a

ring light of this size, you can photograph objects as close as two inches from the lens.

Larger units generally fit a series-9 lens thread. They can be used for photographing small machinery. They can even be used for small group portraits—if this kind of illumination suits your specific need. If the lens is too small to take the thread, you can use a step-down adapter.

Both battery- and AC-powered units are available for these lights. You can use from 25 to 200 watt-seconds of power with them. Their reflectors have a four- to five-inch diameter and you can shoot a subject as close as one foot from the camera lens. If you get too close to the subject, the illumination will be uneven, with the center darker than the outer area.

## STUDIO RING LIGHTS

The largest ring lights are studio units that handle from 400 to 1800 watt-seconds of power. Generally, they are AC-powered, but on location you can power them with a portable generator. The reflectors are 16 inches in diameter. They can be mounted either on the camera or on a light stand directly in front of the camera so the lens looks through the ring light.

## SCIENTIFIC AND INDUSTRIAL USES

Photographers are frequently called upon to produce detailed photographs of machinery or apparatus with complex, overlapping parts. Medical and biological photographers are often required to produce images with the greatest possible amount of unobstructed detail and information.

If you use a single flash off to the side of your camera, some of the overlapping parts of a complex subject will cast obscuring shadows on other parts. A second flash, on the opposite side, would lighten these shadows but would cause others.

A simple subject—one with

A ring light is ideal for simple nature subjects like this. Its ease of operation enables even the non-expert to get satisfactory results fairly consistently.

minimal depth or no overlapping parts—could perhaps be photographed perfectly well with this kind of lighting. A complex subject, such as an assembly of gears, calls for a different approach. This is where a ring light is handy.

Because a ring light sends a nearly uniform cone of light that's essentially on axis with the camera's view, no part of your subject will cast a shadow visible from the camera position. Even relatively deep enclosures, such as are common in an electronics assem-

bly, are uniformly lit so all the working parts are clearly distinguishable. Deep enclosures can be difficult to light by other means.

Ring lights don't work well on glossy surfaces. You'll get too much glare from the flash tube's reflections. In such cases, off-camera flash is a better choice.

## SMALL-OBJECT PHOTOGRAPHY

Ring lights are useful for close-up photography of very small objects, including insects and plant

This accessory, made to fit over a ring light, contains two coaxial and mutually crossed polarizers. One polarizer fits over the ring light, the other over the camera lens. The combination enables you to eliminate or greatly reduce unwanted reflections from many non-metallic objects.

Reflection from the ring light destroyed much of the detail in the watch face (left). With the coaxial polarizing filters, image through the watch glass is clear and unobscured (right). All detail on the watch face is clear, but image looks lifeless and dull. To get an attractive photograph, it is generally best to leave some minor reflections or use a different lighting setup.

parts. These lights are particularly useful when you're photographing on location. The ring light always aims itself—wherever you point the camera, the light's right there.

The flat lighting effect is suitable for color work. The lighting ratio is virtually 1:1. The illumination appears shadowless, and you're not likely to exceed the contrast limitations of your color film.

You can modify ring lighting somewhat by covering portions of the flash head with black tape to block off some of the light. This will partially eliminate the symmetry of the lighting to give a slight illusion of directional lighting.

## EXPOSURE CORRECTION

Calculating flash exposure in small-object photography is not as simple as in regular photography. As you get closer to your subject, the light from the subject is spread out over a wider area, to give a larger image. Consequently, the effect of the light is weaker. Because of this, you'll need to open your lens aperture more to get correct exposure.

Some 35mm SLRs, such as the Olympus OM-2N, the Nikon F3 and F6 cameras, and the Pentax LX, feature through-the-lens exposure control for both existing-light and electronic-flash photography. Because the photocell reads the light actually passing through

the camera lens, it automatically compensates for the dimmer image given by a very close subject. This automatic exposure-compensating system relieves you of concerns about exposure, leaving you free to concentrate on the subject and the picture.

The Olympus T10 ring flash can be operated as a manual flash or as an automatic exposure unit, used in conjunction with the OM-2N camera's photocell. It is a low-power unit, specifically designed for close-up photography. Power is supplied by Power Control 1. This is a standard Olympus shoe-mount unit that has an electrical socket in the place of a flash tube and reflector.

The calculator scale you use for manual operation of the T10 ring flash compensates for the light loss you'll experience at close shooting distances—a very handy feature.

To make focusing easier in dim light, the T10 has several small incandescent lamps built into the lamphead. You need a separate battery or AC supply to operate these lamps, because the batteries in the Power Control 1 only fire the flash tube.

## FASHION PHOTOGRAPHY

Relatively powerful ring lights, from 40 to 200 watt-seconds, are occasionally used in fashion photography for special-effect lighting. Ring lighting works well with some kinds of clothing. The frontal

This setup consists of an SLR with a macro lens and a ring light, mounted on a small tripod. It provides one of the easiest ways of making good close-up photographs.

Olympus T10 Ring Flash can be used with automatic exposure control with Olympus OM-2N camera. It can be used manually with other Olympus cameras. In the manual mode, a calculator on the back of the unit tells you what lens aperture to use. Calculator makes the necessary correction to compensate for light loss due to image magnification.

illumination can highlight threads in the material.

You'll get little modeling on your model's face. You may want to accentuate the face makeup, to compensate for this.

Red-eye, described earlier in this book, is frequently encountered in photographs of people taken with a ring light. It happens when the subject looks straight at the camera and is most likely to occur with children and blue-eyed people. Red-eye is more evident when the existing-light level is low, so that the pupils are large. It is most easily avoided by having the subject turn the eyes slightly away from the camera lens.

You can handhold a ring light and use it off-camera, just like any other flash. The results are similar to those you would get with any other diffused off-camera flash unit.

A ring light is excellent for use in an umbrella reflector, where it works just like a regular flash. You screw the ring light into a simple adapter that slips onto the shaft of the umbrella. For the low cost of the adapter, you can greatly increase the usefulness of your ring light.

# Close-Up Flash

Close-up photography, with a ring light or other forms of electronic flash, can be both useful and fun. It's a way of photographing things so you can see them larger than you're used to. Close-up photography can play a useful part in many hobbies, including stamp, coin and rock collecting, model railroading, and others. The short duration of electronic flash makes it especially suitable for photographing small living and moving things.

Generally, to get a larger image of the subject on the film, you have to move your camera closer to the subject. With electronic flash, two possible problems arise when you do this.

First, you must take special care

that the flash is aimed directly at the subject. For subjects at normal distances, a camera-mounted flash covers approximately the same view as the camera lens. At very close distances, the separation between the flash and the lens becomes significant. The flash may then cover a different area than the image area recorded on film. Some steps must be taken to overcome this parallax problem.

Some flash heads can be tilted down toward the subject area. An alternative is to use off-camera flash.

Second, flash reflectors are designed for use at normal flash distances—usually at two feet or more from the subject. When you get very close to a subject, the reflector design may not perform in its intended manner. This means that you can no longer rely on the manufacturer's recommended guide number. To get correct exposure, you must do some testing. You can begin by using the recommended guide number and bracketing exposures up to two f-stops in either direction.

A third problem in close-up photography relates to all forms of illumination, including flash. As you increase the lens-to-film distance with the use of extension bellows or tubes, the lens aperture

becomes effectively smaller. To get an adequate amount of light on the film, you have two alternatives. One is to open the lens aperture. However, this is generally not advisable in close-up work, because it reduces your already limited depth of field. Remember that depth of field decreases rapidly as magnification increases. The second alternative is to give more exposure.

Close-up lenses, which magnify the image on film without using extra camera extensions, do not have this problem. No additional exposure is required.

## CLOSE-UP EXPOSURE

The aperture numbers on the camera lens—f-5.6, f-8, f-11 and so on—represent, among other things, the amount of light that will reach the film. Each step higher in f-number represents a halving of the light that passes through the lens. For example, f-8 lets through half the light permitted through by f-5.6.

Each f-number is the ratio of the focal length of the lens to the diameter of the lens aperture at that particular setting. For example, at f-8 on a 50mm lens, the diameter of the lens opening is 50/8mm or 6.25mm.

When you focus the lens on in-

Extension tubes and rings allow you to magnify small objects on film, using a standard camera lens. These extenders are generally considerably less expensive than a special macro lens.

If you plan to do a lot of high-magnification photography, a bellows extension is a good investment. It gives you a continuous range of magnifications. If you are not using a ring light, be sure that your flash is aimed accurately at the subject.

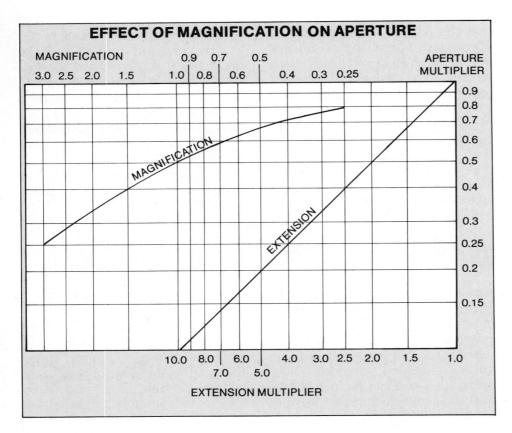

## EFFECT OF MAGNIFICATION ON APERTURE

Let's find out what lens setting will give an *effective* aperture of *f*-16 at a magnification of 0.5X, or a half life-size reproduction.

Use any straightedge—a ruler, pencil or piece of card—and place it vertically at 0.5 on the magnification scale. Where the straightedge intersects the magnification line, go horizontally to the aperture-multiplier scale. There you'll read off an aperture multiplier of 0.67. Multiply the aperture you got from your flash guide number—in this case *f*-16—by 0.67. You'll get 10.72. You can round this off to *f*-11. Set your aperture ring to *f*-11.

Your *lens* will now be set to *f*-11, but because of the extra *camera extension*, the *effective* aperture will be *f*-16.

You can also determine the effective aperture directly from the lens-to-film extension. If the lens has a focal length of 50mm and the extra camera extension is 25mm, the total extension is 75mm, or 1.5 times the focal length of the lens. Follow the 1.5 mark on the extension multiplier scale vertically until it intersects the extension line. Reading horizontally from this point, you again get 0.67 on the aperture-multiplier scale.

finity, the lens-to-film distance is equal to the focal length of the lens. As you focus on closer subjects, the lens-to-film distance increases. For objects a few feet away, this increase is not significant. However, as you move really close to your subject, the lens-to-film distance increases so much that exposure is affected.

This is because the lens aperture now relates to a distance much greater than the focal length of the lens. Let's assume we're photographing an object at life-size, and see what happens to the *effective* aperture.

At life-size, the camera extension is twice the focal length of the lens. This means that the lens-to-film distance with the 50mm lens is now 100mm. When you divide this 100mm by the 6.25mm diameter of the *f*-8 aperture, you'll find that the new *effective* aperture is *f*-16. What this means

in terms of exposure is that, under identical lighting conditions, you'll now need two exposure steps more exposure—or four times as much exposure.

When you're photographing by continuous light, and your camera has TTL metering, the above is no problem. The exposure adjustment is made automatically. Some dedicated-flash units also use the camera's photocell to compensate automatically for the light loss.

If you're using regular flash—manual or automatic—you must compensate for the effective aperture change at close distances.

**Calculating Effective Aperture**— The chart above works only with standard and macro lenses. It does not work with lenses of special design, such as telephoto and wide-angle lenses. Also remember that flash reflectors may not behave in a predictable manner at close shooting distances.

## LIGHTING TECHNIQUES FOR CLOSE-UP PHOTOGRAPHY

Some flash units can be tilted downward when they are mounted on the camera. This way the light can be aimed accurately at a nearby object. Or, you may be able to use a ball-and-socket bracket between the flash and the camera to do the same thing.

An effective alternative is to use your flash off-camera. This has many advantages. It enables you to aim the flash as you wish. It also allows you to move the camera about without affecting the illumination. The greater flash distance you get this way helps to eliminate the unpredictable behavior of the reflectors at extremely close distances. In addition, the farther your flash is from the object, the less likely you are to get light fall-off, or uneven illumination.

**Cross Lighting**—This is a popular technique for close-up lighting. The subject is lit from two sides by two identical lamps. Both are placed at the same distance from, and angle to, the subject. Cross lighting with flash for close-up work generally consists of two small flash units, mounted on a special bracket attached to the camera. This kind of lighting gives even, shadow-free illumination.

To get the effective guide number of two flashes used in this way, multiply the close-up guide number for one flash by 1.4.

When cross lighting is positioned to strike a flat, shiny object—such as a coin or medal—at a glancing, oblique angle, it is also called *dark-field* illumination. This is because it causes the field, or plane surface of the object, to reproduce dark, while the raised contours are highlighted.

**Axial Lighting**—This is light that basically follows the same course as the lens axis. Ring lights give illumination that's almost axial. The following is a way to get truly axial lighting.

A thin, optically flat and thoroughly clean sheet of glass is placed below the camera lens. For very small objects, a microscope slide glass is ideal. For larger objects, a proportionately larger piece is needed.

A small flash is pointed horizontally at the glass. The glass is angled at 45° to the light and the vertical lens axis. The object to be photographed is placed below the glass and camera lens.

The flash light is reflected from the glass to the object, to illuminate it. It then goes through the glass to the camera lens and film, to make the image. To prevent stray light from the opposite side of the glass from being reflected into the lens and spoiling the image, it is essential to place a dark shield on the side of the glass opposite the flash. A simple piece of black cardboard will do.

With this kind of lighting setup, determine exposure by testing.

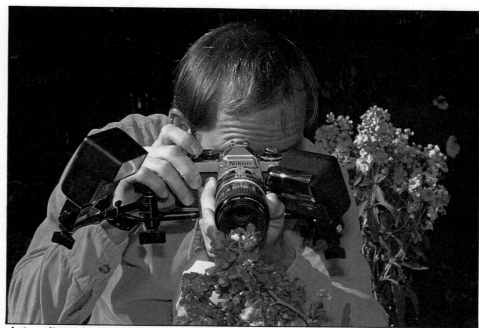

A two-flash bracket is very useful for close-up photography. Each of the flash heads can be aimed inward or tilted. Each can be centered on the object being photographed or pointed in another desired direction. The macro bracket shown is from Lepp and Associates, P.O. Box 6224, Los Osos, CA 93402.

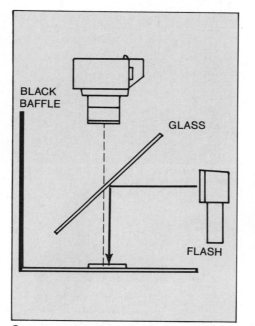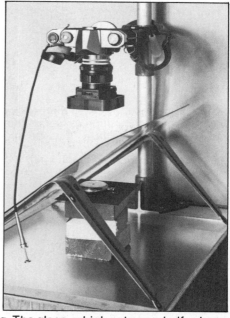

Construct this kind of setup for axial lighting. The glass, which acts as a half-mirror, must be 45° to the horizontal. Size of glass you need depends on size of object you're photographing. Beam of light must come horizontally from the right. It should be directional light, not a diffused source. To avoid unwanted lens flare, either make your exposures in a darkened room or place a black baffle to the left of the glass.

Axial lighting on a flat and shiny object—such as a coin or medal—is also known as *bright-field* illumination. This is because it reproduces the flat surface, or field, of the object brightly, and the raised and lowered contours as dark lines.

Typical example of axial illumination. It is also known as *bright-field* illumination because the flat field of the object is bright. Notice that image has a dark outline wherever there is a raised or lowered contour.

One frontal flash, a few inches above the camera, was enough to record this charming event. Photo by Dennis Poeschel.

To get clear and shadow-free background, lemon was placed on a light box. Lemon was lit from above by flash with a large diffuser in front of it. Lightbox and flash exposures had to be balanced carefully. If light box provided too much exposure, the light would have "burned into" the outline of the lemon and possibly destroyed the image of the stem. When making pictures of this kind, it's wise to bracket exposures. Photo by Theodore DiSante.

# Infrared Flash Photography

Infrared (IR) film allows you to photograph by radiation invisible to the human eye. There are color and b&w infrared-sensitive films. They can produce fascinating photographs of things you cannot see. Infrared is an important tool in scientific, medical and law-enforcement photography.

## B&W

Photos on b&w infrared film feature dark skies, making clouds stand out in a dramatic way. Many kinds of foliage appear snow-white in the photograph. Although flash photography cannot be used on distant scenes, it can be used for infrared photography within the range of the flash.

**Focusing**—With infrared radiation, your lenses have a slightly longer focal length than with visible light. To allow for this, when using b&w infrared film, you have to change your normal focus setting slightly. Most modern camera lenses have a red indicator mark very slightly to one side of the normal focusing mark. Focus the camera in the normal way—without a filter on the lens. Then transfer the distance opposite the normal focusing mark to the red mark. Your camera will now be set for best focus with b&w infrared film.

**Flash And Filtration**—The reason for using flash in b&w infrared photography is to allow the desired infrared and deep-red part of the spectrum to reach the film, while keeping all other light out. There are three basic ways of using flash with b&w infrared film:

• Use the flash unfiltered. Place an infrared-transmitting filter, or a deep-red filter such as a Wratten No. 25 or No. 29, on the camera lens. The camera lens transmits only the deep-red or infrared part of the flash illumination to make the image. Even if you're in dim room light, you should still use the IR filter over the camera lens to exclude unwanted visible light.

• To make the flash less noticeable—such as when you want to photograph people without their knowledge in dark surroundings—use a deep-red or infrared-transmitting filter over the flash head.

• Use a professional infrared flash unit, such as the Sunpak Nocto. It emits virtually only infrared radiation; most visible light is blocked.

Sunpak Nocto is one of the few infrared flash units available. It's intended for use with b&w infrared film.

In a typical infrared portrait, the skin is very light and looks translucent. Lips also tend to be very pale.

Unless you're in a dark room and looking straight at the flash unit, you probably won't see the flash at all.

One advantage of using this flash is that you're provided with reasonably accurate guide numbers. With any other flash/filter combination, you have to establish your own guide numbers by experimentation.

The deep-red Wratten No. 25 and No. 29 filters, such as you may already have in your equipment, transmit enough visible light for viewing and for shooting with a handheld camera. The series 87, 88 and 89 filters transmit infrared radiation at varying wavelengths, and no visible light. These filters are visually opaque, so you can't view through your camera viewfinder. Use a tripod.

**Exposure**—Infrared film tends to be very contrasty and to have little exposure latitude. For this reason, it's a good idea to bracket exposures—even those made with the relatively consistent Sunpak Nocto. Another good reason for bracketing is that you won't know how reflective your subject is to infrared. Just because things look light or dark to your eyes doesn't mean they'll photograph that way.

Examination of a few infrared photos will quickly convince you of this! Dark-green leaves look very light on infrared film. A black person's skin will look nearly as light as a white person's—and the white person's will look whiter still.

### INFRARED EKTACHROME
This is a *false-color* film. Colors,

including near infrared, are reproduced on this film very differently from those seen in the scene. The film was originally developed for detecting camouflage installations among live foliage.

Don't use infrared flash with this film. Remember, it's a *color* film. All you would get is monotonous red slides that look like the inside of a darkroom lit by a ruby safelight. A regular, unfiltered flash works best.

Use a yellow filter over your camera lens. A Wratten No. 12 is a good choice. A No. 8 or K2 filter works well, too. If you do much regular b&w photography, you may already have an appropriate yellow filter.

In the processed photographs you are likely to see some surprising things. Green foliage, which

White ferns? Not really! Just a b&w infrared photograph. Many types of foliage are highly reflective of infrared radiation. That's why trees, shrubs and other plants—like these very normal ferns—often look pale in a b&w infrared photo.

reflects a lot of infrared, reproduces as bright red. Red roses tend to photograph yellow. Some green dyes reproduce magenta. Blue skies look almost normal. Flesh tones don't appear strikingly abnormal, although they don't look exactly flattering. Some blue flowers photograph yellow. IR Ektachrome is full of surprises.

I like to photograph people, with lots of plants and flowers. The effect of the red leaves is always a shocker. It's fun to photograph people who are wearing brightly colored clothes without telling them you're using IR color film. See what their reaction is when they see their wardrobe in all the wrong colors!

As I've said, the infrared color film cannot be considered particularly flattering. Flesh tones are inaccurate. Often veins become prominent and eyes look blank and empty. Sometimes, though, you can get a photograph with a hauntingly dreamy atmosphere.

A word about focusing: Because the image on this film is made mainly by visible light, you should *not* refocus for the infrared.

For best exposure, set the calculator dial on your flash to ISO 100/21°. This film is quite contrasty, so use your flash on-camera to keep the lighting flat and take several bracketed exposures in half-step increments.

You can process your Infrared Ektachrome film with an Ektachrome E-4 processing kit or have it processed by Eastman Kodak.

## CARE OF INFRARED FILMS
Infrared film cannot be stored for as long as conventional films. To get the best quality images, don't buy the film until you need it. If you have any b&w infrared film left over, store it in a refrigerator. Infrared color film should be stored in the freezer. When you remove film from cold storage, allow it to warm up to room temperature before you break the seal on the package, so that you don't get condensation on the film.

Load infrared film into your camera in total darkness, and do so just before you intend to use it.

Infrared color film does strange and unexpected things. Photo at left was taken on conventional color film. Colors are reproduced accurately. Photo at right was made on color infrared film. It's obvious how much infrared the dress reflected. Skin tones and lips have characteristic pale translucent look you would expect from infrared film. Green fern, which reflects a lot of infrared radiation, reproduces red on infrared-sensitive film. Red flowers are reproduced in a totally false color.

This photograph was made in a professional's studio, using a full complement of studio lighting. However, with just three lights and a few large and efficient reflector cards, you can do some ambitious studio-type photography in your home. Photo by Bela Horvath, courtesy of Ferderbar Studios, Milwaukee.

Image of this smoking match was magnified 3X on film. This called for an exposure-increase factor of 16X, or 4 exposure steps. Flash-meter reading at the position of the match indicated a lens aperture setting of $f$-64. Photographer opened the lens by four stops to $f$-16. Black background was necessary to outline the smoke. The smoke doesn't last long after you blow out the match, so you have to act quickly to get your picture. Photo by Theodore DiSante.

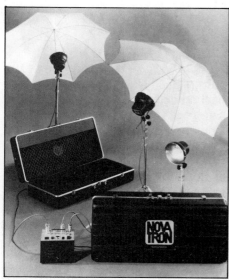

If your flash photography is not going to be done mostly in one location, you need a portable lighting system. This three-head set, with umbrellas, is equally useful in the studio or on location. The kit fits into one of the carrying cases shown.

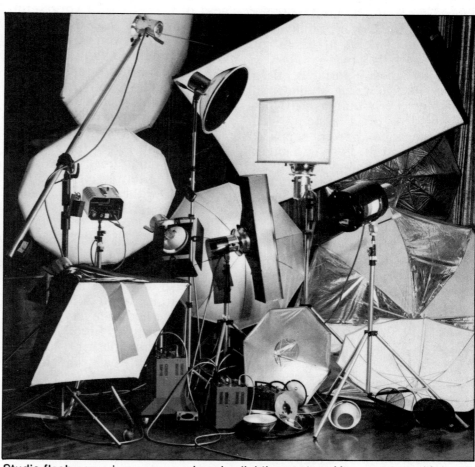

Studio flash comprises a comprehensive lighting system. You can start with just a couple of lights and end up with this collection, or even more.

Photography that you do anywhere else besides an area specifically intended and equipped for it is *location photography*. The location can be a natural scene or a contrived setting. You may photograph a car on a mountain highway, jewelry on a tree stump, or machine parts on a pile of rocks.

Location photography can also be done indoors. Factories, offices and laboratories are all "locations."

If you take photographs in a place *specifically* set aside for photography, whether it's a small corner or a gigantic room, you're doing *studio photography*. You're better able to control everything—lighting, subject and distractions. You can build a complex set or use a plain background paper. The choice is yours.

Studio-flash equipment differs in some ways from portable flash. It is mainly for the professional photographer or the advanced amateur. It's more expensive than amateur flash equipment and requires more care in its selection.

Some studio lighting equipment can be used for location work. Because all studio flash is powered by AC, your main concern when on location is whether or not there is adequate electrical power available.

Because it is AC-powered, studio-flash equipment can be made extremely powerful. You are not limited by the availability or cost of batteries large enough to run the lights. You can also use modeling lights, described later.

## STUDIO-FLASH POWER

The power of a studio-flash unit is generally given in watt-seconds (WS). This, as you remember, is the measure of the energy stored in the main capacitors of the flash unit. Some manufacturers also rate their units in BCPS like portable flashes, but watt-seconds are the most commonly used units for comparing the power of individual flash units. There's a reason for this.

Unlike most portable flash units, practically all studio-flash equipment is sold as components—parts of a system. You select separate power supplies, flash heads, reflectors and other accessories for the type of work you intend to do. Watt-second ratings help you to select safe combinations of flash heads and power packs. I'll get back to this later.

The wide selection of accessories is the key to the versatility of studio flash. You can quickly change the output and quality of your lighting to meet just about any photographic requirement. Let's look at what studio-flash equipment is and what it can do.

## MONOFLASH

This category represents the least powerful studio-flash unit. It is called *monoflash* because the flash head and power supply are all in one piece. Units generally range in power from 100 to 800 watt-seconds, or 2000 to 16,000 BCPS, with standard-angle flood reflectors attached. Most monoflash units put out from 2000 to 4000 BCPS.

The big advantages of a monoflash are low cost and reasonably high light output. The unit is also easy to carry from place to place and to set up. Monoflash is a good choice for the home studio as well as for general studio and location work. Even though each flash unit combines both a heavy-duty power supply and a flashhead, it is still compact and light enough to use on light- to medium-weight light stands.

Most monoflashes have built-in modeling lights, intended for previewing your lighting arrangements. You can also use the modeling light to estimate flash-exposure settings, as I will explain a little later.

Many monoflashes have switches for selecting the brightness of each flash in your setup. Still others let you dial in any brightness level you want. Generally, the brightness of the modeling lamps of these units changes proportionately with the flash brightness you select.

Other features you'll find in some monoflashes include built-in photoelectric slave triggers and *flash-fired* indicators. Slave triggers are for setting off more than one flash without wires attached to all of them. Flash-fired indicators are handy when you're using several flashes at once. These indicators blink momentarily after your flash fires, to show you that each flash did, indeed, fire. Without them, it's often difficult to tell for sure whether every flash in your setup actually fired.

Some monoflashes have a timing circuit that will fire the flash tube several times in quick succession for as long as your camera's shutter is open. This *strobe* feature is used to take stop-action sequences of moving subjects.

A monoflash head can offer many features. This one even offers stroboscopic operation. Monoflash doesn't necessarily mean *small*. Some units are large and powerful.

A useful feature found on some monoflashes is a slow/fast recycle speed switch. A slow recycle speed is one way to keep from blowing fuses. If you plugged two large monoflashes into the same household outlet and both were set on fast recycle, you might blow the outlet's fuse or circuit breaker. At the slow recycle setting, the flash units draw less current.

## SEPARATE-HEAD FLASH

As you get to more powerful studio-flash units, the power packs become too heavy to mount safely at the top of light stands. The power packs and flash heads of larger units are packaged separately so most of the weight can be at floor level or in some other safe location. Only the relatively light-weight head is attached to the stand. However, weight isn't the only reason for separating the two.

Power packs have two or more connections for attaching cables that go to separate flash heads. Frequently, several flash heads are used at one time on a power pack. The watt-seconds stored in the power pack can be divided among the heads in different proportions. You can set this with a switch.

**Versatility**—Power packs are versatile. They range in energy-storage capacity from 100 watt-seconds—no more than that of some shoulder-carried portables—to heavyweights that can store more than 10,000 watt-seconds of energy. Larger power packs, sometimes called *generators*, are usually powered by 205- to 220-volt AC lines. This makes them more efficient and lowers the amount of current they draw.

Many power packs can be connected in parallel, so their *combined* power can be discharged through a *single* high-powered flash head. *Piggy-back* boosters are also available for some units. These are sets of capacitors that you can connect to a flash to get more watt-seconds of power. They cost less than extra power

packs because they don't have their own charging circuits. Their drawback is that they increase the flash recycling time.

The ability to channel power to several heads from one power pack or to supply one head from several power packs is an important feature of studio-lighting equipment.

A studio may have each of its photographers working on a different assignment. Each photographer could be using one or two power packs and a choice of flash heads. A few days later, the studio has to photograph a farm tractor or some other large machine. Because of the size of the object, all of the studio's space and lighting equipment are necessary for a successful promotional photograph. All the available power packs may be called in to light this one setup.

It may even be necessary to rent or borrow additional lighting equipment, if the studio doesn't do enough of this kind of work to justify buying the extra units.

Power packs are designed to work with flash heads of a specific voltage rating. A 450-volt power pack must be used with a 450-volt flash head. A 2000-volt power pack needs a 2000-volt flash head.

As you're examining various kinds of studio flash equipment, consider where you're going to put it and how you're going to move the heavy components about.

Power packs can sit on your studio floor. Low *dollies*—either homemade or purchased—can make moving power packs about much easier. You'll appreciate having dollies if you have high-powered flash equipment and make a lot of setup changes.

You can also keep your power packs attached to the bases of your light stands. Some stands have sturdy trays attached to their base. The power pack fits on the tray. On other stands, the power pack hangs from a hook or stud. This arrangement is not suitable for the heavier power packs.

Photogenic Master-Rail system features ceiling-mounted lights. There are no light stands or cables to trip over. Lights are easily movable along rails. Lamp height is adjusted by pulling the lamp heads down or pushing them up. This kind of installation is popular with professional studio photographers. Photo courtesy of Lombard Studio, Hartland, Wisconsin.

This photograph suggests an elaborate lighting setup. Actually, only two portable lights were used, one was to the left of the group and the other to the right. Each was on a light stand, at a height of about seven feet. Left light lit the right players and right light illuminated the players on the left. Multiple shadow effect is minimized because all shadows coincide at center. Background was lit by spill light from the two lamps. Photo by Alan Magayne-Roshak, courtesy of the University of Wisconsin, Milwaukee.

If your specialty is portraiture or if you are likely to work on only one setup at a time, you can mount power packs on a studio wall. This is a good way to keep your studio both neat and safe.

Carrying the concept one step further, you can eliminate light stands entirely and hang all your lights from secure but adjustable ceiling fixtures. The Photogenic Master-Rail system is a good example. All the wiring and light-ing gear is above you and out of the way. Yet you can move the flash heads wherever you want them, and no one will trip over any cables.

## FLASH-HEAD SELECTION

There's a wide choice in flash heads. While they all produce light, there's more to consider when buying a system.

**Power-Handling Ability—** This is your first concern, especially with

flash heads that are going to be used as main or fill lights. Accent and background lights can be of lower power. You don't necessarily have to select all your flash heads from the same manufacturer as your power packs. Some are interchangeable, with the right set of connecting cables. Check your choice of heads carefully with your dealer before purchasing any units. You must select flash heads of the same operating voltage as your power packs.

**Motion-Stopping Ability**—This is one item that's easily overlooked. Many studio flashes have a longer flash duration than you'd expect if you've used only portable flash before. Some large units are as slow as 1/350 second, while others are as fast as 1/3000 second. As a group, flash units using 2000-volt flash heads have a shorter flash duration and better motion-stopping ability than units with lower voltage heads.

The length and number of flash tubes also affect the flash duration. Long flash tubes have higher electrical resistance and, therefore, take longer to discharge the power pack. Some makes of flash offer you the choice of long or short flash tubes. Longer tubes are generally more able to withstand high power and rapid-fire shooting than smaller tubes. You can also get flash heads with two tubes. Two flash tubes—or two flash heads for that matter—fired by the same power pack will give you a shorter flash duration.

**Focusing Adjustment**—A major feature of studio-flash equipment is the variety of light-modifying accessories available. Nearly every model of flash head has three or more different interchangeable reflectors so you can quickly change the angle of the beam to suit your needs.

A few heads have built-in adjustments that let you move the flash tube back and forth in the housing. Moving the tube changes the focus of the flash and widens or narrows the angle of the beam.

This feature lets you make fine adjustments in the width of your light coverage without having to stop and change reflectors.

**Purpose**—Certain flash heads are better suited for specific jobs than others. For example, a head intended for use as a background light is generally low in power and can only be fitted with a limited number of accessories. Study carefully the descriptions in advertisements and sales brochures.

**Other Features**—Some flash heads have switches that enable you to reduce their light output by one or two steps. You must be careful when using these heads, however. They *must* be used on the same power pack with another regular head in order to work properly on their *low-power* settings. They *can* be used by themselves when switched to *full* power but should *never* be switched to a low-power setting unless another head is attached. Otherwise, the flash tube or the power pack could be damaged.

## FLASH-HEAD TYPES

In addition to being available at different power ratings, flash heads are also designed for different purposes.

**General-Purpose Heads**—These are the most often used flash heads. They are available in many different watt-second ratings. Individual heads of up to 12,000 watt-seconds are available. Most have either tungsten or quartz-iodine modeling lights. The widest variety of accessories is made for general-purpose heads.

**Blower-Cooled Heads**—These are essentially the same as other general-purpose heads but can be fired more times per minute without overheating. An electric blower helps cool the flash tube to prevent it from overheating.

**Spotlight**—When you want sharp shadows in shots of objects or products, or sharply defined facial highlights and shadows in a portrait, a spotlight head is a good choice. A spotlight head has a

Fresnel or other suitable lens in front of the flash tube to change the beam angle and concentrate and focus the light into a well-defined beam with little spill light.

Spotlights are also used for hair lights for portraiture and for adding sparkling highlights to all kinds of other subjects.

**Background Light**—A background light is used to control the brightness of the background. This is done to separate your subject from the background visually so their tones don't blend. Just about any flash head can be used as a background light, but those

For maximum versatility and power, separate power packs like these are the best choice. Each unit can power several flash heads.

A dolly is a convenient piece of studio-flash equipment. Power pack, flash heads, diffuser and adjustable-height light stand are all mounted on this easily movable dolly.

specifically made for this purpose are generally lower in power capacity than general-purpose heads. They also have fewer available accessories and are relatively cheaper. Most background lights can also be used as *bare-tube* flash.

**Ring Light**—For shadowless photographs, these heads are available in different sizes, to handle maximum powers from 200 to 1400 watt-seconds. You can also get ring-light reflectors.

## ACCESSORIES

Accessories are vital if you want to make full use of your flash equipment. Never assume that accessories made to fit one make of flash head will fit a head of another make. Always check it out. Fortunately, the more commonly needed accessories are available for most flash units. Some accessories are usable with, or adaptable to, many different units.

**Accessory Holders**—On certain flash heads you need a holder to attach accessories such as filters, barn doors—see below—and other items. With other flash heads, the barn-door assembly also serves as a filter holder.

**Barn Doors**—They consist of two or four flat metal flaps, hinged to a frame that attaches to the front of the flash head.

Barn doors are used to keep light from falling where you don't want it. They work like the sun visors in your car. You swing them into the light path to block the unwanted light in the desired manner. They are very effective in preventing lens flare.

**Light Stands**—Because studio flash units are generally heavier than portable ones, the light stands you use with them should be sturdy and heavy. Flash heads usually fit one of several diameters of light-stand poles. These can range from 3/8 inch to 3/4 inch in diameter. Adapters are available for the use of larger stands with smaller heads.

Some stands have a heavy cast-

This photo has selective soft focus. The center of the image is sharp. Notice how sharpness apparently decreases toward the edges. In this picture, this blur simulates movement at the top and bottom of the image. You can easily create this soft focus around a sharp central image. Place a clear-glass or haze filter on the camera lens. Apply a small amount of petroleum jelly to the outer area of the filter. You may have to make a few test pictures to find out exactly where to apply the jelly, and how much, to get the effect you want. Don't put the petroleum jelly directly on the camera lens. Photo by Edward Lettau, Peter Arnold, Inc.

iron base. Casters are available for many stands to facilitate moving them about. Lightweight collapsible stands are frequently sufficient for small flash units of up to about 200 watt-seconds of power. Portability is especially important if you do a lot of location work.

**Boom Stands**—These are used to support spotlights and other flash heads *above or behind* your subject. They are constructed so they won't intrude into the picture area.

The flash head attaches to one

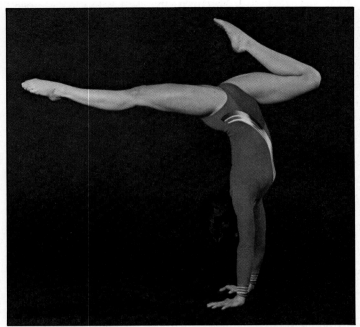

Gymnast was lit by two umbrella flashes, from left and from right. She is almost shadow-free. Photo by Frank Geers.

## UMBRELLA TIPS

Umbrellas vary in design and lighting characteristics. The traditional parabolic type reflects light in more of a concentrated beam than do square umbrellas. The latter tend to produce more spill light. The beam from a square umbrella has softer, less defined boundaries, making the light easier to aim.

Silvered umbrellas are more efficient than white units, reflecting more light but producing a harsher, more directional light.

You can change the lighting characteristics of an umbrella by moving your flash closer to or farther from the reflector. When the flash is moved closer, it lights less of the reflector and narrows the beam. When it is moved farther away, the beam becomes wider.

To minimize spill light, use a parabolic umbrella and cover its outside with a black cloth to absorb any light leaking through the reflector.

What about size? Larger umbrellas extend the light farther to the sides of your subject, giving more side lighting. To use a large umbrella effectively, the flash must be sufficiently far from the reflector to light all of it adequately.

end of a long crossarm that extends outward from the main shaft of the stand. The cross arm, also known as the boom, is counterweighted so you can easily move it up or down for different lamp heights or from side to side for different lamp positions. Use boom lights with care, so they don't accidentally swing or fall and strike your subject or set.

Some booms can be attached to a regular light stand. Others are complete units, with cranks for easy control.

**Background-Light Stands**—Typically, they are short and often of fixed height. For many background lighting applications, there's no need for an adjustable stand. Besides holding background lights, some types of stands are handy for holding small flash units for lighting table-top shots.

## REFLECTORS

The job of a reflector in a flash head is to direct all the flash tube's light in the needed direction. The shape and size of the reflector determine how wide an angle the light is spread over and how harsh or diffused the light is.

Most studio lamp heads offer a selection of at least three—sometimes more—general-purpose interchangeable reflectors. Most reflectors have a matte or textured surface to help even out the light. Others have a mirrored surface for better efficiency in relatively narrow-angled telephoto photography, or for lighting umbrella reflectors.

Reflectors for umbrellas are usually smaller in diameter than other reflectors, so they block as little of the light bouncing back from the umbrella as possible. Some umbrella lighting reflectors produce a lot of spill light; others are designed to spill virtually none.

**Umbrellas**—Umbrellas are controlled bounce surfaces. When designed for studio flash heads, umbrellas sometimes have other accessories, to add versatility. One such accessory is a multihead bracket for aiming more than one flash head toward the umbrella.

The Balcar Microlite is unique among spotlight attachments. It has three fiber-optic light pipes. The end of each can be fitted with spot lenses, color filters, diffusers and other accessories. All three pipes get their light from a single flash head.

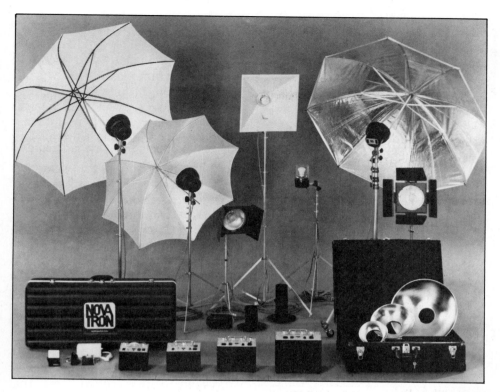

You'll get the best value if you select studio flash equipment with interchangeable parts and a wide selection of accessories.

Below is a general-purpose flash head. Because it accepts many accessories, you can adapt it for many uses.

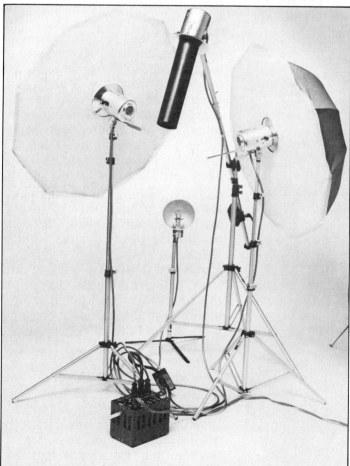

This lighting equipment is sufficient for professional-quality color or b&w portraiture. There's a diffused key light and fill light, a background light, and a rim light or hair light, complete with a light-restricting snoot.

Large Hershey Profoto ring light is mounted on the camera. It could also be mounted on a light stand. You'd simply aim your camera through the ring.

If you want good control of lighting contrast, opaque black umbrella covers are very useful. They prevent light from passing through the umbrella. Such spill light could end up as unpredictable bounce light from other surfaces in the studio or room.

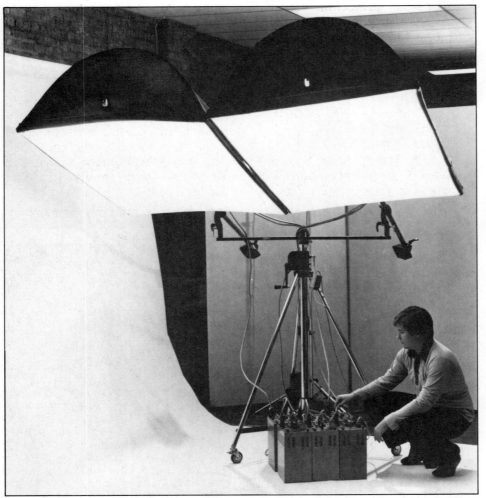

Although skylights are large, they are generally lightweight. To ensure even lighting and enough light output, each skylight usually contains two or more flash heads.

## DIFFUSERS

Diffusers are panels of translucent material that you place in front of your flash heads. They scatter the light to soften its effect. Most diffusers are larger in area than the flash heads, to increase the size of the light source. This helps to reduce lighting contrast and produce soft-edged shadows. Although diffusers all work on the same principle, they differ in construction and effect.

**Diffuser Caps**—These small frosted caps clip in front of the flash tube so no direct, undiffused light can reach the subject. They have only a slight softening effect on the light, but they tone down overly bright highlights on shiny objects.

**Window Lights**—The largest diffusers are called *window lights* or *skylights*. Some are so large that you mount your flash heads on them rather than attaching them to the flash heads. Typical window lights are about 4x5 feet in size or larger and hold up to six flash heads. As much as 24,000 watt-seconds of power can be discharged at one time through some units. For even more light, or to cover a larger area, you can use several window lights side-by-side. They provide soft main and fill lighting, particularly for large subjects and group portraits. Motorized stands are available for easy positioning of some large window lights.

**Umbrella Diffusers**—These clip over your umbrellas to soften their light even more. Their light is similar to that of relatively small window lights or of that produced by flashing *through* a translucent umbrella.

**Free-standing Diffusers And Tents**—A diffuser doesn't necessarily have to be connected directly to the flash head. It can be a separate unit. One advantage of freestanding diffusers is that they work equally well with any make of flash. You can attach several of them together to make larger panels. They can also be assembled

into three-dimensional enclosures, or *tents*. A tent is a diffuser that surrounds your subject, to wrap it in low-contrast diffused light.

You can get pre-formed plastic or glass diffusing panels, or make your own from sheets of frosted plastic.

## SPOTLIGHT ATTACHMENTS

Instead of spreading light like diffusers, spot attachments confine the light from your flash head so it is kept within a narrow, sharply defined angle. Even when you light relatively large areas with a spot, the light will still have two distinguishing characteristics. First, there will be little, if any, spill light. The light will be harsh and contrasty. Second, the outer edges of the beam will be relatively sharp. You'll see clearly where the light stops and the shadow begins. The main types of spot attachments are *snoots*, *grids* and *lenses*.

**Snoots** are simple devices that restrict the spread of a light beam. They are metal tubes of different diameters, usually about 12 inches long. When you slip one over a flash head, it blocks the outer

To convert a standard flash-head reflector for spotlight use, attach a spotlight grid. It'll give you highly directional light, with little spill.

edges of the beam, thus reducing its size. Snoots of smaller diameter produce accordingly smaller beams of light.

**Grids** carry spotlighting a step further. They are generally shorter than snoots. Typically, they are honeycombs of metal that function like hundreds of tiny snoots all working together. Some grids are made of parallel strips of metal that restrict the beam more in one direction than in the other.

You get different beam angles by selecting different grids. Edge sharpness is influenced by the tone of the grid. Black grids produce sharp-edged circles of light; gray ones make more diffuse circles.

Because of their lack of spill light, grids are particularly popular for lighting subjects in front of background projection screens. Grids are also good as hair lights, and for a variety of other spotlighting jobs.

**Lenses** are the least wasteful of light of all the spot attachments. You can focus them. This enables you to vary the beam angle by changing the distance between the lens and the flash tube. Some lens assemblies also have an adjustable diaphragm, to give you additional control of the size of the beam.

## FILTERS

To convert the color of the illumination to the color-balance of the film, and for a wide variety of other purposes, you can use filters on the camera lens, over the flash head, or both.

**Color Filters**—As with other forms of illumination, color filters are used to change the color of the light from the flash. There can be several reasons for wanting to change the color of the illumination. You may want to adapt the lighting to a film balanced for light of a different color temperature. Or, you may need to convert the color of the flash to match the color of other illumination you are using, such as tungsten lamps or fluorescent illumination. Filters

also enable you to change the color of the lighting for special effects.

Follow the filter manufacturer's recommendations on the amount of exposure compensation you'll need. When in doubt, make tests, or bracket your exposures.

**Polarizing Filters**—These special filters are not used to change the color of your lights. Their main purpose with flash is to subdue or eliminate unwanted reflections from shiny objects. When you remove these reflections, you automatically get richer and more saturated colors in color photographs.

To eliminate or reduce reflections from non-metallic surfaces such as glass and varnished wood at virtually any angle to the camera, use one polarizer over the camera lens and another over the light source, or sources.

The plane of polarization in the polarizers over the lights must be identical. For maximum elimination of reflections, the plane of polarization in the polarizer on the lens must be fully perpendicular to that of the polarizers on the lights. You can easily study the effect through your camera viewfinder, provided you have modeling lights.

For copying shiny photographs, artwork or documents, large polarizing screens like this one are very helpful. They are placed in front of each light source. Polarizers should be oriented so the axis of polarization of each light is identical. Another polarizer, over the camera lens, should have its axis of polarization at a right angle to the others. This setup eliminates most unwanted reflections. As a bonus, it also helps give your pictures brilliant, saturated colors.

This is not an Eskimo's igloo, but a photographer's light tent. It's useful for photographing highly reflective objects and to get soft and shadow-free lighting. The translucent tent is illuminated from the outside.

This is a photograph of the setup in the light tent.

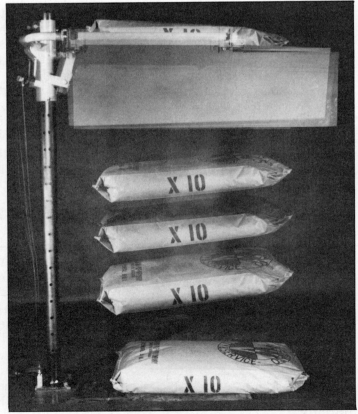

These drop tests were photographed to record the relative sturdiness of two different packaging materials. Five flash units were used to make each picture. Each of the lower four flashes was tripped when the falling bag blocked the light to a specific photocell. Photos by David B. Eisendrath, Jr.

## HOW TO USE MODELING LIGHTS

One advantage that incandescent lighting has over electronic flash is that you can see what the lighting effect looks like before you make the photograph. To *preview* with flash, you need modeling lights—incandescent lamps that are in virtually the same location as the flash tubes. Not only do incandescent modeling lights give you a nice preview of your lighting, they're also useful to focus by. A little extra light to help you see always comes in handy, particularly when you're working on location where the existing light may not be adequate.

Another use for modeling lights is for estimating exposure. Many flash manufacturers suggest determining your flash exposure settings by measuring the modeling-light intensity with a regular exposure meter. For example, the Elinchrom 11 and 22 Monoflash manuals tell you to set the film speed on your meter as usual. Take a reading and note the *aperture setting* opposite the *3-second* shutter speed on the calculator dial.

Set your camera to this aperture and make a series of trial exposures, bracketed around this setting. Always set your camera for its regular X-sync speed. The 3-second mark is nothing more than a convenient indicator for a reasonably accurate aperture setting. Remember, you're reading the *modeling* lamp and assuming it has a definite relationship to *flash* brightness.

This method works because whichever reflector, diffuser or other accessory you use influences the intensity of the modeling lamp in the same way as it does the flash tube.

## THE HOME STUDIO

Without taking up too much room, you can set up a small but useful studio in your home. You don't have to set aside an entire room to do good work. I've done a lot of my photography of objects using an old door, laid across some boxes, as a table. A covering of background paper makes the door work as well as any fancy table.

You can make portraits in just about any room. You may have to move some furniture to get an unobstructed wall as a background. Of course, if you expect to do portraits on a regular basis, it's best to have a room set aside for photography.

The biggest shortcoming of most home studios is inadequate ceiling height. Modern homes generally have about eight-foot ceilings. This is too low for good light placement for full-length standing portraits. Many older homes, or those with cathedral-type ceilings, work better. This is not to say that you can't take effective portraits in a room with a low ceiling. Indeed, you can—you just don't have as many choices of light placement.

**How Much Light?**—A pair of 200-watt-second monoflash units, a background light, and a small boom spot will fill just about any need for a home studio. You can make do with less, especially if you use reflectors wisely.

When you use low-powered or portable flash units with diffusers, umbrellas, or for bounced lighting, the amount of light you lose may force you to use either a larger lens aperture or a faster film.

**AC Adapters Are Helpful**—Battery-powered flash units work fine in the studio. However, you may want to invest in an AC adapter, to avoid high battery costs. Most adapters also speed up the flash recycle time. Many older flash units will continue to work on AC even when the battery circuits are defective. Some units of more recent design won't run on AC unless they have good batteries and the battery switch is turned on.

## FLASH METERING

When making setups using several flash units and a lot of lighting accessories, trying to calculate the correct exposure setting from guide numbers can become complicated. Using a flash meter is faster and far more accurate. After investing a large sum on studio-flash equipment, it's foolish not to get a flash meter for the relatively small extra cost. A good meter can cost $100 or more, but that's not much compared with the cost of an extensive lighting system and a lot of film.

A flash meter works much like a regular light meter. Both measure the illuminance falling on or reflected from a scene. You use a readout to get a recommended camera setting. A regular light meter measures only the intensity of the light. A flash meter also measures the *duration* of the flash because both intensity and flash duration affect exposure.

**Basic Exposure Considerations**—The correct exposure setting to use is the one that will give you the photograph you want. There are a few guidelines to consider when choosing your camera settings.

When using slide or transparency film, avoid *overexposure*. Normal or slightly dark transparencies, having rich and saturated colors, usually look best. You can visually judge whether a transparency is correctly exposed. If it's to your taste, it's right.

Color negative film responds best to slight overexposure, rather than underexposure. Negatives that are too thin are difficult to print properly.

Color negatives are difficult to evaluate visually. They are best examined with a *transmission densitometer*. You should always use enough fill light to produce a negative density of 0.1 to 0.2 above the *base density* in the thinnest negative parts, which represent the darkest subject areas. *Base density* is the optical density of *unexposed* but processed film. Your main-light exposure should be sufficient to give you a highlight density of

about 1.00 above base density.

**Using The Flash Meter**—Most photographers have their own preferences when it comes to using a light meter. Flash meters are no exception. There are two basic ways to measure light—incident and reflected readings.

Incident readings are made by placing your meter at the subject position. You point the sensor—equipped with a dome-shaped diffuser—toward your camera. The meter measures the light falling on your subject. Incident readings ignore the characteristics of the subject entirely. I prefer this method for most of my flash work.

To make a reflected-light measurement, point the meter's sensor—without the diffuser—toward your subject. Reflected-light meters are factory-calibrated to indicate correct exposure for subjects having an integrated 18% reflectivity. Thus, reflected-light readings are most accurate when made from a subject of standard reflectivity. If your subjects are unusually light or dark, you must allow for this by giving accordingly more or less exposure.

Alternatively, if your subject is unusually light or dark, you can take a reflected-light reading from a standard 18% gray card. Hold the card near your subject, set off the flashes and note the meter reading.

It's important to remember that the settings a meter recommends won't necessarily give you ideal exposures in all cases. Bracket your exposures liberally at first. If you find that your meter is consistently calling for too much or too little exposure, change the setting on the meter. Alter it by a third or half step to compensate for the error. Several meters have a screwdriver adjustment to let you trim the meter's response to your needs.

## MULTIPLE FLASH EXPOSURES

Sometimes the light from your flash may not be powerful enough

If you're going to do a lot of flash photography, a flash meter is a good investment. It can make your work easier and, in the long run, may save you a lot of film. These are just a few of the many models available.

to let you use a small enough aperture setting on a particular setup. To get more light, you can fire your flash several times while leaving the shutter open. Of course, this works only with *stationary* objects.

Many flash meters will add the cumulative effect of several flash bursts. Certain meters even count the individual bursts, to keep track of how many times you fired the flash.

Theoretically, each time you *double* the number of flash bursts you gain *one step* in exposure. If one flash calls for *f*-5.6, two flashes will let you use *f*-8. Four flashes let you use *f*-11, and so on. In practice, this isn't entirely true because of the *intermittency effect*, which is a form of film reciprocity failure.

Because of the intermittency effect, ten repeated flashes will not necessarily give you ten times the effective exposure on film as would one flash. Or, if one flash is adequate for an aperture of *f*-5.6, eight may not necessarily be sufficient for *f*-16. You may need ten flashes.

The intermittency effect may vary with different film types as well as with the duration of the individual flash. Therefore, you may need to bracket exposures or make tests to establish best exposure with multiple flash.

## FRONT PROJECTION

The professional studio photographer often wants to create the illusion of being on location without actually leaving the studio. An effective way of doing this is by using *front projection*. In front projection, your subject or model is placed in front of a special projection screen. A slide of the background you want is placed in a projector. The composite image of your subject, superimposed on the projected background, is recorded by your camera. With the appropriate equipment and a little care, the amateur photographer can also use front projection.

Front projection is similar to regular projection, with a few differences. For flash use, the projector has *two* light sources: A quartz or tungsten modeling light for focusing and a flash tube for making the exposure.

The front-projection screen is of a special type. A regular projection screen is designed so a bright and clear image can be seen by a group of viewers. This includes those viewers sitting at a fairly acute angle to the screen. A front-projection screen is highly directional. This means that the image is seen only where it matters—at the camera position. There are no other viewers involved.

Because *all* the projector light goes in the one direction—to the camera—a very bright image is obtained.

In order for the subject in front of the projection screen not to cast a visible shadow on the projected image, it is essential that the projected image follows the camera-lens axis. This is achieved by the use of a half-mirror, as shown in the illustration of the setup.

The background slide is projected onto the screen and the subject. However, the part of the image that hits the subject is not visible to the viewer and the camera. This is because the directional projection screen is many times more efficient as a reflector than the subject. In addition, the subject is, of course, lit separately.

You must control the subject lighting carefully. Avoid throwing any light onto the projection screen. Also, to make the entire scene believable, the illumination on the subject should be consistent with that in the projected scene. For example, if the background consists of a sunlit scene, where all shadows fall toward the right, the subject lighting should be such that its shadows also fall to the right.

This portrait was taken in the studio. The foliage in the background was not real. It was added by front projection of a slide. Photo by Cilento Studios, Milwaukee.

Front projection enables you to photograph your subject in front of virtually any scene, without ever leaving home or studio. This projector is designed specifically for the job.

**FRONT PROJECTION**

SUBJECT LIGHT

CAMERA

HALF-MIRROR

SCREEN

PROJECTOR

SUBJECT LIGHT

127

Avoid frontal lighting. Remember that the projection screen is designed to reflect back all light to its source. Also, place your subject as close to the screen as possible. This will help you with depth of field. It will also make it easier for you to locate the subject properly within the projected scene.

Finally, be sure to balance the brightness of the lighting on the subject with the projection illumination, so both subject and background are exposed correctly.

Special SX-70 film backs now allow you to use Polaroid SX-70 film in conventional cameras. Film backs enabling Kodak instant films to be used in conventional cameras are also available. This enables you to use more than just on-camera flash. This SX-70 photo was made with a diffused light source directly over the subject. Photo by Ed Judice.

## FLASH WITH INSTANT FILMS

Polaroid instant films can be used in a wide variety of conventional 4x5 and 8x10 cameras. Special film holders are made by Polaroid Corporation for this purpose. Film holders from other manufacturers also enable Polaroid films to be used in some medium-format and 35mm cameras.

Some of the 35mm adapters contain special optics that cause some light loss and, therefore, require some exposure compensation. Follow the directions supplied with the film adapter.

Polaroid films are useful for testing your lighting effects, exposure and composition. With the instantly developing films, you can see the results moments after you shoot. This enables you to correct any errors before you shoot on conventional film. Professional photographers often use Polaroid films this way.

When you switch from Polaroid film to conventional film, be sure that you make allowance for film-speed differences. For example, if a lens aperture of $f$-11 gave you a correctly exposed flash picture on an ISO 400/27° Polaroid film, you'll need to change the aperture to $f$-8 with a conventional ISO 200/24° film.

Polaroid color-print films tend to give results that are a little more contrasty than conventional color slides. If you are using Polaroid film to make final pictures, and not just tests, I'd advise you to decrease the lighting ratio accordingly.

Several of the fully automatic cameras made by Polaroid for use with SX-70 film have a built-in electronic flash unit that automatically provides an appropriate amount of fill light in contrasty existing-light conditions. Although these cameras have limited application for the photographer who wants to be creative with light, they are excellent for providing consistently well-exposed snapshots.

High-key lighting used here suits the subject. Equally important, subject is suitable for high-key treatment. She has fair skin and light-colored hair and is wearing a bright blouse. The main light was on the left, facing the front of the subject. Shadows were lightened by generous fill lighting. Photo by Ed Judice.

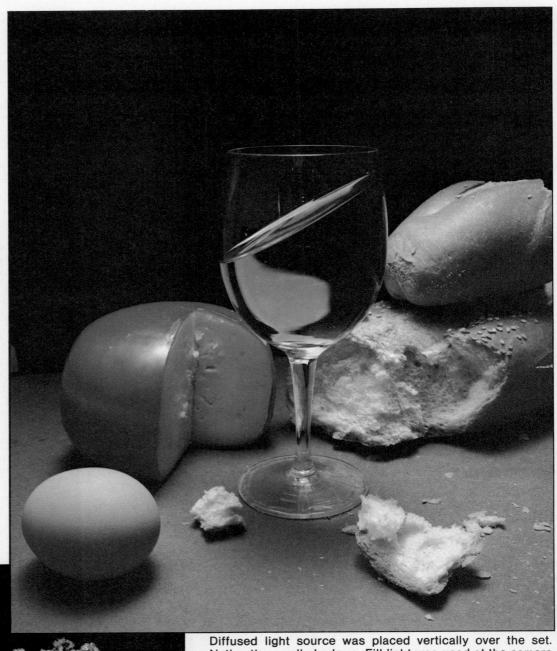

Diffused light source was placed vertically over the set. Notice the small shadows. Fill light was used at the camera position. No, the photographer did not defy gravity. The whole set was tilted, to give the wine this unlikely appearance. Why not inject some humor into your photography once in a while? Photo by Ed Judice.

On-camera flash is ideal for this kind of subject. It gives maximum brightness to the frost by reflecting the light straight back to the camera. Notice how the frost outlines the leaves, flowers and stem. To maintain this detail, a dark background was necessary. Photo by Hans Pfletschinger, Peter Arnold, Inc.

# Flash Care and Repair 10

In Chapter 3, I recommended that you test your flash immediately after purchase. Recycle time, automatic exposure range, and all other important features should be checked. Although your flash may be in perfect operating condition, its performance can differ a little from the data provided in the instruction manual.

By thorough testing, you not only verify that the flash is working, but also become fully familiar with its features and characteristics. If your flash should start malfunctioning later on, you'll be more likely to become aware of it before you waste a lot of film.

If you test your flash equipment as soon as you buy it, you save valuable warranty time. Warranties don't last long.

Getting the longest life and best service from your flash equipment requires a combination of care and common sense. Flash units are no more difficult to care for than cameras or other photographic equipment.

## SYNC CORDS AND CONNECTORS

Most flash failures are caused by battery-related problems and by faulty sync cords and connectors. You can avoid or minimize most of these with occasional preventive maintenance.

There are several types of sync connectors, but the most common one is the PC (Prontor-Compur) connector. Most of my comments on cord testing will apply to all cord and connector types.

Sync cords take a lot of punish-

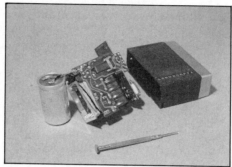

Don't do this! As I emphasize later in the text, disassembling a flash unit is not recommended unless you are fully familiar with the equipment and its functions. It can be dangerous! Anyway, you'd probably have difficulties finding replacement parts.

ment as they're used. They get yanked, stepped on and wadded up in your camera bag. Tarnish and dirt builds up on the connectors until they're incapable of making a reliable electrical connection. Fortunately, these conditions can be either prevented, minimized or cured.

One way to get longer sync-cord life is to use a sturdier cord. You can generally buy more durable cords than the one supplied with the flash unit. If you're going to use your flash off-camera, you'll need to get a longer cable anyway, so buy a really sturdy one.

If possible, take cords out of their packages while you're at the store. Flex them and examine them closely. Test them electrically or on a camera, if possible. Check that they're heavier and thicker than the cord that came with your flash. Also, be sure the metal parts of the plug ends are well made.

Off-camera use generally causes most wear and tear to sync cords. Your cords should be long enough to give you a little slack. If they're not, you may find that you're frequently overreaching the limits of the cord as you hold the flash in different positions. Each inadvertent yank on the cord shortens its life.

**Cord Failures**—There are two wires in an ordinary sync cord. Cords for dedicated flash units have three or four wires. When the wires short-circuit or break, the useful life of a cord is over.

Sometimes you can salvage a bad sync cord for other uses—but first you have to find and cut off the bad parts. More on these other uses in a moment.

**Cord Testers**—A sync-cord tester is a handy item to have and use. You can make one by following the accompanying diagram, or you can buy one to fit the cords you use most. This is how you use a cord tester:

1) Plug one end of your sync cord into the mating connector on the tester. The bulb should *not* light. If it lights or blinks, the cord has a short-circuit.

2) Flex and wiggle the cord at several locations along its length, particularly where the wire meets the plugs at each end. The bulb should not light. If it blinks off and on, the cord has an intermittent short-circuit. The bulb should blink when you flex the cord near the location of the short. If you want to salvage part of the cord, cut it at the location of the short-circuit and discard the smaller part.

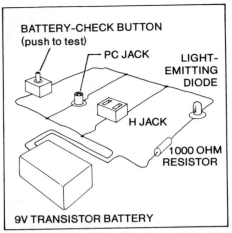

By following this diagram, you can make an effective sync-cord tester. You can use a flashlight bulb in place of the light-emitting diode (LED) and resistor. If you do, use one or two penlight cells instead of the transistor battery. Using the sync-cord tester is described in the text.

3) If the cord passes the above test, check it for open circuits. With one end of the cord plugged into the tester, short-circuit the other end. You can short it in several different ways. One way is to plug it into a specially adapted connector salvaged from a bad cord. To adapt it, strip the insulation from the wires and solder them together. Test it on the cord tester to make sure it provides a good short-circuit.

Alternatively, you can plug the cord into your camera. First set your camera shutter to **B** and lock it open with a locking cable release. The bulb should light as soon as you plug it into the camera.

4) Wiggle the cord at several places, as in Step 2. The bulb should not stop glowing at any time. If it does, you have an intermittent open circuit in the cord. Don't throw away the cord yet. Sometimes, one of the connectors is tarnished or loose. This can usually be corrected. If the open circuit seems to be near the middle of the cord, then the wire is probably at fault. Throw the cord away, or salvage the good parts, as described earlier.

5) If the difficulty seems near

If you don't want to make your own sync-cord tester, you can buy a ready-made one like this. It's easy to use.

one end of the cord, wiggle the connector and see if the connector and not the wire is at fault. If the connector seems to be the problem, try reconditioning it as described next.

**Plug Maintenance**—Remove tarnish and dirt buildup from the plugs with a small wire brush. Ready-made cord testers usually have a brush included. You can make a brush from a short length of standard electric hookup wire—18-gage wire is about right. Strip about 1/4 inch of the plastic jacket from one end. Use the exposed wires as a brush. When you've finished brushing the connectors, blow out any loose particles with a blast of air.

Do *not* use steel wool to clean connectors. Chips break off the wool as it's used. These particles can short-circuit the connectors.

**PC Plugs**—The end of a PC cord that plugs into your camera is particularly prone to damage from mishandling or long use. A yank on the cord here and there tends to spread and deform the outer shell of the plug, loosening its fit.

Ready-made testers usually include a tip-conditioning tool. You can also buy this tool separately. It is a metal rod with a correctly sized hole at one end. All you need do is insert the PC plug into the hole and pull it out again.

Some photographers try to tighten PC plugs by biting them or

A tip-conditioning tool can do a good job of reshaping the outer shell of a deformed PC connector.

You can tighten loose-fitting PC plugs by giving the center pin a slight S-bend. Use tiny needle-nose pliers to bend the pin. The bend in the sketches is exaggerated for the sake of clarity.

squeezing them with pliers. This method may work for a while, but in the long run it only deforms the shell even more.

You can tell if the center pin of the PC plug isn't making good contact. The electrical connection is inconsistent, even though the outer shell is gripping the tester tightly. Luckily, you can also correct this easily. If you give the pin a *slight* S-bend, it will fit more tightly. To do this, grip the pin well into the plug, using a fine-tipped pair of needle-nosed pliers. Bend the pin to the left a bit.

Then grip the pin nearer the top end and bend it back in the other direction. But don't overdo it. Often, a loose fit is due to a worn camera jack. Too much curve in the pin will only make the jack wear out more.

If a *new* sync cord also fits your camera poorly, have the camera examined by a qualified repairman. You'll probably have to have the camera's sync jack replaced. Sometimes the loose connection is *inside* the camera, although wiggling the sync cord makes it look like the jack is bad. This problem, too, requires a camera repairman's help.

## THE BATTERY COMPARTMENT

Clean the metal contacts inside your flash unit's battery compartment occasionally to remove deposits that can build up. A quick cleaning each time you replace the batteries is generally enough. Rub the contacts with a rough cloth, wrapped around the eraser end of a pencil to give it some grip. Give the contacts on the batteries a few brisk rubs, too.

Anytime you expect to leave your flash equipment, or any other battery-powered devices, unattended for more than about two weeks, *remove the batteries.*

This reduces the chance of a faulty battery leaking harmful chemicals into your equipment.

If you're faced with the job of cleaning out a battery-damaged flash, the first thing to do is wipe out the chemicals. Most chemicals leaking from throw-away alkaline batteries are relatively harmless to your skin, when you touch them only briefly. Nickel-cadmium (nicad) batteries have a much stronger alkali in them, but they are less likely to leak in normal usage.

Wipe the compartment with a cloth dampened with a general-purpose household cleaner. Rinse the cloth and wipe again a couple of times. Dry the compartment.

It's important to clean off the chemicals as soon as possible. If they are permitted to corrode the metal contacts, repairing the flash may be difficult, or even impossible. You can sand off the corrosion but the exposed metal will soon tarnish again.

You can put a thin coat of solder over freshly sanded contacts, but be careful not to melt the plastic parts of the battery compartment. Of course, solder won't be as good as the original plating, but it will be an improvement over bare brass. The best repair is to replace the corroded parts.

## BATTERY CARE

Batteries are the lifeblood of portable flash. As I mentioned in Chapters 3 and 4, different applications call for different types of batteries. Different battery types require different care and handling.

In general, batteries last longer if kept cool. Keep them away from extremely hot conditions, such as closed automobiles in sunny parking lots, attics in summer, and near heating installations and hot machinery. Don't buy batteries taken from a window display. Many days in direct sunlight do them a lot of harm. Heat speeds up self-discharge and accelerates drying out of chemicals, shortening a battery's life.

Dancer was wearing a highly reflective silver leotard. Reflection of orange light from the front and blue light from the rear added the color. The light was colored by the use of gels on the flash heads. Photo by Theodore DiSante.

Don't short-circuit a battery, even for a moment, to check if it has any life left. Use a battery tester or a small light bulb instead. Abnormally high current surges are hard on all types of batteries. Also, do not drop batteries.

**Low-Voltage Alkaline Batteries**—Alkaline batteries are the only type of *low-voltage throwaway* batteries to use in your flash equipment. Ordinary, or even heavy-duty, carbon-zinc batteries are not suitable. They can't supply enough current to power a flash reliably.

Flash equipment most often uses sizes AA, C and D alkaline batteries. Some small flash units and a few units that are built into cameras use the smaller AAA batteries. Alkaline batteries are designed for rugged service and show little, if any, load sensitivity. This means that you can either take a few shots and wait a week or so before taking more, or shoot flash after flash until the batteries are run down. Either procedure will give you about as many shots per set of batteries. The shoot-and-rest method sometimes yields a *few* more shots, provided you don't wait months between sessions. A very long wait could result in your batteries dying of old age!

Alkaline batteries, like other batteries, put out less current when they're cold. Temperatures near freezing can easily *double* the recycling time. Temperatures near 0F (−18C) can double the time again.

Alkaline batteries are not, strictly speaking, rechargeable. There are "chargers" available that will *partially* replace some of the energy you took from your batteries. But your batteries must be in good condition to receive any meaningful benefit from charging.

First, the batteries must be fresh. They must not be dried out. The chemicals have to be moist for any electrical reaction to occur. Second, the batteries should be used only briefly between recharg-

A battery tester will give you some idea of how much power is left in a battery or set of batteries. However, it cannot tell you exactly how many more flashes you can make.

ing. If you run them down, they won't accept as much charge as they would if you used them for only about a dozen shots.

There's always the chance of an alkaline battery leaking chemicals while being recharged. Because battery manufacturers have no control over the design and use of chargers, they don't recommend recharging alkaline batteries.

**Battery Testers**—Contrary to popular opinion, a battery tester will *not* tell you how much useful life is left in a battery. All it will tell you is whether a battery is working or not. This information is useful for weeding out weak batteries from a set. You can't estimate the number of remaining flashes in a battery from the reading on a tester. You can get a medium or low reading on the meter when a substantial portion of a battery's chemical energy has been used up or when the battery is drying out. But these two conditions won't necessarily leave the same amount of flash power in the battery.

The best way to estimate how many shots are left in a set of batteries is to keep a rough count of how many shots you have taken and subtract from the typical number of shots you usually get. The number of shots you should

get is usually stated in the flash manufacturer's literature.

The gradual lengthening of the recycling time is also a good indicator of remaining battery life. However, to be able to use recycling time as a reliable guide, you have to be familiar with the behavior of your flash.

A simple way of testing low-voltage batteries requires nothing more than a flashlight bulb and some wire. Connect the bulb to the battery. If it lights normally, the battery is good. If it lights feebly or not at all, throw the battery away.

**Nickel-Cadmium Batteries**—Rechargeable nicad batteries are very popular for flash photogaphy. Here's why. They cost less *per flash* than alkaline batteries and also give shorter flash-recycling times. They do, however, hold fewer shots per charge, or set, than alkaline batteries of the same size.

Nicads also need a bit more care than alkaline batteries, if you want to get the longest life and best service from them. Each of the following suggestions will help you get the most from your nicads:

• Before using any new nicad battery, you *must* give it a full normal

Extreme close-up of the head of a dragonfly. When flash is used at such close range, it's generally not possible to make an accurate exposure determination based on the available flash and magnification data. This is largely because flash reflectors don't behave in their normal, predictable manner at such close range. Bracket your exposures generously, and keep notes for future reference. Photo by Hans Pfletschinger, Peter Arnold, Inc.

This kind of snapshot is easy to take, thanks to on-camera flash. Even with this simple setup, you can influence the quality of the result. This photo was shot from a high viewpoint, to get the children against the bright background of the bed. A lower camera position would have yielded a dark background. This would have produced a somber-looking picture and would not have given good separation between the children and the background. Photo by Dan Ludwig.

Character study of American Indian by Jim Dowling of Ferderbar Studio is good example of how to separate subject from background. Notice that the white rim of the headdress stands out from the dark background, while the dark lower half of the subject is clearly outlined against a bright background. Photo reproduced courtesy of Pitman-Moore and The Brady Co., Agency.

charge. You won't know how much charge is left in a newly purchased battery. If you mix it with other batteries that happen to have more charge left, the new battery will run down first. If you continue using the flash, the new battery will suffer severe damage by being *reverse charged* by the other units. The new battery will not be harmed by a few hours of *overcharging* at a normal charging rate.

• Keep batteries dry. If they get wet, dry them off. You can then wipe them with a cloth dampened with a few drops of alcohol. Denatured or wood alcohol is best. The alcohol evaporates quickly, leaving the battery dry. Water left on the battery surface may corrode it and the electrical contacts. This can eventually cause the chemicals in the battery to start leaking out.

• Run your batteries down periodically. Don't get into the habit of recharging your batteries after every few shots. A steady diet of low usage and frequent recharging can bring on an attack of *memory effect*. Memory effect is the popular name for a temporary loss of energy-storage capability.

Memory effect is easily cured. Run each battery down—really down. It's best to drain each cell separately—a light bulb or battery-operated radio works well for this. Give the batteries a full charge and run them down again. Recharge again. This should cure the problem.

• Try to keep your nicads in sets of equal age and condition. Label them, so they don't get mixed. As they age, nicad batteries sometimes start drying out or lose storage capacity for other reasons. If a weak unit is mixed in with stronger ones, it can be further weakened by reverse charging, as described earlier. Even a little reverse charge will damage a battery, so avoid it.

• Each time you put nicads into your flash, wipe off the ends of the batteries first. This prevents tarnish or chemical deposits.

Be sure to use the right charger for your nickel-cadmium batteries. Rapid chargers such as this unit are for rapid-charge batteries only. Don't put slow-charge batteries in them.

• Keep slow- and fast-charge nicad batteries separate from one another. You cannot charge regular slow-charge nicad batteries in a fast charger without damaging them. You may even damage the charger. Fast-charge batteries are made in such a way that they suddenly heat up when they reach full charge. Most fast chargers have a means of sensing the heat rise and shut off when the batteries are charged. Slow-charge batteries could burst before heating up enough to shut down the charger.

**Testing Nickel-Cadmium Batteries**—To find out the condition of your nicad batteries, so you can keep them in matched sets or replace bad ones, test them. It's easy to measure their energy-storage capacity. Simply run them down at a controlled rate and see how long it takes. The ampere-hour capacity of a battery is equal to the product of the current drawn from the battery times the length of time the battery lasted.

Most AA nicad cells are rated at 0.45 ampere-hours of storage capacity. If you draw a current of 0.45 amperes from them, they should work for an hour before running down. You *can't* draw four amperes for 1/10 of an hour because the AA cell can't supply so much current for that length of time.

If your flash uses removable nicad batteries of another size, check with the manufacturer to find out their ampere-hour rating.

When batteries are connected *in*

series, as they always are in flash units, the whole set has *the same* ampere-hour rating as a single cell. If they were hooked *in parallel*, the ampere-hour capacity would be equal to the rating of one cell multiplied by the number of cells in parallel.

A penlight bulb typically draws between 0.25 and 0.30 amperes. The current remains reasonably steady even as the batteries in the penlight begin to run down. This suggests a simple way to test your batteries.

You can check the ampere-hour capacity of nickel-cadmium batteries by running fully-charged ones down in a penlight or small flashlight. Check the length of time it takes. You'll find more details in the text.

Put a single battery—or a pair, depending on the type of penlight—into a penlight. See how long the bulb remains lit. A fresh AA cell should last more than an hour. You don't have to sit and stare at the light constantly for an hour, waiting for the bulb to go out. Just keep an eye on it while you're doing other things.

When the bulb dims sharply, note the elapsed time in minutes. Divide the minutes by 60, to convert them to decimal hours, and multiply by 0.3—the bulb current in amperes. For accurate results, always run this test with newly charged batteries.

With larger batteries, you have to arrange a suitable fixture to connect the batteries to a bulb.

Nickel-cadmium batteries can fail by drying out. This reduces their ability to hold a charge. They can also short-circuit internally. A shorted battery will take no charge

whatsoever, but will pass current from other batteries or from a charger.

You can store nicads charged or discharged—it shouldn't affect the life of the batteries. Just be certain to give them a good charge before using them again. Properly cared for, nicads should last through 1000 charge/discharge cycles. This means that even if you use and recharge batteries weekly, they can last many years.

**Rechargeable Lead-Acid Batteries**—Lead-acid batteries, similar in operation to your car's battery, are most often found in large flash units using shoulder-carried power packs. They need different care than nickel-cadmium units:

• You don't need to run lead-acid batteries down periodically, as you do nicads. In fact, it's best not to run them down too far, if possible. Typically, a lead-acid battery should last about 500 full charge/recharge cycles, if it's not abused.

• Never *store* lead-acid batteries in a nearly discharged condition. Doing so can cause a condition known as *sulfating*. A sulfated battery is difficult, if not impossible, to recharge completely. The condition is permanent.

The best procedure is to give your batteries a refresher charge after each use. And, be sure to recharge them before setting them aside for an extended period.

• Gelled and dry lead-acid batteries in particular should not be overcharged. Chargers that take overnight to recharge your batteries won't do any real harm if left on for an hour or so too long. But fast chargers will. Overcharging causes the battery to lose water. You can replace the lost water in a wet battery, but in a gelled or dry battery the water is lost permanently.

If you tend to leave things plugged in and running interminably, plug your charger into a household timer and set it to shut off at the correct time.

Beside sulfating and drying out, lead-acid batteries can also short-circuit. This can happen to a battery after a long life. It can also happen sooner, if you persist in running your batteries down completely.

**High-Voltage Dry Batteries**—Because of their high cost, it is especially advisable to handle high-voltage batteries properly, so they last as long as possible. Here are some ways to get the most service from them:

• Never drop or jar them. For example, don't let them rattle around loose in your car trunk. Wrap them in padding when you're traveling. Each battery is made up of *hundreds* of individual cells. If you break the connection between *any* two of them, the battery is a total loss.

• It's best to use a rechargeable battery pack or an AC adapter to charge the flash capacitor once

Separate flash was used to light each of the three mushroom patches. Flash for the front patch was held high. Notice shadow on worker's face. Exposure was balanced in such a way that the helmet lamps would also register on the film. Photo by Cary Wolinsky, Stock Boston, Inc.

before each time you use your high-voltage battery. Do the same to reform the capacitor after storing your flash for a long time. If you were to connect your flash to the batteries right away, they would quickly run down. Deformed main capacitors consume a lot of battery power until they are completely reformed. It's a needless waste of battery power to use them to reform the capacitor.

● Between uses, seal your high-voltage batteries in a plastic bag or wrapper and store them in a refrigerator. All batteries eventually run down in storage, but cold storage slows down the process. Remember to let the batteries warm up to room temperature before unwrapping them, so condensation doesn't form.

● Don't touch both terminals of a battery at the same time. You shouldn't have to touch either one, but if you do touch *both* simultaneously you'll know right away—by the shock you'll get!

● You can get a *battery booster* that can extend the life of your batteries, when used properly. You can't completely recharge high-voltage dry batteries, but you can *boost* them—hence the name.

Graflex markets an AC-powered booster that plugs into their battery packs in place of the flash head. Its effects are twofold: First, it speeds up the dispersal of gas bubbles that form in the battery during use. Second, it *partially* recharges the battery. Both actions improve the battery's performance.

Boosting won't help old, dried-out batteries. In fact, if you greatly overdo the boosting, you might dry out your batteries even faster. To get best results, it's important to follow the booster instructions.

Taking all these precautions with your high-voltage batteries may seem like a lot of needless trouble. But it makes good sense. The batteries are expensive and a little extra care will help you get your money's worth from them.

## FLASH TUBES

Flash tubes are designed to meet a compromise between efficient operation and long life. Generally, if a flash tube is not abused it should last for *many* thousands of flashes. In actual practice, some don't last as long.

Like batteries, flash tubes can fail for a variety of reasons. First, there is gradual aging. All flash tubes experience this. With each use, tiny amounts of metal are set free from the metal electrodes at each end of the tube. This metal eventually settles on the wall of the tube, darkening it. The erosion of the electrodes also releases gaseous impurities that contaminate the xenon gas within the tube. These impurities can eventually cause a flash tube to light spontaneously or quit firing altogether.

Although gradual aging can take years, catastrophic tube failure can render a tube useless in days or even instantly. This kind of failure is a direct result of putting excessive stress on the tube. For example, the flash tube in a separate-head studio flash can be destroyed by operating it on too powerful a power pack. Each flash head has a maximum power limit that it can handle. Never exceed the limits.

You can also overstress a tube by firing the flash too many times in rapid succession. The inevitable heat buildup weakens the glass envelope, causing the tube to light continuously or possibly even explode.

Dropping your flash or striking it against an object can cause tiny cracks in the flash tube's glass envelope. Air will ultimately leak in through the cracks and react with the gas inside the tube. When this happens, your flash will begin putting out less and less light. You're not likely to notice the dimming unless you're using a flash meter, showing the lower readings. However, you'll notice the difference when you examine your underexposed film. Ultimately, your flash will stop working altogether.

## DO-IT-YOURSELF REPAIRS

I feel compelled to begin this section with the following warning: *The energy stored in a studio flash unit can kill!* Even the voltage stored in a portable flash—no matter how small the unit—can be painful and damaging. Therefore, do not undertake the repair of any flash equipment unless you understand electronics and are thoroughly familiar with your flash equipment. The only exception to this is the simple replacement of plug-in flash tubes or modeling lights.

In addition to the above, be aware that trying to repair most flash units yourself is generally more bother than it's worth. With the possible exception of a few flash tubes, most of the components you may need are not readily available from local electronic stores.

Many manufacturers stock repair parts strictly by part number, not by generic description. So you'll generally have to begin by requesting a parts list, and possibly a repair manual, to enable you to identify the parts you need. Some service manuals cost nearly as much as the flash they're written for.

Disassembling a flash unit without proper directions is often difficult. Screws are frequently hidden beneath decorative trim and adhesive lables. Sometimes, plastic snaps are used to hold parts together. These snaps often break when you try to remove them, so you'll need replacements.

**Sending A Flash Unit Out For Service**—Whenever you send a flash out for repairs, attach a note explaining the symptoms and telling what you think might be wrong. If you don't tell the repairman exactly what happened when *you* used the flash, *he'll* have to spend time to find out for himself. This will cost you extra money.

Before shipping—or carrying—the flash to the repair station, remove the batteries. Wrap the

batteries and *send them along, too.* It's possible that your problem might be related to those batteries. Mention in your enclosed note that you shipped the batteries, too. **Other Service Tips**—Make sure everything on a newly purchased flash unit works before you send in the warranty card. As long as you still have all the original packaging and documents, your photo dealer will often let you make a direct exchange for a new unit. After you've mailed in the card, you may have to return the flash to a warranty service facility for repair. Policies in these matters can vary from dealer to dealer.

If your flash develops a fault while it's still covered by the warranty, don't try to fix it yourself and don't ask an unauthorized repair person to handle it. Send it to an *authorized* service center, or you'll void the warranty.

By using light and shade thoughtfully, you can lead the viewer's attention to the key area of the scene. For this interior photograph, foreground area was deliberately kept in shade. This directs attention to the center of the room. Notice that the indoor and outdoor illumination have been balanced in such a way that there is some detail in the scene outside the window. Photograph by Ferderbar Studio, reproduced by courtesy of Rolf Herzog Decorative Painting.

# FLASH POWDER TO ELECTRONIC FLASH—
## WE'VE COME A LONG WAY

Photo courtesy of John Faber, N.P.P.A.

We tend to take the good things in life for granted. Electronic flash is no exception. The following two anecdotes serve to remind us of the difficulties and dangers of flash photography in the earliest days. It'll remind us of just how lucky we are today.

Frank Scherschel is known to many from his days with the photo department of *Life* magazine. In the 1920s, Frank was a Chicago news photographer. Later, he became chief photographer at the *Milwaukee Journal.*

Frank had many experiences with flash powder, as did many of his associates. This is how he remembered those days:

"We had two kinds of flash-powder guns. A small Caywood unit was used mainly for portraits. The powder was set off with a small flint wheel. A much larger Imp gun was used for larger scenes. Its powder tray was about 3-1/2 inches wide. It was fired by a spring-loaded plunger that struck a percussion cap to set off the powder. At the same time, the plunger sent a surge of air down a connecting hose to trip the shutter on the camera.

"If all went well, flash powder and shutter would go off together. Sometimes, a gun would misfire. When this happened with the Caywood gun, bits of loose powder would trickle down into the handle. When the flash eventually fired, the powder in the handle would, of course, go off too. The photographer would end up with a painfully burned hand.

"It's not surprising, then, that, in addition to camera, photographic plates and flash gun and powder, the equipment taken on assignment in those days would nearly always include a tube of burn ointment. Serious injuries were not uncommon.

"In an average-sized room, a photographer could take his photographs, pack up his camera, tripod and other equipment and leave—before the last signs of smoke had died down."

Ed Farber began his photographic career at the *Milwaukee Journal.* He later became a significant inventor in the field of electronic flash. Ed recalled an incident with flash powder that was more amusing than tragic. It shows the power flash powder could produce:

Ed, veteran photographer Robert Dumke, and two assistants, were preparing to photograph the lighting ceremony of the municipal Christmas tree in Milwaukee. They had arranged three cameras on tripods on the upper porch of a nearby house.

A homemade flash-powder gun was fashioned from a section of rain gutter. One man took charge of the powder fuse from a window overlooking the porch. He signaled the men at the cameras to open the shutters, and set off the powder.

The gigantic blast that followed shook the wooden porch and blew all three cameras over. Out of sheer curiosity, the films were developed anyway.

One of the negatives had a blurry, but adequately exposed, image of the courthouse—which was about two blocks away from the camera and the flash!

Over the years, the hazards of flash powder took their toll. In 1933, newspaper magnate William Randolph Hearst banned all further use of flash powder by his staff. His photographers then switched to the recently introduced flashbulbs.

A decade or so later, electronic flash started to be used for press, commercial and general photography.

Window was a studio prop that added atmosphere to this portrait. Subject was lit in the normal way. Photographer added some "raindrops" to the window. Notice that the window frame was lit separately from the outside, to give it more prominence. Girl's head was carefully positioned. It's framed to form a pleasing composition within one window pane. Within the two upper central panes the composition is also attractive. The same applies to the four central panes. Even the four left window panes outline a pleasing picture. This is not an accident—it is evidence of a photographer's trained eye. Photo by Ed Judice.

# INDEX

**Cover Photos:**
Skater—Focus on Sports, Inc.
Dragonfly—Hans Pfletschinger, Peter Arnold, Inc.
Child—Edward Lettau, Peter Arnold, Inc.